'The concept of a "Human Fashion Brand" is ... in the number of fashion-influencing celebritie... consumers. This book is an essential read for tho... ioural science, fashion, marketing and business management.'

Dr Kevin Almond, *Associate Professor in Fashion,*
School of Design, University of Leeds, Former Head of the
Department of Fashion and Textiles,
University of Huddersfield, UK

'The journey in public relations, celebrity brand management, fashion, media, and production is often one of exhilarating excitement and constant change. The authors have been steadfast in their focus, management, and passion on the subject in all its guises.'

JayJay Epega, *BBC Studios Productions,*
Media Consultant and Writer, EpegaMedia, Director

'This is an epic book and illustrates how following celebrity fashions has increased exponentially. The thought process behind this for individuals is: "If I cannot have their lifestyle, at least I can have the same clothes – or cheaper versions of them!" This book describes the impact on the celebrity, the marketer and the consumer.'

Don Rouse, *Celebrities & Lifestyle Communications*
Consultant, Entrepreneur and Mentor

Celebrity Fashion Marketing

This book explores the concept of the celebrity as a 'Human Fashion Brand' and the effectiveness of the celebrity in promoting fashions and shaping the identity and decisions of fashion consumers.

Beginning with an overview of the background and context of the fashion celebrity, the authors consider celebrity fashion classifications and fashion influencers; they explore existing theory, models, and tools and the role of technology; and they explain how celebrity-endorsed products impact fashion consumers and trends. The book defines and develops a 'Human Fashion Brand Model,' which describes the relationships between the fashion celebrity, fashion celebrity marketers, and fashion consumer behaviour choices in celebrity fashion emulation. Coupled with reflective questions to aid learning, every chapter is illustrated by case studies of celebrities as fashion brands, as well as their impact on fashion, including Kylie Jenner and Kim Kardashian, Beyoncé, and Madonna.

Providing a holistic understanding of the celebrity as a human fashion brand and celebrity-inspired fashion consumption, *Celebrity Fashion Marketing* should be recommended reading for advanced undergraduate and postgraduate students studying Celebrity Fashion and Influencer Marketing, Fashion Marketing, Fashion Brand Management, and Consumer Behaviour.

Dr Fykaa Caan is a celebrity fashion marketing specialist, working with celebrity A-list clients, fashion brands, and influencers. Her area of specialism includes celebrity fashion marketing, consumer behaviour, consumer psychology, influencer fashion, human brands, and human behaviour. With the media company she works with in London, her portfolio includes attending/writing for London, New York, Paris fashion week events, Adele X Sami Knight X Rehab, Audi X Olivier Awards, David Beckham X Jaguar X Lunaz, Nicole Scherzinger's Debut Bedding Collection 'Nalu', TCM, The Daily Telegraph, Boss (Gerard Butler), Ralph Lauren, Gieves & Hawkes, Hackett, BFI, BAFTA, The British Fashion Council, The Fashion Awards, and many more.

Professor Angela Lee is Associate Dean (Research) at the University College of Estate Management, UK. She has published more than 300 journals and conference publications based on her research, as well as five books, and she has managed numerous externally funded research projects to successful completion. In addition to her associate dean positions, she has previously held head of department roles at the University of Salford and the University of Huddersfield, UK.

Mastering Fashion Management

The fashion industry is dynamic, constantly evolving and worth billions world-wide: it's no wonder that Fashion Business Management has come to occupy a central position within the Business School globally. This series meets the need for rigorous yet practical and accessible textbooks that cover the full spectrum of the fashion industry and its management.

Collectively, *Mastering Fashion Management* is a valuable resource for advanced undergraduate and postgraduate students of Fashion Management, helping them gain an in-depth understanding of contemporary concepts and the realities of practice across the entire fashion chain – from design development and product sourcing, to buying and merchandising, sustainability, and sales and marketing. Individually, each text provides essential reading for a core topic. A range of consistent pedagogical features are used throughout the texts, including international case studies, highlighting the practical importance of theoretical concepts.

Postgraduate students studying for a Masters in Fashion Management in particular will find each text invaluable reading, providing the knowledge and tools to approach a future career in fashion with confidence.

Fashion Marketing and Communication
Theory and Practice Across the Fashion Industry
Olga Mitterfellner

Fashion Buying and Merchandising
The Fashion Buyer in a Digital Society
Rosy Boardman, Rachel Parker-Strak and Claudia E. Henninger

Sustainable Fashion Management
Claudia E. Henninger, Kirsi Niinimäki, Marta Blazquez Cano and Celina Jones

Fashion Supply Chain Management
Virginia Grose and Nicola Mansfield

Celebrity Fashion Marketing
Developing a Human Fashion Brand
Fykaa Caan and Angela Lee

For more information about the series, please visit: www.routledge.com/Mastering-Fashion-Management/book-series/FM

Celebrity Fashion Marketing

Developing a Human Fashion Brand

Fykaa Caan and Angela Lee

Routledge
Taylor & Francis Group

LONDON AND NEW YORK

Designed cover image: © Getty Images

First published 2023
by Routledge
4 Park Square, Milton Park, Abingdon, Oxon OX14 4RN

and by Routledge
605 Third Avenue, New York, NY 10158

Routledge is an imprint of the Taylor & Francis Group, an informa business

British Library Cataloguing-in-Publication Data
A catalogue record for this book is available from the British Library

ISBN: 978-1-032-00733-5 (hbk)
ISBN: 978-1-032-00735-9 (pbk)
ISBN: 978-1-003-17536-0 (ebk)

DOI: 10.4324/9781003175360

Typeset in Optima
by Apex CoVantage, LLC

Access the Support Material: www.routledge.com/9781032007359

Contents

Acknowledgements

This book is borne from an incredible journey of friendship and passion in the pursuit of understanding ever-changing popular celebrity culture. What started as a chance encounter has led to lifelong sisterhood and many conversations about the potential impact of celebrities, social media, fashion, commercialism, and marketing on our beautiful daughters Aisha, Maryam, and Ayla.

Finally, and most importantly, this book is dedicated to Fykaa's mother, Ami, who always believed and supported her throughout this journey in every possible way.

Abbreviations

CMM Capability Maturity Model
DBI David Brown Index
DIT Diffusion of Innovations Theory
Fansumer Fan consumer
FIFA International Federation of Association Football
FRED Familiarity, Relevance, Esteem and Differentiation
HFBM Human Fashion Brand Model
MERCH Merchandise
MP Member of Parliament
TAM Technology Acceptance Model
TPB Theory of Planned Behaviour
TRA Theory of Reasoned Action
Web 2.0 Twitter, Facebook, TikTok, Instagram and YouTube

Foreword

The journey in public relations, celebrity brand management, fashion, media, and production is often one of exhilarating excitement and constant change. The authors have been steadfast in their focus, management, and passion for the subject in all its guises. It has been a superlative pleasure to have been a part of that journey.

This is a fantastic book that analyses the celebrity as a human fashion brand in the context of celebrity fashion emulation. Particular focus is laid on how celebrities influence fashion, how their innovative trends are diffused to consumers – resulting in consumers imitating celebrities' fashions – and the psychology behind it. Reference is made in celebration of iconic celebrities as human brands such as David Beckham, Madonna, and Run DMC and their impact on society.

The celebrity has pervaded international development causing much debate and diverse responses in their fashions, looks, and style. It is for these reasons that celebrities and fashion should be a central focus for future campaigns of fashion marketers/luxury houses, public relations, consumers, branding, and media communications.

JAYJAY EPEGA – BBC Studios Productions / Brands –

Media Consultant and Writer – Epega Media BBC – MTV Europe – Sony Music – BAFTA – CNN – David Bowie – George Michael – Mariah Carey – Janet Jackson – David Gandy – GQ Magazine US/ GQ Awards UK – The OSCARS – BFI.

Preface

This book discusses the significant growth in the number of fashion celebrities and fashion consumers and their effectiveness in endorsing and promoting fashions as a coercive force in shaping the identity of fashion consumers. It presents the case for analysis of the exemplified fashions of celebrities, which are increasingly being used by consumers for inspiration, thus, resulting in fashion consumers adopting the looks of fashion celebrities they follow. Furthermore, it investigates how and why consumers need a connection to a celebrity and their fashion(s) and why they store the message of the celebrity's idealised image to, at the same time, enhance their own beauty and physical attractiveness.

This book emphasises the idea that today's consumers require fashionable products, easier access to their celebrity's fashions, intimate exposure to their favourite celebrities, faster consumption, and convenient transactions. Kowalczyk and Royne's (2013) book also examines celebrities as "human beings that are branded and marketable objects", that is, Human Fashion Brands. This book describes a symbiotic relationship and an apparent dichotomy among the different stakeholders, emphasising the importance of analysing the complexity of this relationship, which is described in the development and structure of a model in Chapter 5. The three stakeholder groups involved in celebrity fashion and emulation (which are termed 'symbionts' by the authors) are, namely, the fashion celebrity, the fashion celebrity marketer, and the fashion consumer. The interrelationship of these symbionts will be investigated, and a Human Fashion Brand Model is presented to define the critical symbiotic relationships for celebrity emulation.

The need to understand humans as fashion brands is pertinent because there is an enhanced growth in the use of social media by celebrities to communicate their fashions without a clear understanding and monitoring of their positioning, capability/maturity, and the impact this has on consumers. Thus, the book analyses existing models and how they impact the fashion consumer-self, and on the attachments that individuals place on celebrities as opinion leaders and their fashions. The Human Fashion Brand Model is envisaged to be a guide for anyone interested in celebrity fashion marketing and can be further adaptable to any gender, age group, country, campaign location, target customer, religion, or culture.

Chapter 1

Introduction

1.0 Introduction

The Internet and widespread use of Web 2.0 technologies, such as Instagram, Twitter, Facebook, Tik Tok, and YouTube, are rapidly changing and shaping celebrity fashion and how many celebrities communicate their fashion trends and styles to their fans. These mediums have facilitated a direct connection between the consumer and celebrities, resulting in a surge of celebrity marketing and celebrity mimicry in fashion. This trend leads us to the need for an improved understanding of the role of the celebrity, which goes beyond entertainment and now fills a gap, or numerous gaps, in individuals'/consumers' lives (Rojek, 2001).

Meanings and attachments of celebrities and their fashions can significantly shape identity-development in consumers, and many theorists believe these attachments foster their transition into adulthood in much the same way that relationships with peers do. Why individuals (consumers) feel the need to look for inspiration from celebrities and their styles to activate, validate, fulfil their expectations, and create feelings and experiences is important for marketers to understand. This is because, from an industry perspective, there is substantial revenue in the sales of their celebrity ready-to-wear derivations, trends, and mass-market clothing.

This book provides an overview of the need for a Human Fashion Brand Model. It commences by defining 'the celebrity' and examining the celebrity as a Human Fashion Brand, before explaining the growth of fashion celebrities, fashion celebrity marketers, and fashion consumers in celebrity fashion emulation. It highlights the importance of celebrities in the fashion industry and analyses how marketers appoint celebrities for their fashion brands and the impact they have on consumers. Furthermore, it investigates what constitutes a fashion fad or a longer-term fashion or trend which is diffused in society and adopted as a result of its connection to a celebrity.

Images and information about celebrities have become readily available at the touch of a button using smart technology and have resulted in celebrity figures enjoying high profiles. Their individual qualities and glamorous images have enabled living celebrities such as Madonna (American singer/songwriter and actress), Beyoncé (American singer/songwriter, actress, and record producer)

DOI: 10.4324/9781003175360-1

and Leonardo DiCaprio (American actor and film producer) to move beyond national markets. Some celebrities continue to influence fashion consumers even after they have died, including Michael Jackson (American singer/songwriter and dancer) and Marilyn Monroe (American actress).

The glamourous images allow fans and followers to dedicate their lives to individual celebrities and track their moves and monitor them. A celebrity can wear something distinctive, merely once, and fans automatically associate that celebrity with that product (brand), making them meaningfully influential to companies and brands.

Discussion:

Style or comfort – what governs your choices for fashion?

What makes you passionate about a particular fashion brand?

Which celebrity influences your style, and why?

Class and fashion – how is fashion used to distinguish social classes, and how does this impact you personally?

What style of fashion do you think best represents you and your identity?

If you could live in a particular era of fashion, which one would it be?

1.1 Background and Context

Walker (2003) defined a celebrity as anyone that presides in "music, fashion models or the movies . . . [and who has] fans in virtually every country in the world" (additional definitions of the celebrity are analysed in detail in section 2.1.1). Moulard et al. (2015) extend this definition and state that "the rise in the number of celebrities and their influence is undeniable . . . and that cable television, celebrity websites and social media have all proliferated celebrity images." This trend is ensuring that celebrity status is no longer reserved for actors, singers, and sports figures with above-average statistics, but has now shifted to include other life domains such as politicians, CEOs, chefs, and gardeners, too. This growing obsession with the celebrity is contributing towards celebrity identity diffusion. As a consequence, the entertainment celebrity holds more value within society today and is opening new ingresses like "reality TV, which have [in turn] formed new celebrities and become a major part of the media landscape that one might say defines the reality of television" (Joyrich et al., 2015) and currently also to Internet 'influencers' who hold great sway over consumer choices and lifestyles.

However, it is important to note that there is a distinction among the roles the celebrity plays in the context of this study, and how they differ from the endorser role they have conventionally been used for. Traditionally, a celebrity endorser

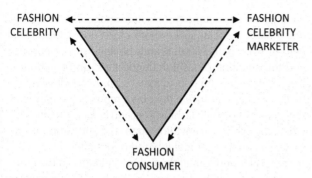

FASHION CELEBRITY

FASHION CELEBRITY MARKETER

FASHION CONSUMER

Figure 1.1

Illustration of the Symbiotic Relationship Among the Fashion Celebrity, the Fashion Celebrity Marketer, and the Fashion Consumer

of a brand would incorporate the celebrity's face with a product or a collection. However, "marketing thought has shifted from viewing celebrities as merely brand endorsers" but as human brands (Fleck, 2012; Ilicic & Webster, 2016; Kelting & Rice, 2013; Kowalczyk & Royne, 2013) to celebrities as constructed human brands (Ilicic & Webster, 2011; Keel & Nataraajan, 2012; Moulard et al., 2015; Thomson, 2006). This concept coined by the mainstream media is not one that has been fully developed in the academic literature (Kowalczyk & Royne, 2013).

Familiarity and likability both play an important part when a receiver (consumer) accepts a message from an attractive source (marketer) because of the desire to be liked and to identify with the endorser (celebrity) (Cohen & Golden, 197; Erdogan, 1999). Thus, as a consequence, celebrities, marketers, and consumers are shifting towards an individual's self-expression of fashion through dress. This is because more and more people are inspired by the celebrity. This opens the debate over the role of celebrities as human brands and what brands essentially do. "Brands offer consumers the opportunity for self-expression, self-realisation and self-identity and this effect is particularly strong in fashion categories . . . where branding strategy becomes less about market share and more about minds and emotional share" (Carroll, 2009).

There are three stakeholder groups involved in celebrity fashion and emulation (Figure 1.1), namely, the fashion celebrity, the fashion celebrity marketer, and the fashion consumer. These three stakeholders are termed 'symbionts' for the purpose of this book – derived from the term 'symbiotic relationship' to describe how different stakeholders [organisms] exist together yet depend on each other in symbiosis for a mutual benefit. In the environment of business and marketing, a strategic symbiosis is "a close association of two or more business activities that are dependent on one another" causing a symbiotic interaction. The shared conventions of the three symbionts, constitute towards interactions. This sharing, or as we have termed it throughout this book; a symbiotic relationship is an important concept to understand as it allows the understanding of how messages are to be communicated across to consumers. Effective celebrity marketing campaigns would not be possible without one or all stakeholder groups. Thus, this book analyses the complexity of this problem and the development of the celebrity as a Human Fashion Brand in the milieu of the apparel sector.

1.1.1 The Fashion Celebrity

Rojek (2001) suggests one of the causes for this public addiction to the celebrity is because many people measure their worth against people they have never met. "Famous people have now become so widespread in our contemporary world,

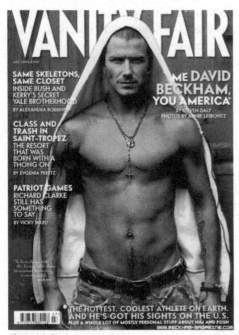

Figure 1.2

David Beckham Vanity Fair

making the instantaneity of celeb images and celebrities inhabit a social space more closer to us than ever before" (Marshall, 2006). Brands benefit from celebrities and the attention of fashion trendsetters, and celebrities themselves can earn considerable sums via endorsement deals. They also enhance their own reputations thanks to their association with fashion Keel and Nataraajan (2012), where they can earn anything up to six-figure amounts by simply wearing a particular brand or designer.

To further understand the fashion celebrity in the context of this research, the focus in this book views celebrities as human brands in fashion. For example, former professional footballer David Beckham is a celebrity whose fashion style has developed over the years and has manifested in fashion, media, and society (Figure 1.2). In January 2021, he had 65.2 million followers on Instagram. One may argue that endorsement and launching fashion collections are just two parts of his celebrity fashion marketing strategies. However, he indeed does many other things under his 'David Brand Beckham' title. Henceforth, this book will take the stance of observing the human brand of a fashion celebrity such as David Beckham and his engagement and development with fans as a brand. Encompassing everything about himself as an entirety of what he does. In particular, how brand names such as David Beckham and other celebrities attain human attributes (Thomson, 2006).

Celebrities such as Kendall Jenner and her sister, model Kylie Jenner (Figure 1.3; the Kardashian-Jenner family), have become prominent in the fields of entertainment and fashion following their reality TV show. They have fashion-branded their own lines of apparel and footwear (including Topshop, PacSun California lifestyle clothing, and Tom Ford). In 2019, it is reported that Kylie is paid around £960,000 for a single post on Instagram, making her the highest-paid influencer of 2019 with her 141 million followers (Digital, 2021). Below are figures derived from their social media accounts in January 2022 to illustrate their influence and their impact:

- ❏ Instagram followers: Kylie 303 million and Kendall 214 million
- ❏ Twitter followers: Kylie 39.5 million and Kendall 31.8 million
- ❏ Facebook: Kylie 33 million and Kendall 22 million

Other examples of fashion endorsements include David Beckham for Armani and H&M, Mark Wahlberg (American actor, rapper, and producer) for Calvin Klein, and Nicole Kidman (Australian actress, singer, and producer) for Chanel. Such endorsements have allowed these celebrities to generate more earnings from self-branded business ventures than through their professional careers (Moulard et al., 2015). The advantages of these types of celebrity collaborations are not only monetary, but also personally rewarding as celebrities are able to

Figure 1.3

Kendall and Kylie Jenner, with Their Sister Khloe Kardashian

demonstrate their innovative fashions, choices, trends, and styles to their fan base in order to generate sales from fashions and new innovations they have created. Consumers desire these celebrity fashions as they allow themselves to feel closer to their icon(s) and to the glamorous lifestyle affiliations associated with them. They allow consumers to perceive these brands and products associated with celebrities as being more prestigious, of higher quality or otherwise more desirable (Batra & Homer, 2004; Keller, 1993; Spry et al., 2011). The intricacy in the fashion choices that celebrities make or what they decide to do is important to understand as more and more consumers are using celebrities as role models. Therefore, it is important for celebrities to be conscious of the image they present, because their image can have a profound impact on the products they endorse. This includes many factors, such as their behaviour and the perceived image/reputation, which equally impact the consumer.

Fashions and behavioural influences vary and can have a short-term impact; for example, a fashion fad like the hat that Pharrell Williams (American singer, rapper, songwriter, record producer, and fashion designer) wore on the front of an album cover (Figure 1.4; a remake of Vivienne Westwood's 1980s-style buffalo hat). They can also have a more long-lasting effect and impact; for example, Amy Winehouse's fashion and style (Figure 1.5; English singer/songwriter admired the 1960s and based her style on the classic beehive hairstyle and

Figure 1.4

Pharrell Williams' Hat

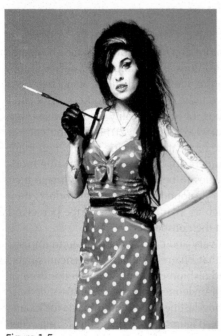

Figure 1.5

Amy Winehouse's Iconic Style

tea house dress). Understood to have revolutionised and changed fashion for their fans worldwide. The profusion of celebrity styles influences fashion behaviour, not only on a macro level but also on a micro level by influencing the-self and identity of their fashion-fan consumers.

1.1.2 The Fashion Celebrity Marketer

Previous celebrity research in this area has revolved around using the celebrity as an endorser for another brand's product, rather than understanding the celebrity brand itself (Moulard et al., 2015). This concept is further supported by Thomson (2006), who found that certain human needs (i.e., autonomy and relatedness) influence an individual's attachment to a celebrity brand and that the perceived authenticity of the human brand likely plays an important role. Whether we choose to follow celebrity fashion and celebrity endorsements or not, we are in some way or another impacted by celebrity fashion to some degree, and through these meanings, the connotations of fashions can also change. Marketers use celebrities in advertising to endorse their products by associating the celebrity's face

with their brands to impact consumer behaviour. This gives them mass exposure and allows them to reach out to a wider target audience. Thus, by allowing celebrities and their fashion brands to enter the market, they bring instant awareness and automatic exposure to millions of people all over the world. While a new brand would conventionally need to work very hard to gain this level of awareness of a new product (Brooke, 2016), celebrity marketing fast-tracks recognition exponentially.

It is important to understand that there are positive and negative factors associated with using a celebrity, and marketers should be mindful of this and select celebrities that make the best match that fits with their fashion brand and their target market. These types of positive match-ups are important and are factors that need to be considered prior to the selection process, because they synchronise a celebrity's image with a brand which result in an impact on consumers' desires. A positive fit for a marketer is an actress like Jennifer Aniston (American actress and producer) who is often used by brands because of her reputation of being "the good girl next door." Likewise, the personality and charisma of Daniel Craig (English actor and producer) is communicated through brands because of the perception consumers hold of him as the quintessential British gentleman. It is an intrinsic prerequisite to select the right celebrity and match it to a brand because, in a single day, a scandal can ruin a brand and a celebrity's career completely.

Knittel and Stango (2009) explored the negative consequences to endorsements and the effect of a scandal by examining the infamous Tiger Woods' (American professional golfer) extramarital affairs and erratic behaviour, which led to an estimated loss for the brands (which associated with him) of between $5 billion and $12 billion. Scandals can become costly, and it is an important factor for marketers to understand the reputation of the celebrities they use because they are the face of their brand. Another example of a negative effect on a fashion brand involves Burberry and Danniella Westbrook (English actress, EastEnders soap star, D list). As Britain's foremost fashion house, Burberry had been using the nova check since the 1920s, first lining its trench coat. However in 2002, there was a now-infamous paparazzi shot of Danniella Westbrook wearing a Burberry skirt and a Burberry bag, while lifting a child dressed in a Burberry kilt out of a Burberry buggy. Best known for her role on *Eastenders* and a public battle with cocaine addiction, the image was printed by *The Sun* alongside the caption 'chavtastic.' "Danniella's way of shopping Burberry and the way in which she put the look together was seen as the epitome of bad taste and the all-over check took on rebellious, if not violent connotations, hailing back to the casual movement of the 1980s when football hooligans draped themselves in designer logos and bolshy monograms. In cultural terms, the 'chav' was a descendent of that abject archetype" (Rodgers, 2022). Defined as "a young person characterised by brash and loutish behaviour, usually with connotations of a low social status... the then-prime minister Tony Blair's "regular attacks on scroungers, chavs, single mothers, asylum seekers, and hooded youths provided a sheen of respectability to TV executives who made a career out of mocking Britain's most marginalised" (Dawson, 2020). The picture of Daniella Westbrook unfortunately for Burberry was repeated every time there was a press story, so it became synonymous with 'British chav culture' and became detrimental to the Burberry brand's reputation (Lea-Greenwood, 2012).

1.1.3 The Fashion Consumer

Research indicates that, "in addition to relations with family and peers, consumers often form secondary attachments to figures they encounter in the popular media, such as celebrities . . . these celebrities are perceived as role models/guides and are influential" (Pringle, 2004). According to Schickel (2010), this is because the use of celebrity images in the media is a useful ideological symbol for constructing meaning, and it is highly likely that people (the general public) can relate to celebrities and their fashions and either want to look like them or aspire to be them (Meyers, 2009). As the role celebrities play in people's lives goes beyond a voyeuristic form of entertainment, it is actually fulfilling an extremely important research and development function for them as individuals and for society at large (Pringle, 2004). Rojek (2001) suggests the reason for this is because "celebrities operate as models for emulation, embody desire, galvanise issues in popular culture, dramatise prejudice, affect public opinion and contribute identity formation."

The celebrity can often elicit positive emotional responses for the public/consumer. According to Quiroga et al. (2005), this is because the celebrity holds a positive valence and is able to assist in fulfilling various behavioural goals. These include "meeting an audience's needs for gossip, fantasy, identification, status, affiliation, and attachment" (Adler & Adler, 1989). In exploring this connection between brands and the consumer's psyche, Belk (1988) explores the extended-self, "which encompasses the self (me) and possessions (mine); stating that possessions are a reflective part of ourselves and that our experiences occur as a result of encountering, undergoing or living through things." In addition, a neurological study evidenced an intrinsic link between consumers and celebrities and found that celebrities, through both their image and/or printed name, can trigger fast-access memory cells in the brain (Quiroga et al., 2005). The onslaught provides sensory, emotional, cognitive, behavioural, and relational values that replace functional values (Schmitt, 1999).

However, it is important to note there is no one defining facet of a consumer's life, there are many which can be what is happening presently to a consumer and/or how they see themselves versus their reality, against what they aspire to be. Consumers want to look more and more like their favourite celebrity idols, and this is to fulfil their emotional needs (Gobé, 2001). This can be achieved through fashion, style, and how they present themselves with their clothes. This use of clothing has been interpreted as a code/language that allows a (form) of message to be created and (selectively) understood and, as a result, the celebrity and fashion are becoming interwoven (Carroll, 2009). Marketers use celebrity advertising codes fused with symbolic prompts to create distinctive brand images and associations to target people who aspire to behave and look like celebrities.

Furthermore, today, with the introduction of social media, the opportunities to learn about fashion celebrities are endless. We can experience a celebrity's wardrobe, home, and world, intruding on their lives like never before. This is new territory and could not have been done before at this scale. For example, we can see all aspects of our favourite celebrities' lives: their mode of dress, regular hairstyle changes, beauty regimes, their partners, families, their food, favourite

places, their houses, interior design, and children. Social media allow fans and consumers to act out a life parallel to celebrities which they can relate to, aspire to, and imitate (Pringle, 2004).

This type of "fashion consciousness is characterised by an interest in clothing and fashion, and in one's appearance" (Summers, 1970), but if it is combined with the "following" of a celebrity, the consumer gains up-to-date styles, frequent changes in wardrobe, pleasurable shopping experiences, a degree of involvement with the celebrity's style and fashion for their clothing (Nam et al., 2007). This allows consumers to absorb tacit meanings from these type of idols (celebrities), because they are able to provide much more than entertainment and a sought-after commodity among advertisers (Um, 2013) for high recognition and the creation of a strong product perception which allows the celebrity to vastly raise the profile of a product or fashion trend (Jamil & Rameez ul Hassan, 2014; Shaw & Koumbis, 2014).

1.2 The Need for a Human Fashion Brand Model

The need for a Human Fashion Brand Model is pertinent because there is an enhanced growth in the use of social media by celebrities to communicate their fashions without a clear understanding and monitoring of their positioning, capability/maturity, and the impact this has had on consumers. This book analyses existing models and how these impact the fashion consumer-self and the attachments that individuals place on celebrities as opinion leaders and their fashions. The Human Fashion Brand Model is envisaged to be a guide for anyone interested in celebrity fashion marketing and can be further adaptable to any gender, age group, country, campaign location, target customer, religion, or culture. However, it is equally important to state what the model is not purported to support. It is not about moving a fashion celebrity from the D list to the A list. Furthermore, in the same vein, it does not advocate that all celebrities must influence fashion. It illustrates the relationships among the symbionts and the apparent dichotomy among the different stakeholders.

This book on the Human Fashion Brand explores a new area of research within celebrity fashion marketing and reviews scholarly literature of fashion marketers, including an overview of models and tools used to analyse and appoint celebrity brand endorsers. The celebrity fashion models/ tools and adoption models will be identified in the literature to investigate if there is a dearth of models that support the understanding of the needs of the consumer. Currently, there is no holistic model that understands the symbiotic relationship and generally no universally accepted celebrity fashion classification model. This supports a need for a Human Fashion Brand Model in celebrity fashion marketing and calls for a wider focus and study to promote a better understanding of the key issues that fashion consumers have when emulating the fashions of celebrities.

1.3 Summary

This chapter described the significant growth in the number of fashion celebrities, fashion celebrity marketers, and fashion consumers. It presented the case for analysis of the exemplified fashions of celebrities which are increasingly being used by consumers for inspiration and, in addition, examined why fashion consumers want to adopt the looks of fashion celebrities they follow. Furthermore, it discussed how and why consumers feel they need a connection to a celebrity and their fashions and why they want to store the message of the celebrity's idealised image to enhance their own beauty and physical attractiveness.

The chapter highlighted how today's consumers require fashionable products, easier access to their celebrity's fashions, intimate exposure to their favourite celebrities, faster consumption, and convenient transactions. It is important for marketers to understand this relationship and its meaning in the analysis of the fansumer (fan consumer) because of the critical factors of the impact of the fashions of celebrities that consumers desire to emulate. The remainder of this book will examine celebrities as "human beings that are branded and marketable objects" (Kowalczyk & Royne, 2013). Thus, an appropriate Human Fashion Brand Model which illustrates the relationships among the symbionts and this apparent dichotomy is important to analyse in the understanding of the complexity of this relationship. The information on understanding why people choose to adopt a celebrity-inspired fashion product and how they feel its personality somehow corresponds to their own is extremely useful to marketers.

References

Adler, P. A., & Adler, P. (1989). The gloried self: The aggrandizement and the constriction of self. *Social Psychology Quarterly*, 299–310.

Batra, R., & Homer, P. M. (2004). The situational impact of brand image beliefs. *Journal of Consumer Psychology*, *14*(3), 318–330.

Belk, R. W. (1988). Possessions and the extended self. *Journal of Consumer Research*, *15*(2), 139–168.

Brooke, Z. (2016). *Behind the business of banking on big-name clothing brands.* Retrieved from www.ama.org/publications/marketingnews/pages/marketing-celebrity-brand.aspx#channels

Carroll, A. (2009). Brand communications in fashion categories using celebrity endorsement. *Journal of Brand Management*, *17*(2), 146–158. Doi:10.1057/bm.2008.42

Cohen, J. B., & Golden, E. (1972). Informational social influence and product evaluation. *Journal of Applied Psychology*, *56*(1), 54.

Dawson, B. (2020). *The British 'chav' stereotype is making a comeback on TikTok.*

Digital, P. (2021). *How do influencers make money.*

Erdogan, B. Z. (1999). Celebrity endorsement: A literature review. *Journal of Marketing Management*, *15*(4), 291–314.

Fleck. (2012). Celebrities in advertising: Looking for congruence or likability? *Psychology & Marketing*, *29*, 651–662.

Gobé, M. (2001). *Emotional branding.* Allworth Press. Retrieved from http://marketingpedia.com/Marketing-Library/Quotes/Emotional%20Branding_quotes.pdf

Ilicic, J., & Webster, C. M. (2011). Effects of multiple endorsements and consumer-celebrity attachment on attitude and purchase intention. *Australasian Marketing Journal (AMJ), 19*(4), 230–237.

Ilicic, J., & Webster, C. M. (2016). Being true to oneself: Investigating celebrity brand authenticity. *Psychology & Marketing, 33*(6), 410–420. Doi:10.1002/mar.20887

Jamil, R. A., & Rameez ul Hassan, S. (2014). Influence of celebrity endorsement on consumer purchase intention for existing products: a comparative study. *Syed Rameez ul Hassan, RAJ (2014). Influence of celebrity endorsement on consumer purchase intention for existing products: a comparative study. Journal of Management Info, 4*(1), 1–23.

Joyrich, L., Kavka, M., & Weber, B. R. (2015). Project reality TV. *Camera Obscura, XXX*(88), 1.

Keel, A., & Nataraajan, R. (2012). Celebrity endorsements and beyond: New avenues for celebrity branding. *Psychology & Marketing, 29*(9), 690–703. Doi:10.1002/mar.20555

Keller, K. L. (1993). Conceptualizing, measuring, and managing customer-based brand equity. *Journal of Marketing, 57*(1), 1–22.

Kelting, K., & Rice, D. H. (2013). Should we hire david beckham to endorse our brand? Contextual interference and consumer memory for brands in a celebrity's endorsement portfolio. *Psychology & Marketing, 30*(7), 602–613. Doi:10.1002/mar.20631

Knittel, C. R., & Stango, V. (2009). Shareholder value destruction following the tiger woods scandal. *Retrieved on January 5,* 2010.

Kowalczyk, C. M., & Royne, M. B. (2013). The moderating role of celebrity worship on attitudes toward celebrity brand extensions. *Journal of Marketing Theory and Practice, 21*(2), 211–220. Doi:10.2753/MTP1069–6679210206

Lea-Greenwood, G. (2012). *Fashion marketing communications.* Somerset, NJ: John Wiley & Sons.

Marshall. (2006). *The celebrity culture reader.* New York; London: Routledge.

Meyers, E. (2009). 'Can you handle my truth?': Authenticity and the celebrity star image. *The Journal of Popular Culture, 42*(5), 890–907.

Moulard, J. G., Garrity, C. P., & Rice, D. H. (2015). What makes a human brand authentic? Identifying the antecedents of celebrity authenticity. *Psychology & Marketing, 32*(2), 173–186.

Nam, J., Hamlin, R., Gam, H. J., Kang, J. H., Kim, J., Kumphai, P., . . . Richards, L. (2007). The fashion-conscious behaviours of mature female consumers. *International Journal of Consumer Studies, 31*(1), 102–108. Doi:10.1111/j.1470-6431.2006.00497.x

Pringle, H. (2004). *Celebrity sells.* Chichester: Wiley.

Quiroga, R. Q., Fried, I., Reddy, L., Koch, C., & Kreiman, G. (2005). Invariant visual representation by single neurons in the human brain. *Nature, 435*(7045), 1102–1107. Doi:10.1038/nature03687

Rodgers, D. (2022). *Burberry and the chequered politics of working-class appropriation.*

Rojek, C. (2001). *Celebrity.* London: Reaktion.

Schickel, R. (2010). I blog therefore I am. *Society, 47*(6), 521–524. Doi:10.1007/s12115-010-9372-9

Schmitt, B. (1999). Experiential marketing. *Journal of Marketing Management, 15*(1–3), 53–67.

Shaw, D., & Koumbis, D. (2014). *Fashion buying: From trend forecasting to shop floor.* London: Fairchild Books.

Spry, A., Pappu, R., & Bettina Cornwell, T. (2011). Celebrity endorsement, brand credibility and brand equity. *European Journal of Marketing, 45*(6), 882–909.

Summers, J. O. (1970). The identity of women's clothing fashion opinion leaders. *Journal of Marketing Research, 7*(2), 178–185. Doi:10.2307/3150106

Thomson, M. (2006). Human brands: Investigating antecedents to consumers' strong attachments to celebrities. *Journal of Marketing, 70*(3), 104–119. Doi:10.1509/jmkg.70.3.104

Um, N.-H. (2013). Effects of negative brand information: measuring impact of celebrity identification and brand commitment. *Journal of Global Marketing, 26*(2), 68–79. Doi:10.1080/08911762.2013.804614

Walker, J. A. (2003). *Art and celebrity*. London: Pluto.

Zafer Erdogan, B., & Kitchen, P. J. (1998). Managerial mindsets and the symbiotic relationship between sponsorship and advertising. *Marketing Intelligence & Planning, 16*(6), 369–374. Doi:10.1108/02634509810237578

Chapter 2

The Fashion Celebrity

2.0 Introduction

Celebrities are seen as aspirational examples and archetypes in today's society.

Much of human behaviour, and specifically purchasing, can be attributed to the desire to improve presentation and desirability . . . as when someone identifies with a celebrity from a physical point of view, they may see an enhanced fantasy reflection of themselves, and imitate them.

(Pringle, 2004)

Celebrities are people that exert significant influence in several facets of society, ranging from the arts, music, movies, television, sports, culture, politics and religion. In the fashion world, the list of celebrities include designers, their muses, models, photographers, ad any prominent person involved in the artistic aspects of fashion such as make-up artists and fashion consultants.

(Okonkwo, 2010)

"As arbiters of taste, style and public opinion . . . their endorsement and creative input enable them to bring attention, credibility and other intangible benefits to a brand in a way that no other type of advertising can" (Euromonitor, 2014). The growing obsession with celebrities and their fashions has generated massive industries making the global market for fashion, hair, and make-up worth billions and resulting in consumers becoming more fashion conscious than ever before (Giovannini et al., 2015; Thomson, 2006).

This chapter provides a detailed review of the celebrity and, notably, the fashion celebrity. The role of the celebrity as a Human Fashion Brand will be explored and how their fashions contain meaning, messages, and behaviours that impact on their fans and consumers. The term celebrity will be defined, and different classifications will be presented. Furthermore, the function of the celebrity as a persuasive phenomenon in fashion branding and the relationship between fashion and the celebrity will be discussed to examine how their innovative fashions are diffused and influence consumers who imitate them.

DOI: 10.4324/9781003175360-2

> ## Discussion:
>
> How do you define a celebrity and what different types of celebrities are there?
>
> Do we need celebrities?
>
> Which celebrity influences you and why?
>
> What role does the media play in celebrity influence?

2.1 Why Use Celebrities?

If we analyse the role and meaning of the celebrity in society, we will realise that celebrities have become progressively more personal. They are considered to be "a worldwide phenomenon . . . wherever there are people, there is celebrity . . . no population is too small to produce, circulate, and consume fame" (Taylor & Francis, 2015). There are a multitude of references and exposures to the celebrity from billboards and magazines to people simply chatting about their favourite TV programmes. It is also rather interesting how some individuals say they don't follow celebrities, yet they are still exposed to them in some manner and know them by name and their latest activities.

Research has proven that the use of a celebrity as an endorser is more effective than other types of endorsers (Agrawal & Kamakura, 1995). This is because celebrities can generate consumer interest through their existing work profile and relationships with their fan base and social media. This continued growth and exposure of brands using celebrities has prompted the media to coin the term 'celebrity brand,' which reflects brands that are defined by a well-known celebrity name. An example is Gary Lineker (former English footballer and current sports broadcaster) who first collaborated with Walkers Crisps in 1994. Since then, Lineker has starred in more than 150 commercials, and in October 2020, he signed a new three-year contract worth £1.2 million to continue promoting the brand.

The concept of human characteristics associated with a brand and brand personality in marketing literature was introduced by Aaker (1997). In addition, Pringle (2004) characterises the celebrity brand/product as a clearly defined personality and reputation of a well-known or famous person who professionally labels, manages, and promotes himself or herself to consumers and other stakeholders for the purpose of commercially leveraging their own unique image (Kowalczyk & Royne, 2013). This can be "a well-known persona who has associations, images, and features" attached to them as described in Thomson (2006), where the *Washington Post* refers to Tiger Woods as more than just a person, but a brand name (DiCarlo, 2004). More definitions can be found in section 2.1.1.

Marketers offer unique brand extension opportunities for those celebrities who licence their names for a product, or even develop a product themselves, and become their own multimillion-dollar corporation. This chapter intends

The Psychology of Marketing with Celebrities		
Brand & Commercial	**Explanation of Advertisement**	**Psychological Response Elicited**
Chanel featuring Brad Pitt (American actor and film producer)	A black and white picture of Brad Pitt standing in the hallway, wearing a tuxedo and sipping a drink. A bottle of Chanel No. 5 is superimposed over the image.	**Sex and Desire**: Consumers are made to feel that they can imitate Brad's sexual attractiveness by wearing Chanel No.5.

Figure 2.1

Consumer Psychological Response Elicited by the use of a Celebrity

to understand why consumer opinions are persuaded by the fashions of well-known and popular celebrities and why consumers grow this deep connection to celebrities. It aims to contribute to a better understanding of the celebrity and celebrity-inspired fashion consumption by analysing pre-purchase decisions of consumers that are due to desires of directly imitating the celebrity for the consumer's construction of their own self. Figure 2.1 is an example, illustrating a psychological response elicited by the consumer when introduced to products of a celebrity (Kowalczyk & Royne, 2013).

It is estimated that 20% of advertisements in the United States feature celebrities (Solomon, 2014). For this reason, companies invest considerably in matching the right celebrity with the right product. Up to "10% of an organisation's budget is spent on celebrity endorsement" (Agrawal & Kamakura, 1995). This figure is more than 70% in Japan, where Japanese culture uses celebrities for labelling all kinds of products (Mukherjee, 2009).

> Within their popular media system, the consumer is a fansumer (fan-consumer) and the celebrity, an object of deep desire, fantasy or an ideal construct. A "mirror" reflection, which resonates with deep affective or emotional meaning . . . these idols appeal to various demographics and often broad cross sections of society . . . they are a currency of exchange in the promotion and advertising of all manner of other products and services.
>
> (Galbraith & Karlin, 2012)

Statistics such as these are useful in that they show the stature of the celebrity in other cultures and the status given to them by their societies, thus illustrating how highly they are esteemed and how powerful they are. The next section will explore the celebrity and their fashions before demystifying who the celebrity really is.

2.1.1 Celebrity Definitions

In order to understand the impact of the celebrity on fashion and branding, it is imperative to first understand what is meant by the word celebrity, because as the celebrity has evolved, so has its meaning to consumers. The term celebrity is not simply a noun but an adjective that signifies that someone possesses the quality of attracting attention (Furedi, 2010). Table 2.1 provides various definitions from the literature, some of which designate how fashion is heavily part

Author	Definition
(O'Neill, 2003)	Celebrity is the impact on public consciousness and can be defined as a person well-known in one of a wide variety of fields and entertainment arena such as pop singers, film stars, science, politics, and entertainment worldwide.
(Leithart, 2007)	Celebrity is an omnipresent feature of contemporary society, blazing lasting impressions in the memories of all who cross its path.
(Dyer & McDonald, 1998)	Both stardom and particular stars are seen as owing their existence solely to the machinery of their production.
(Diener, 1999)	A celebrity is a name which, once made by news, now makes news by itself. The core essence of the celebrity is commercial. A person whose name has attention-getting, interest-riveting, and profit generating value.
(Pringle, 2004)	A celebrity has a clearly defined personality and reputation; he or she is known to be extremely good at something, beyond appearing in advertising, and it is their outstanding skill in their chosen field of endeavour which has brought them into the public eye and made them an object of veneration and respect.
(Walker, 2003)	A celebrity is anyone who is familiar enough to the people, a brand which communicates and adds value to the people by association with their image. "Nothing moves in our entertainment universe without the imprint of celebrity."

Table of definitions of a celebrity taken from six different authors

Table 2.1 Definitions of a Celebrity

of the celebrity (Boylan, 1999, p. 146). Most commonly, the celebrity is understood to be a quality of individuals. However, a "celebrity may also refer to social groups (e.g. sports personalities/teams, pop groups, business management partnerships) and social events (e.g. the Olympics, the World Series, the FIFA World Cup)" (Rojek, 2015). Thus, the celebrity has become a fascination in recent times, even more so due to their continuous change and updating of their image. It is difficult to choose just one standard definition of the celebrity, as it in fact encompasses many traits and connotations. A contemporary definition of the celebrity "must acknowledge that not only must the individual be popularly recognised, he or she must also possess social or cultural currency to motivate popular interest and media exposure" (Wigley, 2015). New definitions over time have fluctuated in meaning and fallen into various contexts that reflect historical, spiritual, religious, media, social, art, music, sports, and political concerns and, more recently, the use of social media marketing. It is useful to commence this analysis of the celebrity by first defining some terms of its delineation and how different types of celebrities have been identified throughout history. In Boorstin (1992), "the hero was distinguished by his achievement . . . the celebrity by his image or trademark." Boorstin also observed acerbically that "two centuries ago when a great man appeared, people would look for God's purpose in him; today we look for his press agent."

The definitions presented in Table 2.1 all share a main characteristic: that social-figure celebrities invite large-scale public attention. The greater the number of people who know of and pay attention to them, the greater the extent and value of that individual's celebrity. Another unanimous thread is that "they elicit positive emotional responses from the public" (Rindova et al., 2006). These responses arise because the celebrity has a positive valence (Malär et al., 2011). Milner (1994) claims that "celebrity is a distinctive form of status in part because it matches the vast scale of modern social organisations and the commodification of mass communications." This form of status translates directly into financial benefit with some of the most sought-after celebrities being among the highest wage earners in the world (Kurzman et al., 2007). According to Forbes, the 2020 highest-paid celebrities were Kylie Jenner with $590 million (£430.6 million; American media personality, socialite, model, and businesswoman), Kanye West with $170 million (£124 million; American rapper, record producer, and fashion designer), followed by Roger Federer with $106.3 million (£77.6 million; Swiss tennis player).

In addition to the definitions in Table 2.1, there exist many classifications of the types of celebrity which are a means to describe celebrities based on their accomplishments and fame. A review of the various definitions and one that this research will use can be found in section 2.2.1.

2.2 The History of the Celebrity and Their Fashions

This section goes back in history to describe how the role of the celebrity came into being, and thus, it attempts to define the evolutionary definition of the celebrity. It gives examples of how celebrity fashions have shaped certain eras and illustrates their impact over time. If we analyse the root word celebrity, the word itself comes from the Latin word 'celebritatem' which means the 'condition of being famous' (Rebus, 2008). *Celebritas* is a Latin word which is part of the same root and denotes 'commonness' or 'a crowd.' This indicates celebrity culture had a place in classical antiquity. The start of any kind of celebrity were inspirational religious leaders. Information about them was spread by word of mouth, and they were individuals who were ranked and occasionally considered to have magical, spiritual, and healing qualities (Okonkwo, 2007). Garland (2010) states that "fashion as a symbol of society has been influenced by these historical, social, traditional, religious, political, economic, psychological and most recently technological changes" (Okonkwo, 2007, p. 14).

❑ **Egyptian Civilisation** – Early Egyptian art revealed the use of fashion and its association to beauty on the exterior with extravagant headpieces, crowns, and jewellery. "The finest materials were used to produce their fashion pieces, including footwear which were often made of pure gold" (Okonkwo, 2007, p. 15).

❑ **Roman Times** – The populace heard of legends that lived geographically distant. Thus, to make them visually seen and immortalised, sculptures, artworks, and public statues were created. Image profiles of the Roman emperor were stamped on coins and disseminated across the empire. Make-up also played a

key role in this period for both women and men to generate attention. Individuals demonstrated their status through clothing. Those that could afford luxury adorned themselves with clothes, placed precious objects in their homes, and wore elaborate wardrobes to show their class and power (Inglis, 2010).

❑ **Middle Ages to the Early Nineteenth Century** – There were dramatic shifts in science, religion, and culture in this era. Flamboyant in dress and costume, poets and scriptwriters now became celebrities and were gaining recognition. William Shakespeare (English playwright, poet, and actor) became popular in the 16th century, and a new form of social entertainment called reading shaped the way for passing time. Due to this interest, literacy levels improved, and people were able to entertain themselves with reading. In the early 19th century, Charles Frederick Worth (English fashion designer) invented haute couture in Paris and became the private designer of the wife of Napoleon, Empress Eugene. "He publicised his creations through the famous celebrities and the influential women of the day (celebrities) . . . greatly influential in the manner fashion was retailed; by introducing models and private fashion shows. At the peak of his career, his fashion empire employed 1,000 seamstresses and he boasted production time to be cut by 50%" (Okonkwo, 2007, p. 26).

❑ **War** – World War II made cinema the most established entertainment medium, also bringing shifts in trends for clothing and cosmetics. The news had become a major source of communication and updates about the social environment. Personalities around the world of film became influential fashion icons, changing attitudes towards fashion and luxury. Subsequently, improvements in printing press technology led to magazines and newspapers becoming full of images, fashion, and stories about film, stage stars, singers, models, and sporting heroes, with more of a focus placed on their personal lives than on their performance credibility.

❑ **Television** – On the small screen, television shows in the 1950s featured Elvis Presley (American singer, musician, and actor; regarded as one of the most significant cultural icons of the 20th century who is often referred to as the "King of Rock and Roll"). In the 1960s, the Beatles (English rock band) became icons on television and the global music scene. The paparazzi in this period would go to great lengths to buy pictures showing celebrities in compromising positions, and they were increasingly accused of invading celebrities' privacy. However, in some cases, celebrities found that by colluding with the press, they could gain extra publicity and could tap into people's thirst for gossip and intrigue.

2.2.1 Classifications of the Celebrity

As discussed, various means of classification in the literature define the different types of celebrity. The following are the more well-known classifications which are commonly used terms for industry and academic practitioners:

❑ Rojek's classification
❑ Ulmer scale classification
❑ The David Brown Index celebrity classification

2.2.1.1 Rojek's Classification

There are five categories according to Rojek (2001) that describe how fame is achieved and define the achievements of celebrities.

According to Rojek (2001), celebrities are able to move within these classifications. They can move from being an ascribed/achieved celebrity position to attributed and through to celetoid celebrities. This is usually done by achievement, scandal, or notoriety. "Once upon a time, Hollywood would cultivate movie stars over many years; today, television stars can rise and fall from their classifications in a single year's programming cycle" (Kurzman et al., 2007). Ascribed, achieved, and attributed celebrities are still those celebrities that are given greater credibility among the public, and traditionally they are the ones that retain their celebrityship (title).

Rojek's (2001) classification of celebrities argues that the "achieved celebrity derives from the perceived accomplishments of the individual" (Kyllonen, 2012). This is because of the erecting of barriers to entry, as high-status groups did in the past, which now involves celebrity status and the constant recruitment of new members: 'celetoids,' as Rojek calls them. These are "lottery winners, one-hit wonders, whistleblowers . . . and various other social types who command media attention one day, and are forgotten the next" (Rojek, 2001).

2.2.1.2 A to D List–Z List (Ulmer Scale)

The Ulmer Scale is used as one of the most widespread classifications among celebrities, marketers, and consumers. It is used by various authors in public relations, entertainment, the general public, and in media vocabulary. It was devised by entertainment journalist James Ulmer as a tool to calculate the "bankability" of a given star (Riggs, 2009). It categorises celebrities by applying a scale of A, B+, B, C and D listings to any person with an admired or desirable social status. From the celebrity's perspective, the ultimate success is attained when the celebrity reaches the A list. The A-list Ulmer scale is most frequently applied when referring to a very famous singer/actor like Beyoncé (American singer, songwriter, actress, and record producer) or Angelina Jolie (American actress, filmmaker, and humanitarian). It is commonly used in magazines, newspapers, and entertainment news programmes before the actor is named; for example "A-list actor Angelina Jolie is seen out shopping with her family." This A-list classification is part of a larger guide called 'the hot list' which has become an industry-standard guide in Hollywood.

❑ A-list celebrity is a term for the most bankable movie stars in the Hollywood film industry, major recording artists, and international sports stars.

❑ B-list/C list celebrities are those popular celebrities that are slightly less exposed and paid less than the A-list star celebrities; e.g., TV soap stars, current teen idols, or musicians.

❑ D-list/Z-list celebrity refers to the lowest rating on the Ulmer Scale, and it is often used to describe persons that are known and recognised but for smaller projects such as reality TV or for some sort of TV appearances, or for those who were formerly famous.

Classification	Description
Ascribed Celebrity	Refers to social impact that reflects bloodline. Hereditary-titled individuals such as kings, queens, emperors, ladies, duchesses, and so forth are positioned in the social hierarchy automatically. These celebrities command significant respect and deference (Rojek, 2015). They are people who acquire their celebrity through blood or inheritance that comes from the royal, political, or business realms. They can even be the children of the celebrities.
Achieved Celebrity	Refers to a meritocratic celebrity with recognised talents and accomplishments (Rojek, 2015). They acquire celebrity through individual skills; for example, sports stars, musicians, writers, artists, and successful businesspeople. Examples include the likes of Richard Branson and J.K. Rowling.
Attributed Celebrity	These celebrities arise from media exposure; for example, newsreaders or hosts of media shows, such as Oprah. The attributed celebrity is also a cultural fabrication, constructed by cultural intermediaries who operate to stage-manage celebrity presence in the eyes of the public. Mediators such as "agents, publicists, marketing personnel, promoters, photographers, fitness trainers, wardrobe staff, cosmetics experts and personal assistants. The task of these individuals is to concoct the public presentation of celebrity personalities that will result in an enduring appeal for the audience of fans . . ."(Leithart, 2007).
Celetoid Celebrities	Celetoids are individuals who attain intense bursts of fame. The term is an amalgamation of 'celebrity' and 'tabloid' (newspaper); this gives a clue to the meaning of the phenomenon by highlighting the pivotal role of media communication in the process. According to Rojek (2015), these are celebrities like influencers and reality TV stars who command extensive media attention due to scandals, pseudo-events, or participation in reality TV shows like Big Brother. However, according to Rojek, their celebrity status may be quite short-lived; for example, most Big Brother contestants fade into obscurity.
Celeactors	These are fictional characters who achieve media attention and become a cultural reference point. They can be animals, cartoons, animatronics, and puppets who start off as anonymous characters, but through media exposure and their likeability become extremely well-known brand ambassadors and even quasi-celebrities in their own right; for example, Shrek, the Jolly Green Giant for sweetcorn, and the Labrador puppy for Andrex.

Table of definitions of five different celebrity classifications

Table 2.2 The Five Types of Classifications Defining the Achievements of Celebrities

Newspapers, magazines, and social media can boost sales by showing A-list stars (Smith, 2003). In recent times, however, the term celebrity has been applied to any person in the limelight, regardless of their profession or skills. They can also be socialites with popular press coverage and even elite romantic associations transforming them into A-list celebrities. An example of this phenomenon would be Liz Hurley (English model and actress). She joined the A list overnight in 1994 when she wore her famous Versace safety pin dress while being escorted by Hugh Grant (English actor), her previously more famous boyfriend, to the premiere of his film *Four Weddings and a Funeral* (Hardy, 2012). It is also possible to move up by dating, living with, and/or marrying someone famous, as former C-list actress Catherine Zeta Jones (Welsh actress) did when she married Hollywood legend Michael Douglas (American actor and producer).

2.2.1.3 The David Brown Index

The David-Brown Index (DBI) is "an independent index that quantifies and qualifies consumer perceptions of celebrities" (Repucom, 2016b). Companies access the impact of celebrities with a systematic approach for quantifying and qualifying the use of celebrities in marketing campaigns. The DBI does this through eight key attributes:

- ❑ Appeal
- ❑ Notice (their pop ubiquity)
- ❑ Trendsetter (their position as such)
- ❑ Influence (do they have any?)
- ❑ Trust
- ❑ Endorsement (spokesperson ability)
- ❑ Aspiration (do we want his or her life?)
- ❑ Awareness (expressed as a percentage)

The scores are then cross-referenced in a database that helps advertisers decide among a list of more than 1,500 celebrities (McDonald, 2016). "This type of evaluation allows marketers and industry specialists (not accessed by the public) to analyse how the celebrity's awareness, appeal and relevance to a brand's image influence consumer buying behaviour" (Repucom, 2016a).

2.2.1.4 Reality TV

In addition to the Ulmer Scale, the more recent classification reality TV has led to the emergence of ordinary people . . . who are discovered and extracted from their everyday lives and processed for stardom. "It is 15 minutes of fame, literally – you don't have to sleep with the president any more" (BBC, 2003).

The introduction of reality TV has created new celebrities and made our idols more like us (Western, 2006). Reality TV began in 1992 with America's MTV network show *The Real World*, a programme about several strangers living in

a place together and a window into their ordinary lives. Similarly, today, there is *Big Brother, Keeping Up with the Kardashians,* and *MasterChef.* In addition, some celebrities who began their careers in this way rose to fame to upper levels of the B list to the A list (Kardashian-Jenner family). This also happened to Paris Hilton (an American socialite and now a model, singer, actress, and DJ), the great-granddaughter of Conrad Hilton, founder of Hilton Hotels.

Reality TV has grown dramatically in recent times and has now penetrated YouTube vlogs where vloggers have become influencers. "Whole media formats have been devoted to the reality theme, and the contemporary media consumer has become increasingly accustomed to witnessing what happens to the 'ordinary' person who has been plucked from obscurity to enjoy a highly specified and circumscribed celebrity" (Turner, 2010). However, commentators such as Rojek (2015) and Turner (2014) argue that these are not celebrities with real celebrity credited virtues.

2.2.1.5 Influencer

Over the past decade, social media has grown rapidly, and with this, the influencer has emerged. Influencers are persons who have built up a repu-tation for their knowledge and expertise on a specific topic. "Social media influencers were among the top celebrity endorsers for brands in 2021, and recent estimates show influencer marketing set to become a $15 billion dollar industry by 2022 . . . as popularity, demand and marketing spend increase, marketers plan to increase their influencer marketing budgets in 2021" (Hub, 2021).

Influencers in social media are known to have two key properties:

❑ They have power to affect the purchasing decisions of others because of their authority, knowledge, position, or relationship with their audience.

❑ They have a following in a distinct niche, with whom they actively engage. The size of the following depends on the size of their topic in the niche (Hub, 2021).

Influencers make regular posts on their preferred social media channels that generate large followings of enthusiastic, engaged people who pay close atten-tion to their lives and views. The more popular influencers have high numbers of followers/views and end up becoming celebrities themselves. Influencers can be categorised multiple ways, such as by follower numbers, subscribers, types of content, and the level of influence. The appeals for new starters are that the costs are low and all that is required is a laptop, Internet, and a camera (even a phone camera). The attraction is that everyone who vlogs thinks they can be fast-tracked as a celebrity. They can be grouped by the niche in which they operate to attract more followers. Niches include fashion, the entertainment sector, music, lifestyle, beauty-related topics, health care, exercise, and toys. Influencers can fall into one or all of the following categories:

❑ Blogger – In 1994, the word blog was coined to describe a personal diary that people shared online. Usually, a blog displays entries in reverse

chronological order, with the latest posts appearing first, at the top, and it is a platform where a writer or a group of writers share their views on an individual subject. In this online journal, you can present your daily life or share things that you are doing. It was seen as a means to communicate information in a new way online (Minaev, 2021). Many highly influential bloggers on the Internet have built up sizable followings and earned impressive revenues in specific sectors such as fashion, music, sport, cooking, or simply walking trails.

❑ Vloggers – Vlogs, or video logs, are blogs that contain video material. Vlogs combine embedded video or a video link with supporting text and images. In recent years, vlogging has produced a large community on social media, becoming one of the most popular forms of digital entertainment. Vlog entries are usually popular and shared on YouTube where YouTubers create a channel specifically to gain followers and likes. Often brands and celebrities align with popular YouTube content creators. It is believed that, in addition to being entertaining, vlogs can deliver a deep context for communication through imagery as opposed to written blogs.

❑ Podcasts – Many influencers and celebrities are now producing podcasts. Individuals are motivated to create a podcast for a number of reasons. The producer of the podcast is often the podcast host and may wish to express opinions about a personal passion, fashion, beauty, ideas, and products to gain professional visibility or a social network, or to present influential ideas, cultivate a community of like-minded viewers, or put forward pedagogical or ideological ideas (possibly under philanthropic or endorsed support).

Influencers can be paid, in some cases, considerable sums of money, in the form of:

❑ Affiliate marketing
❑ Display advertising
❑ Sponsored posts/images/videos and brand campaigns
❑ Courses, subscriptions, and eBooks
❑ Photo and video sales
❑ Acting as brand representatives or ambassadors
❑ Payments to an account for exclusive content
❑ Co-created product lines
❑ Promoting their own merchandise

2.2.2 Review of Celebrity Definitions

On review of the various definitions and classifications discussed so far, this book will adopt the following definition created by the authors:

Celebrities are a powerful voice in the entertainment world and a product of an entertainment process which includes various components such as public interest, excitement, star, fame, glory, control and appeal to attract attention, publicity, and fans. We as a society get the privilege to watch them, enjoy them, consume them and share them and in the construction of their-self; they in turn impact on our behaviours and contribute towards our own identity formation.

It is important to note that all the classifications of celebrities (section 2.2.1) are subjective, and as such, there is currently no formal celebrity fashion classification system and definition that is governed by the media. Moreover, this definition is not specific to where a celebrity should fit on the Rojek's classification, the Ulmer Scale, or the DBI. The reason for this is, from whatever background or position in their career an individual becomes a celebrity, the impact on a consumer can happen at any level (either at A, B+ to D list). This is because it is dependent upon meaning; that is, the individual may copy an eccentric politician that nobody has heard of because they like them and follow their views, opinions, and actions even though the specific MP (Member of Parliament) may not be fashionable or fit into any of the categories of celebrity classification.

These classifications give celebrities a label, and "celebrities have become the ultimate commodities and are routinely fabricated by the media industries. When in the past fame could be achieved through talent, heroic deeds, skills, hard work and charisma. Now fame is seemingly achievable for all. Anyone can be famous, regardless of talent or skill; outside the media event from which they initially emerged" (Kyllonen, 2012). This has ominously enhanced the appeal of the average person desiring to become a celebrity.

2.3 Fashion and the Celebrity

The current life cycle of a fashion product is generally designed to be quick as it maintains a whole industry based on the need of continuous change to maintain economic viability (Slater, 2003). The fashion industry reports that UK consumer spending continues to rise and is worth £52.9 billion (Mintel Group Ltd, 2014). The high street has become a homogenous experience throughout the UK with major chains dominating cities and towns throughout the country. The drivers of the fashion industry are key to its success, and these facets require explanation. In order to investigate the increasing link between the celebrity and fashion, this section will analyse the extent to which consumer lives are affected by the influence of celebrity fashion role models and celebrity fashion marketing communications. It will seek to investigate the phenomena of fashion and its association with glamour, novelty, and consumption and how celebrity fashion is used to define individuals through their appearance (Pesendorfer, 1995).

Fashion clothing has been described as a code. Davis (1994) states that in the context of this code, clothing styles and the fashions that influence individuals over time constitute membership in and conformity to the code. This is because as individuals we have different personalities and our "own" style in the manner of living, speaking, dressing, and purchasing. A code as a fashion look involves a form of clothing on the human body and its potential for meaning to the wearer and to others (Solomon & Rabolt, 2009). A new look may be the result of innovations which are sub-codes and in the way items are put together, or the type of behaviour elicited by the manner of dressing. DeLong (2016) suggests fashion clothing coding has become central to mass culture as a means through which individuals express themselves and create identities; it's a kind of social glue. Such coding can be imitated through different fashion brands and market levels.

2.3.1 Market Levels of Fashion Brands

Fashion brands are segmented into market levels for fashion consumers where each brand or label can be placed into a group of fashion:

- ❏ Haute couture
- ❏ Designer wear
- ❏ Street fashion

While each market belongs to one category, each level of the market requires a different marketing strategy. Furthermore, fashions can move within the levels. For example, high fashion can trickle down and street fashion can have a trickle-up impact on fashion (Figure 2.1).

The market levels of brands section emphasises that celebrities are an important part of the process of influencing fashion on different market levels of brands. This is because their imprint is evident in many areas of the fashion clothing industry, and they appeal to consumers at many stages. One of the reasons is because clothing is a visual language, and Lurie (2000) suggests that "it is complete with distinctive grammar, syntax and vocabulary." "Similar to music, where emotion and mood overcome the attribution of unambiguous meaning . . . realistically, clothing purchasing is likely to be affected by all these elements. Thus, making clear reference to one's social and cultural identity, albeit in a rather imprecise way" (Dodd et al., 2000).

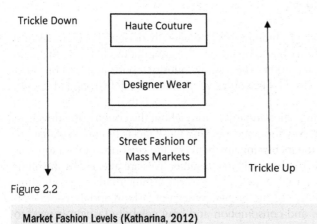

Figure 2.2

Market Fashion Levels (Katharina, 2012)

Fashion Level	Description
Street Fashions or Mass Markets	**Value Market** (e.g., Primark and Matalan) Value market companies place the price and materials of their products as cheap as possible and rely on high-value sales by providing cheap basics, like plain T-shirts and vests. Primark is one value brand that has grown and promoted itself as less value and more temporary fashion for the consumer by using its cheap clothing as a selling point for replaceable, highly changeable fashion looks.
	Mass Market High Street (e.g., H&M and River Island) These mass-market retailers manufacture in bulk and high volumes with fashion stock rotating and changing every 6 to 12 weeks.
	Mid-Level High Street (e.g., Zara and M&S) These mid-level high street retailers stock the latest in women's fashion and new season trends with a distinctive personality and individual brand mix. They require specific branding and are popular among their target market and are an established fashion name on the high street.
Designer Wear	**High-End High-Street Brands** (e.g., All Saints) This level focuses on their core customer profile and a very defined style. The price and quality tend to be very high for the high street.
	Diffusion Brands (e.g., Marc by Marc Jacobs and Moschino) These are brands that are based around the main luxury range and diluted as secondary lines to create a cheaper range of products; they are more in line with High-End High-Street brands. Still rather expensive, they have a specific fashion consumer which they expose to luxury brands as prospective customers in the future.
Luxury Brands	**Ready to Wear** (e.g., Marc Jacobs and Moschino) These collections are based on trend prediction information (pret i.e, short) and offered by luxury brands twice a year. Fashion clothing is accepted by a limited number of fashion leaders (celebrities) who are the first to have the new items and who can afford to buy them (Renfrew & Renfrew, 2014). The price is accepted by consumers which signified the start of the ready-to-wear market and mass consumerism. These lines are good for TV, pop videos, and award ceremonies as the celebrity is in the spotlight and can be seen by many.
	Haute Couture (e.g., Chanel, Gucci, and Prada) Haute couture is a French word meaning 'high fashion.' It is a very specialist level and involves working with expensive material and highly intensive labour. Official permission from the Syndical Chamber for Haute Couture in Paris is needed for this (Renfrew & Renfrew, 2014). "It is estimated that no more than 4000 women across the globe can afford to buy Haute Couture wardrobes . . . as such, many designers and fashion houses will loan evening gowns to celebrities to freshen the image of couture and these will be shown at celebrity events such as The Oscars, BAFTA and the Golden Globes" (Renfrew & Renfrew, 2014).

Table of definitions of three different levels between fashion and designer/luxury brands

Table 2.3 Summary of the Levels Between a Fashion and a Designer/Luxury Brand

Attribute	Fashion Brands	Luxury Brands
Product Design	Changes frequently and drastically depending on the current popular trend.	Iconic design that changes very rarely as an evolution, not a drastic departure from the initial concept.
Price	Broad price range, depending on the brand positioning within its category.	Inaccessible to most, price acts as a selection tool that limits access to the brand.
Price Discounts	A very common strategy, in particular at the end of the season when the product is no longer in fashion.	Not advisable as the high price increases product desirability.
Celebrity Endorsement	Seeking endorsement from current trendsetters in entertainment and sports is a very common strategy.	Not advisable as luxury brands transcend the current trends and celebrities.
Product Line	Can be broad – one product for each segment targeted.	Very narrow – a flagship product and only a few variations.
Country of Manufacture	Usually manufactured in low-cost countries to allow for price flexibility at the end of the season. Manufacturing country is not important in purchasing decisions.	Country of manufacture is part of the brand myth. Brands should not relocate manufacturing facilities to lower-cost countries. Country of manufacture is very important in the purchase decision.
Delivery	Immediate. The goods must be delivered in time to capture the latest trend.	Not urgent. The wait for the product to be built/created/fully matured contributes to the overall luxury experience.

Table of definitions of seven different facets between fashion and designer/luxury brands

Table 2.4 Summary of the Key Differences Between a Fashion and a Luxury Brand (Michael, 2016)

2.4 Using Celebrities as Fashion Brands

"Internationally, the media landscape has changed in ways that have significantly affected the nature of the media's involvement in the construction of cultural identities" (Rojek, 2015). "Celebrities have metamorphosed into brands and they seek new ways to differentiate their fashion products and brands" (Cope & Maloney, 2016). Thus, brands allow celebrities to communicate fashion messages and new trends in the global fashion market where the celebrity dress sense and style are demonstrated and communicated in various ways through movies, television, awards, music videos, and shows. When celebrities are used in an advertisement, people often equate that product with the appearance or star quality of the celebrity. Hence, their advice on beauty and fashion is worth considerable space in magazines and on television talk shows (Kurzman et al., 2007). For this reason, "when brands establish a relationship and connection to popular names in entertainment, sports, fashion, and other verticals there is

the potential to boost sales drastically. Especially when the consumer believes the product or service is actually used by the celebrity him or herself" (Bradic, 2015). Table 2.5 illustrates how celebrities can establish a distinctive celebrity brand personality.

Celebrities use their fame to build brand equity and name recognition, and then profit on this fame by attaching their brand names to sellable products or services (see Table 2.5). This is viewed as one of the best ways to create brand differentiation and make brands more desirable. When a brand possesses this, it attracts the consumers' attention and helps them to identify themselves with the brand's personality traits. Thus, accordingly, as celebrities establish and market themselves as brands, they are extending their names into product categories both in and out of their respective genres that may or may not "fit" with the celebrity's overall image but links them to a product or service. Some celebrities

Types	Examples
"Celebrepreneurs" (brand empires)	Oprah Winfrey (American talk show host, producer, and author), David Beckham (former professional footballer), Jamie Oliver (British chef and restaurateur)
Licensing Name	George Foreman grills (former American professional boxer), Ainsley Harriott foods (chef and television presenter)
Brand Ambassadors (celebrity spokespeople)	Tiger Woods for Nike (American professional golfer), Jennifer Aniston for L'Oréal (American actress), Beyoncé for Pepsi (American singer-songwriter)
Celebrity-branded Products	Elizabeth Taylor perfume (English-American actress), Beats by Dr. Dre (headphones; American rapper and songwriter, producer), Ken Hom woks (Chinese-American chef, author, and television presenter)
Brand Collaboration	Rihanna (Barbadian singer and actress) with River Island & MAC Cosmetics
Assuming a Company Title	Jay-Z ("co-brand director" for Budweiser Select; American rapper, songwriter), Alicia Keys ("global creative director" for Blackberry; American singer-songwriter)
Co-Advertising Partnerships	Samsung and Jay-Z (American rapper, songwriter)
Endorsing Products on Social Media	Kim Kardashian (American media personality, socialite, and model), Justin Bieber (Canadian singer-songwriter)
Lending Celebrity Voices	Kevin Hart with Waze (American comedian and actor)
Promoting Charitable Causes	Angelina Jolie and Brad Pitt (Maddox Jolie-Pitt Foundation; American actors), Elton John (Elton John AIDS Foundation; English singer-songwriter and composer)

Table of definitions of 10 different celebrity branding

Table 2.5 Types of Celebrity Branding (Euromonitor, 2014)

have gone beyond this and "developed clothing lines that feature their fashion sense and celebrity brand image" (Pappas, 1999). An example of this is Michael Jordan (American, former professional basketball player). He owns a large range of basketball shoes and markets fragrances; his brands include Jordan, Michael Jordan, 23, and Michael Jordan Legend.

2.4.1 The Intimate Relationship Between the Celebrity and the Fashion Consumer

Fashion and the media have long had links with celebrities, whereby designers have designed costumes for film and theatre alongside their own fashion collections; for example, Prada designed many of the garments for the film *The Great Gatsby*, and Armani for Richard Gere (American actor) in the film *American Gigolo* (Renfrew & Renfrew, 2014). This highlights how there is something quite unique in the way a celebrity can bring a design to life and create a story for the viewer. They are often strong levers that entice symbolic fashion feelings that link the consumer-fan to a celebrity-inspired lifestyle and personal identity. With the media increasingly reporting on celebrities, it appears that more value is placed on celebrities' lives and opinions, serving as a motive for consumers to purchase celebrity-fashion-branded products which draw them into the high profile and perceived glamour of the celebrity.

With celebrity culture and celebrity fashion becoming more mainstream because of social media, there has been a growth in individuals wanting more celebrity information in order to follow their favourite celebrities. Fashion magazines illustrate the experiences of celebrities' lives to attract attention. This is not just for fans but also for anyone who happens to recognise their fame (Kurzman et al., 2007). Thus, "celebrity magazines have become tremendously popular" (Korchia & Fleck, 2006). Magazines such as "Vogue, Glamour, OK and Heat provide insights into celebrity life and propagate the concept of celebrity itself; often by focusing on the controversial aspects of the celebrities' life while simultaneously promoting their glamorous lifestyles, ostentatious fashion, romantic liaisons and influence on consumer choices" (Feasey, 2008; Holmes, 2005). These factors contribute to the increased exposure of celebrities and allow for creativity at the leading edge of fashion, which explores new ideas in clothing (Pringle, 2004). Imitation celebrity couture is sold on the high street as fast fashion for fans who desire the clothing for its connection to celebrities (Barnes et al., 2006).

It is not only fashion clothing that celebrities use when profiling themselves, "it is a complete look," which includes hair, make-up, and accessories. For example, Jennifer Aniston's (American actress) hairstyle for her character "Rachel" on the TV show *Friends* became one of the most imitated globally. Called the 'Rachel cut,' millions all over the world recognised it and emulated it. Some critics suggest that imitations like these are not gender specific and can be done by males, too. David Beckham, an international star, has transformed his hair to match his fashion styles on numerous occasions which have made headlines. His Mohican haircut in the noughties was reminiscent of the punk style which was widely imitated. Both celebrities mentioned are international celebrities that have attained their own 'brand iconography' over their careers. Their hair

innovations were relatively inexpensive, and their styles were such that ordinary people could reproduce and experiment with them, due to media and advances in technology such as the Internet and TV, which allowed their images to be increasingly exposed and accessible.

The increasing emphasis on the fashion, looks, and glamour of the celebrity has paved the way for a new format of shows like *E! News* and *Fashion Police* that are deliberately created to tap into the fashion individual (consumer), featuring up-to-date styles that celebrities wear. The shows are devoted to the subject of celebrity fashion, the celebrities' clothing is critiqued, and new styles are given credibility. The stars wear fashion designs to events, and they are captured at red carpet award ceremonies like the Oscars, Emmys, and Grammys. These ceremonies are viewed as important fashion-forming events then shown on various shows and seen in the media where fashion critics, fans, consumers, and marketers review the outfits that are worn and shown to recreate their own image and new fashion styles (Alexander, 2014).

Further down the fashion process, these lines inspire fashion labels like ASOS, which stands for As Seen on Screen, an online retailer that was established in 2012 in which the products emulate only celebrity fashion. Who What Wear is another fashion label which is specifically dedicated to celebrity fashion and shows the latest on celebrities, street style, and fashion trends. These fashion brands promote and stock style inspirations of the red carpet and casual styles of favourite celebrity names. An example of such brands are high street chains such as Primark, New Look, and River Island who have used celebrities such as Rihanna (Barbadian singer, actress, fashion designer) for their marketing campaigns. Rihanna is held as a fashion icon, a billionairess with her own brand Savage X Fenty attitude, and Rihanna is quoted as saying, "she can beat me, but she cannot beat my outfit" (YouTube, 2022).

A significant amount of pressure is placed on celebrities to produce innovative fashion styles that are new and inspirational for consumers that desire to be like them. Although clothing and fashion form part of the celebrity's business, many celebrities use their name and personal brands to link themselves to other products and services. One such celebrity example is Kim Kardashian (American media personality, socialite, and model). She has an extensive brand profile that is emulated and a fashion marketing strategy.

2.4.2 Celebrity Case Study: Kim Kardashian

Kim Kardashian (American media personality, socialite, and model) is a celebrity that has successfully exemplified the intersection of celebrity and fashion in contemporary society. She appeals to the younger and older consumers who aspire to be like her (Figure 2.12). Kim has received many fashion and best-dressed awards because of her fame. As a celebrity, she appeals to her fans and followers, with more than 280 million followers on Instagram, 70.9 million on Twitter, and 33 million on Facebook (January 2022). The number of her fans is growing rapidly. As a consequence, part of this appeal to her fans and their obsession with her is because she is watched, and she has a body that real women across the globe can relate to and attempt to emulate.

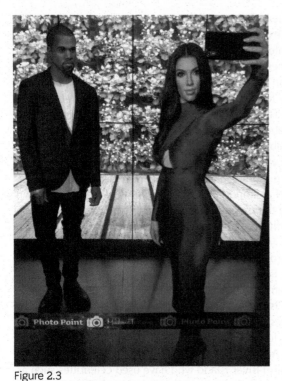

Figure 2.3

(Kim Waxwork) Kim Kardashian as Part of Her Reality TV show Keeping Up with the Kardashians

Kim Kardashian has been called a celebrity-preneur and is part of the Kardashian-Jenner family. For more than a decade, this family empire has dominated fashion, media, reality TV, social media, and magazines, and fashion consumers purchase products that are publicly endorsed by them. These products range from fashion, beauty, fragrances, health, alternative therapies, socks, innovative products, interior design, and accessories (Euromonitor, 2014). The target market that emulates them by adopting their clothes, hairstyle, make-up, and overall looks comprises mostly young consumers who are most influenced by them because they watch and follow their international hit show *Keeping Up with the Kardashians*. The mother is Kris Jenner, who in her 60s appeals to the 50-plus age group as a mother, manager (momager title licensed by Kris), TV presenter, and successful entrepreneur. A contributing factor to this obsession with the looks and beauty regime of the Kardashian-Jenner family is that more people today are taking care of their looks and appearances because of the influence of celebrities, and they want to look and feel younger.

Keeping Up with the Kardashians also has taken advantage of the influencer subculture of Kardashian look-alikes that has now emerged online. This is because of an influencer subculture of Kardashian look-alikes that has now emerged online. These women look identical to the real thing and have become influencers with from 500,000 to one million followers on social media. For them, following Kim Kardashian isn't enough – they need to be her. They are the ultimate followers. They go under the knife to become her, having their lips, nose, and chin modified. Having plastic surgery isn't enough – it's becoming a business for them. "Influencer marketing agencies claim that brands seeking influencer support for product launches or to raise awareness that can't afford the real thing now have their pick when it comes to Kardashian-esque types. A quick search on Instagram shows that these lookalikes have worked with brands from Estee Lauder and MAC Cosmetics in the Middle East to London. The reason for all these copycats is twofold: the Internet and modern medicine" (Strugatz, 2018).

However, it is important to note, although celebrities can have a positive influence, there can also be negative consequences for celebrities and the brands they are associated with discussed in Chapter 3. For example, individuals could become addicted to this type of consumerist lifestyle as they become determined to do whatever is necessary to get the product they are seeking to follow or become like their favourite celebrity – even if it causes financial debt and

physical harm by extreme acts as mentioned in the cases when plastic surgery is used. Knittel and Stango (2009) explored the negative effects of one scandal: "the scandal of the infamous Tiger Wood's extramarital affairs and irregular behaviours with regards to his sponsorship firms . . . indicating an estimated loss of between \$5 [billion] and \$12 billion when compared with firms who did not utilise Tiger Woods as a celebrity endorser."

2.5 Conclusion

This chapter identified the evolution of the fashion celebrity and what factors contribute towards making the celebrity a highly sought-after commodity. Kaiser argues that "fashion is a symbolic production which differs as a concept from clothing which is a material production and something that fulfils our physical needs for protection and functionality" (Niinimäki, 2010). The chapter highlighted how celebrities, with their names attached to a brand, can have a colossal impact. Fashion celebrity marketers need to regularly devise new strategies in order to make their brands distinctive to engage with consumers on a level of their senses and emotions to give meaning (Gobé, 2001).

Miuccia Prada said, "What you wear is how you present yourself to the world, especially today, when human contacts are so quick. Fashion is instant language" (Thornton, 2015). "This meaning can be derived from a product, but the meaning can also be developed from ways of wearing the product, or from the body itself . . . you don't just buy clothes, you buy an identity and fashion identity reflects our society and our culture" (DeLong, 2016). "It is a symbolic innovation and as stated can be seen as a code or language. It is also context dependent which means the same item can be interpreted differently by different consumers in different situations" (Solomon & Rabolt, 2009). For the purpose of this book, research has been undertaken on consumer behaviour literature about reference groups and peer group influences on purchase behaviour. The next chapter will open up new dialogue of the symbionts and how celebrity fashion culture impacts the lifestyle determinants of fashion consumer groups which, in effect, impact emulation and will focus on how imperative it is for fashion celebrity marketers to produce celebrity fashion marketing communication strategies that are able to forge a deeper lasting connection in individuals through products (Lafferty, 2001).

References

Aaker, J. L. (1997). Dimensions of brand personality. *Journal of Marketing Research, 34*, 347–356.

Agrawal, J., & Kamakura, W. A. (1995). The economic worth of celebrity endorsers: An event study analysis. *The Journal of Marketing, 59*(3), 56–62.

Alexander, P. (2014). *Why do celebrities influence fashion trends?* Retrieved from www.styleflair.com/why-do-celebrities-influence-fashion-trends/

Barnes, L., Lea-Greenwood, G., Bruce, M., & Daly, L. (2006). Buyer behaviour for fast fashion. *Journal of Fashion Marketing and Management: An International Journal, 10*(3), 329–344.

BBC. (2003, Friday, 4 April). *Stars speak out on fame*. Retrieved from http://news.bbc.co.uk/1/hi/entertainment/showbiz/1681596.stm

Boorstin, D. J. (1992). *The image: A guide to pseudo-events in America*. New York: Vintage Books.

Boylan, J. (1999). *Life the movie: How entertainment conquered reality* (vol. 37, pp. 85). New York: Columbia University, Graduate School of Journalism.

Bradic, L. (2015). *Celebrity endorsements on social media are driving sales and winning over fans*. Paper presented at the Social Media Week. https://socialmediaweek.org/blog/2015/09/brands-using-celebrity-endorsements/

Cope, J., & Maloney, D. (2016). *Fashion promotion in practice*. London: Fairchild Books.

DeLong, M. R. (2016). *Theories of fashion*. Retrieved from http://fashion-history.lovetoknow.com/fashion-history-eras/theories-fashion

DiCarlo, L. (2004). Six degrees of tiger woods. *Forbes.com*, March 18.

Diener, B. J. (1999). High visibility:991Irving Rein, Philip Kotler, Martin Stoller. High Visibility: The making and marketing of professionals into celebrities. Lincolnwood, IL: NTC/Contemporary Publishing Company 1997. 346 pp, ISSN: .95: The making and marketing of professionals into celebrities. *Journal of Consumer Marketing, 16*(1), 96–97. doi:10.1108/jcm.1999.16.1.96.1

Dodd, C. A., Clarke, I., Baron, S., & Houston, V. (2000). Practitioner papers: 'Looking the part': Identity, meaning and culture in clothing purchasing – Theoretical considerations. *Journal of Fashion Marketing and Management: An International Journal, 4*(1), 41–48. doi:10.1108/eb022578

Dyer, R., & McDonald, P. (1998). *Stars*. British Film Institute.

Euromonitor. (2014). *Celebrity power and its influence on global consumer behaviour* [online].

Feasey, R. (2008). Reading heat: The meanings and pleasures of star fashions and celebrity gossip. *Continuum: Journal of Media & Cultural Studies, 22*(5), 687–699.

Furedi, F. (2010). Celebrity culture. *Society, 47*(6), 493–497. doi:10.1007/s12115-010-9367-6

Galbraith, P. W., & Karlin, J. G. (2012). *Idols and celebrity in Japanese media culture*. Springer.

Garland, R. (2010). Celebrity ancient and modern. *Society, 47*(6), 484–488. doi:10.1007/s12115-010-9365-8

Giovannini, S., Xu, Y., & Thomas, J. (2015). Luxury fashion consumption and generation Y consumers: Self, brand consciousness, and consumption motivations. *Journal of Fashion Marketing and Management, 19*(1), 22–40.

Gobé, M. (2001). *Emotional branding*. Allworth Press. Retrieved from http://marketingpedia.com/Marketing-Library/Quotes/Emotional%20Branding_quotes.pdf

Hardy, R. (2012). Liz Hurley bares all . . . about fiancé Shane Warne's startling new look, her feelings for Hugh Grant – and why she shares her life with both of them. *Mail Online* Retrieved from http://www.dailymail.co.uk/femail/article-2145814/Liz-Hurley-bares--fianc-Shane-Warnes-startling-new-look-feelings-Hugh-Grant--shares-life-them.html

Holmes, S. (2005). 'Off-guard, unkempt, unready'?: deconstructing contemporary celebrity in Heat magazine. *Continuum, 19*(1), 21–38.

Hub, I. M. (2021). *13 influencer marketing trends to watch in 2021*. Retrieved from https://influencermarketinghub.com/what-is-an-influencer/

Inglis, F. (2010). *A short history of celebrity*. Princeton: Princeton University Press.

Kaiser, S. B. (1990). *The social psychology of dress: Symbolic appearances in context.* New York: Holt, Rhinehart & Winston.

Katharina. (2012). *Levels in fashion.* Retrieved from https://fashion2011marketing. wordpress.com/2012/01/03/levels-in-fashion/

Kendall, G. T. (2009). *Fashion brand merchandising*: Fairchild Books.

Knittel, C. R., & Stango, V. (2009). Shareholder value destruction following the Tiger Woods scandal. Retrieved on January 5, 2010.

Korchia, M., & Fleck, N. (2006). *Celebrities in advertising: The role of congruency.*

Kowalczyk, C. M., & Royne, M. B. (2013). The moderating role of celebrity worship on attitudes toward celebrity brand extensions. *Journal of Marketing Theory and Practice, 21*(2), 211–220. doi:10.2753/MTP1069-6679210206

Kurzman, C., Anderson, C., Key, C., Lee, Y. O., Moloney, M., Silver, A., & Van Ryn, M. W. (2007). Celebrity status. *Sociological Theory, 25*(4), 347–367. doi:10.1111/j.1467-9558.2007.00313.x

Kyllonen, H. (2012). *Representations of success, failure and death in celebrity culture.* University of Sussex.

Lafferty, B. A. (2001). Emotional branding: The new paradigm for connecting brands to people. *Journal of Product & Brand Management, 10*(7), 466–469. doi:10.1108/ jpbm.2001.10.7.466.1

Leithart. (2007, 16 August). *Celebrity.* Retrieved from www.firstthings.com/blogs/ leithart/2007/08/attributed-celebrity

Lurie, A. (2000). *The language of clothes* (vol. 1, Owl books). New York: Henry Holt.

Malär, L., Krohmer, H., Hoyer, W. D., & Nyffenegger, B. (2011). Emotional brand attachment and brand personality: The relative importance of the actual and the ideal self. *Journal of Marketing, 75*(4), 35–52. doi:10.1509/jmkg.75.4.35

McDonald, D. (2016). *The celebrity trust index.* Retrieved from http://nymag.com/ news/intelligencer/16143/

Michael. (2016). *Luxury marketing: The difference between fashion and luxury brands.* Retrieved from http://branduniq.com/2015/luxury-marketing-the-difference-between-fashion-and-luxury-brands/

Milner, M. (1994). *Status and sacredness: A general theory of status relations and an analysis of Indian culture.* Oxford: Oxford University Press.

Minaev, A. (2021). *What is a blog?: Definition of terms blog, blogging, and blogger.* Retrieved from https://firstsiteguide.com/what-is-blog/

Mukherjee, D. (2009). *Impact of celebrity endorsements on brand image.* Retrieved from www.slideshare.net/brandsynapse/impact-of-celebrity-endorsement-on-brand-image

Niinimäki, K. (2010). Eco-clothing, consumer identity and ideology. *Sustainable Development, 18*(3), 150–162. doi:10.1002/sd.455

O'Cass, A., Lee, W. J., & Siahtiri, V. (2013). Can Islam and status consumption live together in the house of fashion clothing?. *Journal of Fashion Marketing and Management: An International Journal.*

O'Neill, T. (2003). *Celebrity.* London: Little, Brown.

Okonkwo, U. (2007). *Luxury fashion branding: Trends, tactics, techniques.* Basingstoke: Palgrave Macmillan.

Okonkwo, U. (2010). *Luxury brands & celebrities: An enduring branding romance.*

Pappas, B. (1999). Star power, star brands. *Forbes Magazine Online, 6.*

Pesendorfer, W. (1995). Design innovation and fashion cycles. *The American Economic Review,* 771–792.

Pringle, H. (2004). *Celebrity sells.* Chichester: Wiley.

Rebus, I. (2008). *Latin quotes, sayings, tattoos, phrases & mottos.* Retrieved from www.inrebus.com/index.php?entry=entry080103-161402

Renfrew, E., & Renfrew, C. (2014). *Developing a fashion collection* (vol. 2). New York: Fairchild Books.

Repucom. (2016a). *Celebrity DBI: The global celebrity evaluation index*. Retrieved from http://repucom.net/celebrity-dbi/case-study/

Repucom. (2016b). *Market research celebrity DBI*. Retrieved from http://repucom.net/celebrity-dbi/

Riggs, R. (2009). *The ulmer scale*. Retrieved from http://mentalfloss.com/article/21688/ulmer-scale

Rindova, V. P., Pollock, T. G., & Hayward, M. L. A. (2006). Celebrity firms: The social construction of market popularity. *The Academy of Management Review, 31*(1), 50–71.

Rojek, C. (2001). *Celebrity*. London: Reaktion.

Rojek, C. (2015). *Celebrity the Wiley Blackwell encyclopedia of consumption and consumer studies*. John Wiley & Sons, Ltd.

Smith, M. D. A. (2003). *From A-Z list*. Retrieved from http://news.bbc.co.uk/1/hi/entertainment/showbiz/2864691.stm

Solomon, M. R. (2014). *Consumer behavior: Buying, having, and being*. Engelwood Cliffs, NJ: Prentice Hall.

Solomon, M. R., & Rabolt, N. J. (2009). *Consumer behavior: In fashion*. Upper Saddle River, N.J: Pearson/Prentice Hall.

Strugatz, R. (2018). Influencer subculture: the Kim Kardashian lookalikes. *Los Angeles Times*.

Taylor & Francis. (2015). *Celebrity studies cultural report*.

Thomson, M. (2006). Human brands: Investigating antecedents to consumers' strong attachments to celebrities. *Journal of Marketing, 70*(3), 104–119. doi:10.1509/jmkg.70.3.104

Thornton, K. (2015). Parsing the visual rhetoric of office dress codes: A two-step process to increase inclusivity and professionalism in legal-workplace fashion. *Legal Communication & Rhetoric: JALWD, 12*, 2018–2017.

Turner, G. (2010). *Ordinary people and the media: The demotic turn*. Sage Publications.

Turner, G. (2014). *Understanding celebrity*. London: SAGE Publications.

Walker, J. A. (2003). *Art and celebrity*. London: Pluto.

Western, M. (2006, 1 April). *Celebrities* [1 ed.]. Retrieved from http://search.proquest.com.libaccess.hud.ac.uk/docview/341593069?pq-origsite=summon#

Wigley, S. M. (2015). An Examination of contemporary celebrity endorsement in fashion. *International Journal of Costume and Fashion, 15*(2), 1–17.

YouTube. (2022). *She can beat me but she cannot beat my outfit*. Rihanna – YouTube.

Chapter 3

The Fashion Celebrity Marketer

3.0 Introduction

The previous chapter explored how celebrities have been influential in shaping the trends of fashion consumers who recreate and/or emulate their innovative fashions. This chapter will provide an analysis of celebrity fashion marketing theory. It will commence by analysing media and marketing domains in which celebrities are used and discuss how they work in the context of some current theories of marketing, fashion, behaviours, and branding. It examines how advertisers and their agencies select the right celebrity for their brand and highlights how industry and marketers obtain and monitor information on the behaviours of fashion consumers who follow fashion celebrities. Finally, it will analyse what celebrity fashion marketing strategies and lifestyle messages are used in the media to extend opportunities for fashion consumers seeking to emulate and imitate celebrity fashions.

> ### Discussion:
>
> Is there a particular brand/celebrity that you have a connection with that creates particular feelings and emotions?
>
> What characteristics constitute a 'good' celebrity and a 'bad' celebrity for fashion marketing, and why?
>
> What impact does celebrity endorsement have on products, and is celebrity marketing always necessary?

3.1 Ideals of Beauty in Fashion

Marc Jacobs said, "Clothes mean nothing until someone lives in them" (Marc Jacobs Advertisement, 2022). "In sociological terms, fashion products are

DOI: 10.4324/9781003175360-3

regarded as high involvement purchases, closely connected to sentiments of self-image, social status and cultural identity" (Fairhurst et al., 1989; O'Cass, 2004). This attitude places pressure on individuals to look and act in a certain manner. Yves Saint Laurent said, "I have always believed that fashion was not only to make women more beautiful, but also to reassure them, give them confidence" (Misani & Capello, 2017). Gibson (2012) claims that scholars seem unaware that "for many young women, celebrity and fashion are virtually synonymous." Hence, "celebrities, with their pervasive media coverage and popular associations with luxury, fascination, success and attractiveness, are natural partners for fashion brands seeking to convey attractive lifestyle affiliations and tap into consumers' liking" (Wigley, 2015). Kaiser and Chandler (1985) observed that not only is this true for young individuals, but also for the older generations that implicitly use television for processing appearance and fashion-related information. This is advantageous for marketers, as they can appeal directly to a consumer's emotional state, their needs, and their aspirations.

Advertising possesses the ability to communicate messages and can strongly influence female fashion consumers into believing that in order for them to look good they need to purchase beauty products and fashionable garments. An example of this type of advertising emphasising beauty is by Bahman (2014) who stated: "Love isn't blind . . . if it were – there would be no such thing as makeup and push-up bras." If we explore this deeper, in order for individuals to compare themselves, some exchange of information must logically occur. Because a celebrity's appearance is perhaps the first stage, this is the exchange.

3.1.1 Celebrity Impact on Society, Human Behaviour, and Purchasing

Celebrities are part of a highly marketed industry in which commercial success is often determined by the dissemination of aspirational imagery and lifestyle affiliations and immediate brand recognition. Naomi Campbell said, "I make a lot of money, and I am worth every cent" Naomi Campbell (Mind Zip, 2022). Brands/celebrities with a high level of worldwide recognition and popularity can successfully transcend national borders and overcome cultural barriers in global marketing communications (Choi et al., 2005). Due to this extensive exposure, there has been a growth in [the use of] celebrities as influencers.

Moreover, celebrities and fashion companies need to understand celebrity fashions to target fashion consumer groups. Why individuals feel the need to look for inspiration from celebrities and their styles to activate, validate, fulfil their expectations, and create feelings and experiences is important for marketers to understand. This is because, from an industry perspective, there is real revenue in the sales of their celebrity copy ready-to-wear derivations and mass market clothing.

Choices in brands help consumers to exercise their preferences in the marketplace . . . ultimately enabling consumers to exercise choice in their decision-making. Equally important, they come with a certain image – whether for luxury, trendiness or social responsibility which consumers care about, and in turn influence which goods and services they purchase.

(Property, 2013, p. 6)

Fashion celebrity marketers are able to then pick up on leads exemplified by celebrities and the fashion catwalk (Pringle, 2004).

How individuals style themselves is due to many factors that impact on a personal level. "Marketers categorise fashion in many ways for products and services which we purchase," this can be by age, gender, social class, income, faith, and occupation, and furthermore, by our interests in clothing and the way we spend our leisure time. Consumer information, according to Solomon and Rabolt (2009), is very useful when analysing fashion consumer buying behaviour. There isn't a single fashion identity that defines a consumer, there are many. This information has important implications for retailers and marketers alike, which will be covered in the following sections.

3.2 Media Fashion and Branding in the Social Media Age

The celebrity's exposure and engagement are largely due to communication technology and the development of new forms of media technology. As a result of this, the celebrity is able to reach larger audiences more rapidly (Meyers, 2009). This is due to the advent of globalisation and increase in international travel, digital media, fashion magazines, and intercultural influences that have impacted consumers and how their icons are portrayed.

"Most notably the Internet and social media marketing are a growing phenomena, giving customers a sense of affiliation and belonging to a brand" (Lea-Greenwood, 2012) and assisting practitioners and celebrities to influence consumers by promoting celebrity brands. As lifestyles are changing, consumers are turning to the Internet and smart technology for ideas on celebrity fashion which are attracting more activity. These are resulting in many celebrities setting up websites, Facebook, Twitter, Instagram, TikTok, YouTube channels, and other social media accounts which allow them to be verified with blue ticks. Using these types of social networks allows celebrities to track and respond to the opinions of their fans in a timely fashion, in particular about their products, services, and/or fashion trends. An advantage for celebrities of this engagement is that they can connect to those consumers and individuals who may not possess the highest level of celebrity fandom and emphasise their lifestyles which can attract new fans (Kowalczyk & Royne, 2013).

Social media stars are bypassing the usual gatekeepers of the celebrity industry and becoming famous through their videos and websites. This type of celebrity, while less-esteemed, is far more attainable than movie stardom, and some social media stars are becoming A-list celebrities. "It has in effect made fame seem achievable for ordinary people" (Kurzman et al., 2007). As mentioned in section 2.4.2, the Kardashian-Jenner fashion brand uses social media to effectively control the persona of fans and consumers, proving these methods are

influential (Euromonitor, 2014). They are avidly followed on social media by their fans who watch their programmes for tips on how to be stylish and beautiful and for an escape. This leads us to the next part of this chapter: why marketers need to understand the reason why consumers choose to escape into the world of the celebrity.

3.2.1 Importance for Marketers to Understand the Social Psychology of Dress and Fashion

Fashion [sense] can be a conscious decision made to manage the inferences drawn about one individual by other individuals or to manage social perceptions of the-self. "In order to be irreplaceable, one must always be different," said Coco Chanel (Brainy Quote, 2022a). The way an individual dresses and what they purchase are related closely to their beliefs, attitudes, feelings, and behaviours. These are shaped by the influence of others and their environment. Gobé (2001), author of the book *Emotional Branding*, claims that the most successful brands connect with people on a personal and holistic level (Lockwood, 2001), and he says a fashion brand is meaningless without an emotional attachment (Gobé, 2001). Furthermore, he adds that success will be with those brands who can capture the emotions and personal convictions of their customers and their psyche to understand the constant evolving trends in consumer lifestyles (Hancock, 2009).

This type of emotional attachment typifies branding literature in that a consumer needs to build a personal emotional attachment to any product prior to purchasing it. It also reinforces the idea that fashion brands fascinate consumers by their capacity to connect with them as they live in the minds of the consumer longer alongside their aspirations (Vincent, 2012, p. 64). This then takes us into a new level and the need to understand the celebrity in fashion, media, and advertising as a symbiont as they hold the ability to transform products into brands by creating brand mythologies around mythical characters, places, and feelings. These are especially effective when the feelings validate the emotional or psychological benefits associated with the product (Randazzo, 1992).

3.2.2 The Importance of the Celebrity Image for Marketers

'Celebritism' is a term used for modern-day entertainment figures in the entertainment industry who are organised by a business as a 'brand business' (Wigley, 2015). As the previous chapters discussed, we cannot ignore the popular interest in celebrities, their fashions, and lifestyle. According to McCracken (1989),

> *celebrities build up their celebrity identities (images) as a collection of meanings which they draw from their roles in TV, mass media, cinema etc. and reflect these meanings through their lifestyles and personalities . . . the ownership of these meanings is ensured by reflecting them continuously in front of the public and drawn from culture and society.*
>
> (Şahin & Atik, 2013)

"This is emanated from the fact that the media overloads society with news and illustrations about celebrities and provides them for us as an entertainment function" (Hoekman & Bosmans, 2010). "One of the criticisms of the advertising industry is that it creates idealised stereotypes that in some way forces ordinary 'consumers' to live up to . . . which leads them to conform with an impossible image of beauty" (Pringle, 2004).

"Fashion is like eating, you shouldn't stick to the same menu," says Kenzo Takada (Vogue, 2022). If we consider fashion products, every product has an image, and when an individual consumes a celebrity fashion brand, it is usually because it has the maximum fit with their own personality/image and the celebrity endorser fits in-between these two interactions. The aim for marketers is to try to bring the image of the product closer to the expectation of the consumers, by transferring some of the cultural symbolic meanings residing in the celebrity's image to the product and transferring that into meaning for the consumer (Rawtani, 2010). Gobé (2001), Sheth et al. (1999), and Solomon and Rabolt (2009) all support the claim that fashion consumers have needs, and marketers can satisfy those needs if they understand their customer's fashion is based on emotions, such as being aesthetically beautiful. They can do this by enticing fashion consumers to buy fashion clothes that celebrities have influenced (Lee, 2015; Pringle, 2004) to make them feel attractive, amplified in status, modern, and novel. Often the purchases of these clothes are not made for need but for pleasure of the consumption experience, and they can be used for a variety of different fashion brand endorsements from clothing, footwear, bags, and accessories. Michael Kors said, "I've always thought of accessories as the exclamation point of a woman's outfit" (Perteh, 2022). Therefore, information on the fashion celebrity marketer, celebrities endorsing brands, fashion trends, fashion designers, fashion diffusion, consumer identification, and the role of the media and its influence on future fashion innovations are all necessary to understand. The following section will explain the various strategies, communication, and promotional tools that marketers use in the positioning of their fashion celebrity.

3.3 Celebrity Endorsement

A celebrity endorser is defined as "any individual who enjoys public recognition and who uses this recognition on behalf of a consumer good by appearing with it in an advertisement" (McCracken, 1989). It is imperative for industry practitioners and marketers to understand how consumers view celebrity-endorsed products in order to generate more sales. This type of amalgamation of the consumer, fashion, celebrity with a brand/product is one of complexity (Kaur & Singh, 2011). From a fashion celebrity marketer's perspective, choosing the right celebrity and fitting him or her with a brand is a difficult task. Therefore, companies often opt to choose entertainment sector celebrities because they are the most exposed and popular in endorsing products (Pringle, 2004).

By using a celebrity endorsement, the consumer receives positive feelings of security and association. This is because someone they are familiar with and like (their idol) is recommending the product. Therefore, the assumption is being made that it is of a good standard and a quality product. The consumer would

like to identify themselves with the celebrity and buy the product because they would like to affiliate themselves with the celebrity (Hoekman & Bosmans, 2016). By accepting a celebrity endorsement, the consumer receives positive feelings of security and association. "Celebrity endorsements have been found to be effective in positively changing consumers' attitude towards brands by influencing the believability and credibility of advertisements and impacting consumers' purchase intentions" (Amos et al., 2008; Erdogan, 1999; Mishra et al., 2015). Pringle (2004) reports that a well-executed celebrity endorsement strategy may return more than 20 times its cost in terms of extra sales. Therefore, a fashion celebrity endorser must be an individual who is popularly associated by consumers as wearing and using fashion brands (Wigley, 2015). Some of the advantages of using celebrities to promote a fashion brand's appeal are listed below (Okonkwo, 2007):

❏ Celebrities create brand awareness and draw on consumer attention.

❏ Celebrities can reach a global market and capitalise on public recognition.

❏ Celebrities can penetrate the busy clutter of advertising spots.

❏ The celebrity has his or her own existing fan base.

❏ Celebrities can create and differentiate product images.

❏ Celebrities can increase sales and profits.

❏ Celebrities position and reposition existing brands.

❏ Celebrities generate extensive PR (public relations) leverage and opportunities for brands.

"Millions of pounds are used on celebrity endorsement contracts on the premise that source effects play an important role in persuasive communications" (Tripp et al., 1994). Marketing researchers have found that these celebrity endorsements, in comparison to those from non-celebrities, have produced more positive attitudes towards advertising and greater purchase intentions than a non-celebrity endorser (Figure 3.1). This is because celebrities are viewed as more powerful than anonymous models and campaigns as they verbalise the meaning of the celebrity in relation to the brand (Carroll, 2009), thus allowing celebrity endorsement brands to stand out from the competition. Ways in which celebrities are used to help promote and endorse fashion brands are described in Table 3.1.

Celebrities can hold a strong attraction for and impressive power to pursue the audience through their likeness, attractiveness, and trust or by their congruency with a brand, which leads to a creation of a strong brand image and value in the viewers' minds (Sharma & Singh, 2014). One of the most successful ways to communicate a fashion product is through celebrity endorsement (Table 3.1). This is because "it is one of the most important channels or tools in fashion and most academic commentators concur that using celebrities alongside products, affects consumer behaviour. This is evident through three key ways the celebrity can impact on the consumer which are transference, attractiveness and congruence" (Lea-Greenwood, 2012). Table 3.2 shows some explanation of how this can be successfully achieved.

Mukherjee (2009) presents a 20-point model, which can be used by brand managers in the selection of celebrities and brand communication. All the points

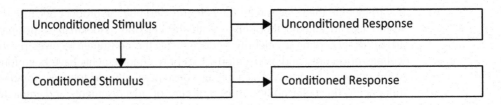

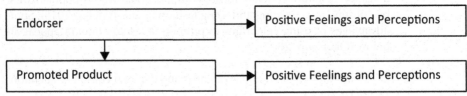

Figure 3.1

Classical Conditioning Paradigm in a Marketing Communications Context (Erdogan, 1999)

are important to understand when running an effective celebrity endorsement campaign for capturing the attention of the consumer:

❑ Celebrity product match
❑ Celebrity target audience
❑ Celebrity popularity
❑ Celebrity credibility
❑ Celebrity values
❑ Celebrity physical attractiveness
❑ Celebrity regional and international
❑ Fit with the advertising idea
❑ Celebrity should be a brand user
❑ Previous endorsements
❑ Interest of endorser
❑ Unique idea of promotion
❑ Endorsement management team
❑ Brand image formation
❑ Effective use of promotional medium
❑ Celebrity controversy risk
❑ Multiple endorsements
❑ Costs of acquiring the celebrity
❑ Celebrity availability
❑ Consumer opinion influencing advertisement

Celebrity Involvement and Examples

Paid-for Advertising to Mass Audiences

This endorsement is traditionally dominated by professional models, but designers are now increasingly using high-profile musicians, entertainers, and others.

For example, brand advertising campaigns such as SS2014

Miley Cyrus (American singer and actress) for Marc Jacobs, Rihanna (Barbadian singer, actress, and fashion designer) for Balmain

Infomercial

Advertorial, direct mail, or online advertising to niche or tailored audiences; known as 'below the line advertising'

For example, Azealia Banks (American rapper and actress) for T Alexander Wang fashion film (2012)

Paid or Unpaid Product Placement

Where celebrities wear fashion brands in films, TV reality shows, or in 'real life' (where they may be coincidentally 'papped' by press photographers)

For example, Anne Hathaway (American actress) wearing Tiffany jewellery to the 2011 Academy Awards ceremony

Beyoncé (American singer and actress) appearing at Kanye West's (American rapper and fashion designer) birthday in 2013 wearing Topshop

Paid-for Mentions

Brand mentioned in song lyrics.

For example, Beyoncé (American singer and actress) singing about getting her kicks from her Jimmy Choo shoes

Celebrity/Brand Design

Heavy involvement from celebrity in designs

For example, Madonna (American singer and actress) for H&M (2007)

Kate Moss (British supermodel) and Beyoncé (American singer and actress) with Topshop

Naming Products After Celebrities

For example, Gucci named the Jackie bag after Jacqueline Kennedy (American socialite who became first lady of the United States when her husband, John F. Kennedy, became president)

Mulberry's Del Rey bag named after Lana Del Rey (American singer)

Hermes' Birkin bag named after Jane Birkin (British actress)

Social Media Endorsement

For example, Calvin Klein #my calvins campaign (2014)

Burberry with Romeo Beckham (British model, son of David and Victoria Beckham)

Table of Definitions of Six Examples of Celebrity Involvement, with Examples

Table 3.1 Types of Celebrity-Brand Relationships in Fashion (Cope & Maloney, 2016)

Lea-Greenwood (2012) suggests that paid endorsements involve a brand signing a celebrity to represent the label in a traditional fashion advertising campaign, and unpaid endorsements occur when a celebrity wears a brand because they like it. However, the most preferred type of endorsement is an overt endorsement. This is when the celebrity has chosen to wear a brand and they are paid.

Type of Endorsement	Celebrity Enhances Sales of Fashion By:
Transference	When a celebrity endorses a brand associated with their profession, such as sportsmen endorsing Adidas or Nike. The theory of transference suggests that consumers will feel some of the skills of the celebrity might rub off on them if they purchase and use the brand.
Acceptance	This is aspiring to look like a celebrity in terms of hairstyle, clothing and so on, allowing the consumer to enter the world of the celebrity's lifestyle; for example, young women adopting the style of the celebrity they admire.
Congruence	A fit congruence is a key concept in celebrity endorsement. It ensures a fit between the brand and the celebrity to the consumer. It is credible to the consumer that the celebrity would wear the brand.

Table defining three types of endorsements

Table 3.2 Types of Celebrity Endorsements and Their Impact (Lea-Greenwood, 2012)

Typically, celebrities that have entered celebritydom through birth and/or achievement and A-list celebrities are still the top choice to be endorsers. However, there are also new endorsers (see sections 2.2.1.5 and Table 2.2), such as Internet blogger and entrepreneur Rumi Neely who joined designer Calvin Klein in his 2014 fashion promotion which utilised celebrities such as Fergie (American singer, formally member of the band Black Eyed Peas) in the "show yours #mycalvins campaign" (Cope & Maloney, 2016). In addition to fashion apparel, another growing celebrity range is the cosmetics and perfume industry by celebrities such as Kylie Jenner, Ariana Grande, Jennifer Lopez, Rihanna, Nicki Minaj, Britney Spears, Elizabeth Taylor, and Jessica Simpson. According to Fleck (2012), celebrities no longer achieve recognition merely due to the intrinsic quality of their products, but by the image they project through their advertising campaigns.

3.3.1 The Meaning of Fashion Brands to the Consumer

Customer behaviour research has revealed that humans do respond to brands, and scholars agree that identity represents a stable point of reference for consumers and is a cornerstone in the process of creating and maintaining relationships with customers who find specific values appealing (Jan Alsem & Kostelijk, 2008; Kapferer, 2008; Solomon et al., 1999). Sections 3.2, 3.3, and 3.3.1 highlight the idea that the celebrity endorser and fashion brand are highly complex, and a campaign needs to be accurate in order to work effectively.

Information on products/fashions/styles/products is a source of data that can be extremely influential and that can enable marketers to reach a worldwide audience and encourage the consumption of fashion brands that are marketed to tap into the psyche of the consumer-self. These can be defined as:

- ❏ Brand lifestyle personality
- ❏ Brand image
- ❏ Celebrity brand ambassadors

3.3.2 Brand Lifestyle Personality

"Fashion is not just products, but rather about how they are marketed and sold as a brand image or lifestyle marketing" (Hancock, 2009). Brand personality is defined as "the set of human characteristics associated with a brand, which tend to serve a symbolic or self-expressive function" (Aaker, 1997). It is suggested that the symbolic use of brands happens because consumers often imbue brands with human personality traits as they think about brands as if they were celebrities or famous historical figures (Rook, 1985). They then relate those brands, fashion products, and celebrities to themselves (Fournier & Yao, 1997).

Will Smith was quoted saying, "Too many people are buying things they can't afford, with money that they don't have . . . to impress people that they don't like!" (Good Reads, 2022). Lifestyle brands operate by creating an experience that is often at odds with reality. For example,

> most of the consumers who buy the [Ralph Lauren] polo apparel do not own or ride a horse . . . they probably know very little about the game of polo and a high percentage of them are not affluent . . . for these consumers the brand helps them fulfil a lifestyle goal to which they aspire and makes that lifestyle more a part of their everyday reality.
>
> (Vincent, 2012)

Ralph was famously quoted saying, "I don't design clothes. I design dreams" (Brainy Quote, 2022b). Celebrity endorsement teamed with this type of lifestyle branding is a useful tool to create a story in order for marketers to build an attachment to fashion products for consumers (Hancock, 2009), thus leading the brand image to be even more central to the celebrity marketing strategy (Erdogan, 1999). This phenomenon suggests that although clothing is an essential component of popular culture, the actual garment itself has become secondary to the branding techniques used to sell it.

3.3.3 Brand Image

This insight into brand and celebrity image opens up new ways of looking at the marketplace (Forbes, 2018). If we analyse image and look at its value in terms of fashion media marketing, image is regarded as a reflection of a consumers' perception of a brand and can be gauged by the associations held in the memory, therefore enabling customers to form a deeper and instinctive need to know about products and services they buy. This resulting impression "is created by both brand messages and experiences that are assimilated into a perception through the processing of information" (T. R. Duncan, 2001). Brands often do this by featuring celebrities, models, and society personalities in their

promotional and advertising campaigns to reflect the brand essence and message. This strategy was implemented by Tom Ford (American fashion designer) who used "the celebrity and sex" concept to sell luxury for Gucci and now his own international brand (Okonkwo, 2007).

3.3.4 Celebrity Brand Ambassadors

Celebrity brand ambassadors involve the use of strong celebrity personalities that are connected with a brand by "giving it a face" as a brand ambassador or a symbolic figure linked with a brand. The people who act as brand ambassadors include creative directors such as Tamara Mellon (British fashion entrepreneur) of Jimmy Choo and Gerard Butler (Scottish actor) for Hugo Boss. These brand ambassadors become household public names and sometimes celebrities in their own right, holding their own personal brand value (Okonkwo, 2007). Moreover, a celebrity brand ambassador's influence extends beyond consumer attitudes and purchasing behaviour. In fact, health communication research indicates that star power can generate public interest in many issues and even result in behavioural change (Noar et al., 2014). However, in some instances, a brand ambassador can overpower the brand and overshadow it, as happened, for example, with Tom Ford (American fashion designer) for Gucci or Karl Lagerfeld (German fashion designer) for Chanel.

There can also be occasions when a celebrity is not chosen by a company to be a brand representative, but fans link that particular celebrity to the product anyway. This is because the celebrity regularly uses the brand as part of his or her identity/image and is often seen in the media wearing it. For example, Paul Weller (British singer/songwriter) out of his own personal choice wore Ben Sherman for many years. This made him then become an unofficial brand ambassador, and many of his fans followed suit to identify with him and his music by wearing the same brand.

3.3.5 Celebrity Brand Negativity and Its Effects on the Marketer

How to choose a celebrity for a brand, fashion, or product is an important topic in advertising and marketing as the celebrity must make an impression on consumers with his or her power and appeal. The use of celebrities can work effectively (as discussed in sections 2.1, 2.4, and 2.4.1, and Table 2.5), but it is important to understand that the resultant impact can also be negative. This relationship between negative celebrity information and brand evaluation can be moderated by certain factors (Edwards & La Ferle, 2009; Lee, 2015; Ahluwalia et al., 2000). A major concern for companies is determining how to select/retain the "right" celebrity among many competing alternatives and how they simultaneously manage this resource, while avoiding issues in the celebrity's personal life that could be deemed as inappropriate. Eclipsing is when the celebrity overshadows the endorsed brand by dominating it in an advertisement

and diminishing the associative link between the celebrity and endorsed brand. This can have profound results for advertisers and brand managers in the execution of their advertisements featuring endorsements. It takes into account factors such as match-up, celebrity attachment, and brand familiarity (Ilicic & Webster, 2014): (1) high-eclipsing is when the celebrity is the focus which enhances brand attitude and (2) low-eclipsing is when both the celebrity and brand are emphasised.

3.4 Negative Celebrity Brand Campaigns

The personal lives of celebrity endorsers are outside the control of advertisers. All celebrity endorsements are vulnerable to scandals or negative press. Marketers anticipate that their target consumer elicits positive feelings toward a chosen celebrity which will transfer to the endorsed brand. In some instances, if either during or after an advertising campaign negative information about the celebrity becomes public, it can prove to be detrimental to the brand. For example, "Pepsi Cola's series of devastations with three tarnished celebrities: Mike Tyson (American former professional boxer, who was in 1992 convicted of rape and sentenced to prison, although later released on parole), Madonna (American singer/songwriter and actress, which in her 'Like a Prayer' music video included imagery of burning a Catholic cross and making love to a saint, which led the Vatican to condemn the video and religious groups to ban and cancel several sponsorship deals) and Michael Jackson (American singer/songwriter and dancer, was later accused of sexually abusing a child). Suggesting that celebrity endorsers may at times become liabilities to the brands they endorse" (Till & Shimp, 1998). In recent years, Johnny Depp (American actor, was another celebrity who brought a libel lawsuit against the media for calling him a "wife beater," subsequently losing a whole host of acting roles and sponsorship deals). Today, "negative publicity is a real concern for such sponsoring companies as it can affect brand image and sales, but this is not necessarily true across the board. Misbehaviour and even criminal activity by celebrities have at times grabbed the attention of marketing executives who believe that . . . any publicity is good publicity" (Thwaites et al., 2012). O'Mahony and Meenaghan (1997) argue that to obtain successful publicity, celebrities must possess expertise in product categories consistent with their public profiles and perceived lifestyles. Thus, consumers expect a congruence between the perceived images of the celebrity endorser and the types of products that they endorse. In these cases, the advertiser needs to try to avoid a celebrity's poor judgement, ill-advised behaviour, or controversial stands (Um & Lee, 2015). Sometimes a celebrity will personally consume, purchase, or use a particular brand or fashion design, and then they are pictured carrying or wearing it. The fashion brand has no control over this. When it happens, the brand is sometimes pleased to be associated with the celebrity. But there are times when the

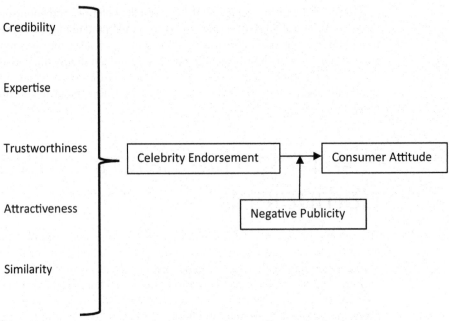

Figure 3.2

A Model Illustrating Negative Publicity on Celebrity Endorsement Influencing Consumer Attitude (Hoekman & Bosmans, 2016)

brand does not want to be associated with a particular celebrity because of the celebrity's negative role, reputation, and profile, which can lead consumers to have a negative brand evaluation, thus leading to a negative purchase intention (Um & Lee, 2015). Burberry experienced this negative effect when Danniella Westbrook (British soap actress) wore the famous Burberry check from head to toe, dressed her baby in the Burberry check, and posed with a Burberry pram (section 3.3.1.5 and Figure 3.2). This photo was repeated every time there was a press story, so it became synonymous with 'British Chav Culture' and became detrimental to the Burberry brand image and took them many years to over-come (Lea-Greenwood, 2012).

3.4.1 Negative Celebrity Fashion Impact on the Youth

As mentioned in the previous chapters, fashion is a critical means of expression for many individuals, especially for young consumers who are in the process of defining their identities and are impressionable. Gianni Versace was vocal about this by saying "don't be into trends . . . you decide what you are, what you want to express by the way you dress and the way you live" (Brainy Quote, 2022a). "Research shows that the use of celebrities has the most positive effect on the key youth demographic" (Lea-Greenwood, 2012). "They are also the most avid consumers of fast fashion and heavily influenced by the fashion press

and media" (Barnes & Lea-Greenwood, 2010). This is because this group looks up to celebrities as peers and role models who guide their fashion choices, their look, and self-appreciation (Le Bon, 2015).

Miley Cyrus (American singer and actress), daughter of Billy Ray Cyrus (American singer and actor), started her career as a child actress and has starred in children's TV and films (Fisher, 2016). At 23, she hit the headlines several times with negative connotations associated with her fame. Her new turns of identity shifted her presentation of herself for a mature audience, including experimentation with haircuts and provocative videos. These provocative behaviours displayed by celebrities raise concerns for parents/society and can lead to many different issues affecting their followers that are predominantly young. Celebrities can heavily manipulate teenagers and adults, and a government-backed report (Bailey, 2011) expressed concerns that young children were becoming more like teenagers in their behaviour and used fashion to create their looks and identity.

This is because they are looking for role models on how to act and how to dress, and they often look at celebrities for inspiration as well as fashion media and magazines for a dress sense to incorporate into their own fashual (fashion-sexual identity). Celebrities featured in magazines can be especially influential for young girls. Therefore, celebrities, marketers, and parents should be aware of how celebrity dress can affect young girls, how they can be influenced, and by which medium (see Table 3.3 and 3.4). Such new body images can be seen as more insidious than the much-debated thinness of catwalk models according to

	Yes	No	Don't know
1 hour + a day on social media	59%	37%	3%
Followed a celebrity	55%	44%	1%
Followed a company	36%	62%	2%
Clicked on an advert on social media	35%	61%	4%
Bought/ asked my parents to buy something after seeing a celebrity use it on social media	64%	31%	5%
Streamed a video of myself/my friends live	29%	69%	2%

Table showing impact of social media on children between the ages of 10–15

Table 3.3 Social Media Behaviour of 893 Children Between the Ages of 10 to 15 (Mintel, 2016)

Age	Yes	No	Don't know
10–12 years	50%	47%	3%
13–15 years	67%	29%	4%

Table of children between the ages of 10 to 15 that have followed a celebrity on social media

Table 3.4 Children Between the Ages of 10 to 15 That Have Followed a Celebrity on Social Media (Mintel, 2016)

(Marshall, 2006), suggesting that the fashion industry should not be the only one castigated over issues of size, shape, sexualisation, and the problems created for young women. People should look at celebrity influences as well.

Celebrity profiles are an important aspect of social media, and there is growing uptake of Instagram, TikTok, and Twitter by many celebrities and sports stars. Girls and teenagers are most likely to follow a celebrity online – with 60% of girls and 67% of 13- to 15-year-olds following at least one celebrity on social media and many opening Instagram accounts. These increasing users, likes, followers, celebrity sponsorships, and promotions on social media are valuable. Nearly a third of social media users have at least asked their parents to make a purchase after seeing a celebrity use/wear a product on social media, rising to 35% among those aged 10 to 12 and 39% from households with an income of £50,000 or more (Mintel, 2016). Studies by Engle and Kasser (2005) and Greenwood and Long (2011) found that consumer groups of young girls are most impressionable as they are learning about their own sexuality and role in society. Girls in such groups are trying to identify their place in the world, and they are more prone to embrace attachment, belongingness, needs, and relationship status together with a much-greater imagined image and intimacy with media figures.

3.4.2 Summary of the Market Industry Value of the Celebrity

"The ultimate customer is stylish, not fashionable. To be fashionable, all you need is money," said Marc Jacobs (Wow report, 2022). Celebrity brands, as stated, can have a colossal impact; they influence fashion consumers who purchase products or services related to a particular fashion celebrity to satisfy a need based on what they feel. What effect this has on consumers is a question that marketers are keen to answer. Because of the market being highly flooded with global brands, fashion companies are being forced to have that familiar face for their fashion products and services (Jyothi & Rajkumar, 2005). They do this because they want to align themselves and their brands with endorsers which work for the celebrity and the brand/company. As a consequence, firms today are making vast investments in hiring celebrities for the positioning of brands with endorser qualities (Malik & Sudhakar, 2014). The following section in this chapter will review how marketers and industry practitioners do this through specific celebrity marketing communications models and tools which work on precise strategies within celebrity marketing.

3.5 Celebrity and Marketer Models and Tools

Models showing factors forecasting celebrity effectiveness can demonstrate the processes through which consumers perceive advertisements with fashion celebrities and how those processes of messages are received by consumers.

This section will look at the use of celebrity fashion marketing models that use celebrities and will be split into two main areas:

❏ The fashion celebrity and fashion celebrity marketers
❏ The fashion celebrity marketers and the fashion consumers

A number of key models, tools and theory will be examined in the subsequent sections:

❏ The-Self Product Congruence
❏ FRED
❏ The Flow of Fashion Trickle Down, Trickle Up, and Trickle Across
❏ McCracken's Meaning Transfer and Emulation Model
❏ Kapferer's Brand Identity Prism Model
❏ Maslow's Hierarchy of Needs Theory
❏ Model of Innovation and Adoption
❏ The Fashion Product Life Cycle
❏ The Celebrity Life Cycle
❏ The Culture Innovation Theory

3.5.1 The-Self Product Congruence Model

Consumers articulate their personal identity and promote social interaction with others via brands that embrace psychological and social symbols (Lee, 2015). In the case of celebrity fashions, the need to purchase goes deeper than the actual clothing need. "Lifestyles as a theoretical concept, means the totality of a person's social practices" (Niinimäki, 2010). These could be associated with a fashion/celebrity and some sort of social status which contributes towards constructing identity and expanding towards a desire for attaining certain lifestyles and status.

Agrawal and Kamakura (1995) found that overall, celebrity endorsements introduce positive assertions from consumers and positive affirmations. According to Sirgy (1982), "consumers prefer certain products or brands that are consistent with their self-image and can enhance their self-image." In other words, they "purposefully choose certain products and brands to express their self-image to the public (self-consistency) and also to enhance their own self-esteem through experiencing the positive reflection of themselves in the public" (Aaker, 1997). "Research supports the idea that there is a match between product usage and the self-image" (Bahman, 2014). The following two diagrams illustrate the congruence between the brand and the self, and the image impact to both. Figure 3.3 is produced by Rogers who identified one's self-concept as the frame upon which personality is developed, and Figure 3.4 is a diagram illustrating the purpose of each person seeking a balance in three areas of their lives: self-worth, self-image, and the ideal self.

| Self-Image | = | Product Usage |

Figure 3.3

The Congruence Between Usage and Image (Bahman, 2014)

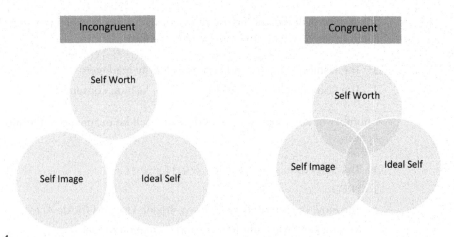

Figure 3.4

The-Self Product Congruence (Journal Psyche, 2016)

3.5.2 The FRED Principle

The FRED concept is a tool used as a guideline when selecting a celebrity. As discussed, choosing celebrity endorsers is vital to the success of an advertising campaign. Marketers use this acronym to evaluate the strengths and weaknesses of potential celebrity marketing campaigns (Marketing-School.org, 2016):

❑ Familiarity – The target market must be aware of the celebrity and perceive him or her as empathetic, credible, sincere, and trustworthy. The more familiar a celebrity is to the widest possible segment of the population, the more effective their advertisements will be.

❑ Relevance – The audience must be able to identify with the person, and marketers must choose to create the greatest fit between a product and its celebrity endorser. The greater the link, the more customers will trust the message being delivered, accepting and preferring to buy the brand over its competition.

❑ Esteem – The more esteem that a celebrity endorser has, the more that esteem will transfer over to the product they are endorsing, and consumers will have confidence in the celebrity.

❑ Differentiation – Advertisers are always trying to find a message or an image that makes their product seem unique when compared to competitors.

3.5.3 The Flow of Fashion

The flow of fashion can be seen as trickle down, trickle up, or trickle across (Figure 3.5).

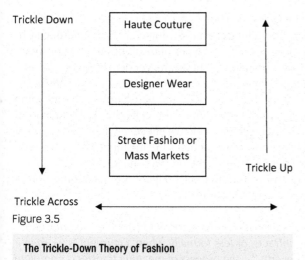

Trickle Down

Haute Couture

Designer Wear

Street Fashion or
Mass Markets

Trickle Up

Trickle Across

Figure 3.5

The Trickle-Down Theory of Fashion

Trickle down: The trickle-down theory was produced by sociologist and philosopher Georg Simmel who indicated the upper classes were leaders of popularity as they held political and economic power. This type of diffusion of fashion has been described as a movement, a flow, or a trickle from one element of society to another where "fashion is a form of imitation . . . the elite initiates a fashion and then the mass imitate it to obliterate the external distinctions of class" (Simmel, 1957).

This model highlights that "popularity arose when the lower classes imitated the upper classes, incorporating it into lifestyle" (Wu, 2015) and

the desire to be viewed as wealthy or equivalent to the higher economic class justifies the imitation . . . when the majority of customers start to adopt this product, wealthier consumers begin to avoid it and look for new trends . . . the elite initiates a fashion and the mass imitate it.

(Le Bon, 2015)

Trickle up/down: This explains the reverse spread of fashion and multi-centre diffusion of fashion as we know it today; for example, fashion stemming from young consumers and then gradually spreading to the more mature. Innovation here is initiated from the street; for example, Hip-Hop fashion is now sold by luxury houses/brands. In modern fashion, the street level is often the origin. In fact, customers choose someone they want to look like, such as a celebrity or a fashion model, where their mimicry is not based on wealth but on identity (Le Bon, 2015).

Trickle across: This trend claims that fashion can move horizontally between social levels. Key influences enabling this trend are social media communications, celebrities, promotional efforts of marketers, and exposure to fashion leaders. Here, fashion choices place much emphasis on personal identity rather than on class in terms of differentiation.

3.5.4 McCracken's Meaning Transfer Model

The academic McCracken (1989) focused on the types of meanings between fashions and branding, and he proposed a new model which showed how meanings pass from celebrity to product and from product to the consumer. This model offered a new approach to celebrity endorsement highlighting the limitations of the 'source.' His theoretical models suggest that through social interaction, individuals (and eventually society) assign status to fashion-branded garments, making celebrities a successful strategic match as they echo the symbolic meanings and values that are closely tied to the culture in which they have

attained their eminence (McCracken, 1989). McCracken argues that meaning, associations, emotions, and storytelling are the key ingredients for building fashion branding success. He identifies different types of meanings for the consumer that are usually targeted by companies. These are gender, lifestyle, decade, age, class, status, occupation, time/place, value, fad, fashion, and trend meanings. McCracken (1989) defines this transfer as "the translation of the meaning of celebrity to a product or brand, for example, the celebrity spokesperson in advertisements and through endorsement which is effective when an individual who buys and consumes the product appropriates the meaning associated with the celebrity which has been transferred to the product" (Fleck, 2012).

The meaning movement shown on the model (Figure 3.6) can come from a celebrity's persona, attributes, and achievements.

> *Transferable to consumers from a product associated with the celebrity, either through endorsement contracts, or less formally when a garment is worn in a movie, or at high profile events ... the process of meaning transfer is complete when consumers use the meanings transferred to help construct their own identities by wearing identical (or similar, lower-priced) garments to those associated with and/or are given meaning by-celebrities.*
>
> (McCracken, 1989)

The model explains how celebrities transmit an extensive set of associations with the brands they endorse. Therefore, before companies select celebrities to represent their brands, they need to ensure that the person conveys the right meaning. The wrong celebrity, as research suggests, will make consumers avoid products with negative symbolic implications, which leads to the consumers' rejection of those products and brands (Banister and Hogg, 2004) and their

McCracken's Meaning Movement and Endorsement Process

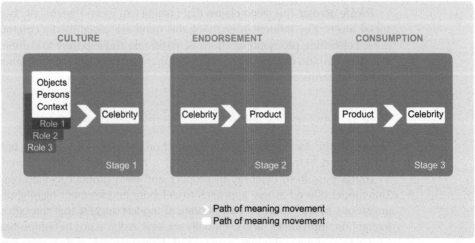

Figure 3.6

The Meaning Transfer and Emulation Model (McCracken, 1989)

expression of negative attitudes toward lifestyles they wish to avoid (Lowrey et al., 2001).

McCracken's transfer of meaning model appears to offer the most inclusive model for linking the celebrity to an 'object,' but the following factors are unaccounted for, and the model does not:

❑ Provide a complex set of parameters and evaluate the celebrity fashion processes in the transfer of meaning between the celebrity to the consumer.

❑ Measure levels of the capability of a celebrity product and the position of the symbionts.

❑ Demonstrate the position of the celebrity as a human fashion brand.

❑ Describe the role of fashion celebrity marketers and where they fit.

❑ Show the impact on the celebrity fashion consumers' self and perceptions.

❑ Explain the causes of growth.

McCracken's model also does not provide any guidance on the needs processes of fashion consumers and their levels of adoption. Another limitation is that it emphasises products and individuals but not the combined role of the three constructs in a symbiotic environment with a focus placed on fashion and emulation.

3.5.5 Kapferer's Brand Identity Prism Framework

Kapferer (2000) introduced a brand identity prism framework which works on six areas, claiming that "for any brand to succeed, it needs to present a coherent image in the minds of the consumer." According to Kapferer (2000), "all six facets of the brand need to tie in with the central brand essence" (Guide, 2014). "Brand Identity involves many dimensions and any communication originating from the brand; whether it is formal or informal, verbal or non-verbal it should be in sync with its brand identity" (Ponnam, 2007). Figure 3.7 shows how this works by the shape of the sender arrow as a celebrity and a recipient arrow for the fashion consumer.

3.5.6 Maslow's Hierarchy of Needs

Human behaviour and decision-making are motivated by needs. "Marketers use Maslow's 'hierarchy of needs' (Figure 3.8) as a guideline against which to target their marketing efforts . . . there are five stages of need requirements for human beings. Physiological/basic life need, shifting upwards with safety and security, love and belongingness, self-esteem and finally self-actualisation." This model is useful as it can also be applied to any product that an individual feels they need.

For the purpose of this research, the model can be utilised to display a level of choices in fashion. From a practical perspective, a customer driven by Maslow's second needs level requires safety and security, and they may be enticed to buy a new fashion item if the look ties into a style that they like and want to

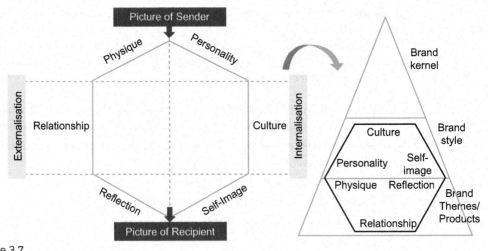

Figure 3.7

Kapferer's Brand Identity Prism Framework (Guide, 2014)

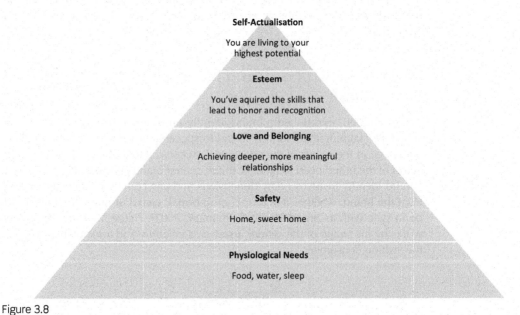

Figure 3.8

Maslow's Hierarchy of Needs (Adapted from Egcoa, 2014)

incorporate as their own. However, someone driven by the need for self-esteem can be seen as looking for recognition and validation. This fashion consumer for example may follow Kim Kardashian (American media personality, socialite, businesswoman) and belong to her reference group. They may be convinced that the outfit and shoes she wears connect with their own self brand and that

Kim Kardashian fashion will elevate their fashion status, making them look good in society and in their own social circles.

For these reasons, the model of Maslow's hierarchy of needs are deficient to use on their own in this investigation. However, Maslow's hierarchy of needs as a model removes the emphasis from product to people and does display a leniency towards human needs and a human motivational approach which is scored on a low to high-level. However, it does not attribute the following:

❑ Fashion consumer needs

❑ What drives fashion

❑ The levels of the celebrity and their fashion choices made by fashion consumers

❑ The grouping of fashion consumers

❑ The fashion categorisation of choices made by fashion consumers

❑ The groups of fashion consumers

❑ How celebrities are best able to connect to fashion consumers

The proposed Human Fashion Brand Model will seek to incorporate how celebrities connect best to the fashion consumer, how they deliver fashion messages, and how with these messages celebrities and marketers convince fashion consumers that they can fulfil needs.

3.5.7 Models of Innovation and Adoption in Fashion

Innovations are usually known as a new concept, idea, practice, or object that is perceived as new by a person or a group. Rogers (1995) defined diffusion as "the process by which an innovation is communicated through certain channels over time among the members of a social system." Rogers (1983) believed that "the individual's decision to adopt or reject an innovation depends on receiver variables, social system variables and perceived characteristics of innovation" (Pashaeypoor et al., 2016).

3.5.7.1 Diffusion of Fashion

Diffusion of fashion means the spread of fashion within and across social systems. There are two aspects of the innovation and adoption theory. The adoption process focuses on individual decision-making, and the diffusion process centres on the decisions of how the masses adopt an innovation. How fast and how far a fashion innovation diffuses is influenced by several factors like mass media communications, personal communications (among adopters and potential adopters), the persuasive influence of consumer leaders, and the degree to which the innovation is communicated and transferred from one social system to another (Rogers, 1983).

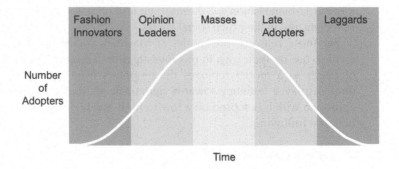

Figure 3.9

Five Types of Consumers Emerge at Each of the Fashion Life Cycle Stages.

3.5.7.2 The Fashion Product and Celebrity Life Cycle

Many factors determine the amount of time that specific trends spend in the fashion cycle; for example, celebrity popularity/likeability, culture, society, and religion. Models such as the fashion product and celebrity life cycle are useful because they show the influence of celebrity fashions on consumers. As celebrities are style leaders and fashion innovators (see Figure 3.9 and Table 3.5), their fashion styles are espoused by a large group of people and are useful. They illustrate the processes of diffusion in the stages of fashion, particularly when displaying how fashions by celebrities are socially diffused and a new style is adopted. These groups imitate the celebrity for group acceptance, adoption, and/or for public and personal admiration of a prevailing style.

3.5.7.3 Stages of the Fashion Life Cycle

Stages of the fashion life cycle can be typically classified in six groupings:

❑ **Fashion Innovators:** Fashion innovators adopt a new product first, which is diffused and adopted by fashion consumers who like the innovative and unique features of the fashion product by a celebrity. Marketing and promotion emphasise the newness and distinctive features of the product in order to make them more visually appealing and enact the desire to buy.

❑ **The Rise:** Fashion opinion leaders' impact upon early adopters who copy the fashion innovations and change/wear the product as a popular style. The product is produced by more companies and sold at retail outlets. Fashion followers will then pick up the style in versions that are cheaper and less extreme.

❑ **Maturity:** At the peak of its popularity, a fashion product is adopted by the masses. There will be a lack of exclusiveness, and, by this time, the fashion opinion leaders will have usually dropped the style.

❑ **The Decline:** Although people are still wearing the style, it has become less interesting due to overexposure. Less style-conscious members of the public

Stage	Cycle Stage Diffusion
Introduction	Adopted by a limited number of persons. The new designs are launched, but at this stage only fashionistas and opinion leaders have heard of it. These few consumers adopt these fashionable products.
Acceptance	Acceptance by a large number. More shoppers become aware of this new trend and want to adopt it to be as fashionable as the opinion leaders.
General Conformity	The new design spreads and to be fashionable at this stage means conforming to others.
Decline in Consumption	Fashion trend declines, fashion shoppers start looking for something new and more exciting, and then the fashion cycle restarts.

Source: Fashion Marketing

Table 3.5 Fashion Evolves Through Four Main Steps

will adopt the style at this stage. These people are known as decline laggards or fashion reactives as they are slow to react to changes in fashion.

❑ *Obsolescence:* The style at this stage is often far removed from the original version.

❑ *Retro:* A style is redeveloped and becomes aged from the generation who originally bought it. This can happen in fashion, music, and media and can be revived. It may take decades for the style to be regenerated because a style never returns in exactly the same way. This is because society and technology have moved on.

The life-cycle curves of basic, fashion, and fad products are pictured in (Figure 3.10) and illustrate the different stages of the fashion cycle:

❑ *Style:* A mode of presentation by a celebrity, with its construction or execution in any art, employment, or product which is distinctive. The style can take some time to be accepted from introduction, rise, and maturity and may decline into obsolescence after a little while.

❑ *Fashion:* Fashion is any style which is popularly accepted and purchased by several successive groups of people over a reasonably long period of time. A style does not become fashionable until it gains some popular use, and it remains fashionable as long as it is accepted.

❑ *A Fad:* The fad has the shortest life cycle normally and does not remain popular as long as a fashion item. It is typically a style that is adopted by a particular subculture or younger demographic group for a short period of time. The fad garment sells very fast in the introduction and rise stages, peaks very quickly, and declines without trace, usually within one season (for example, the poncho/studded footwear and bags).

The fashion life-cycle stage of diffusion (Figure 3.11) is a fashion product life cycle which shows how fashion is a style of the time and how a large number of

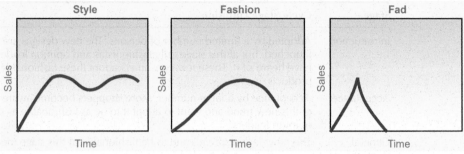

Figure 3.10

Style Fashion and Fad Product Life Cycle

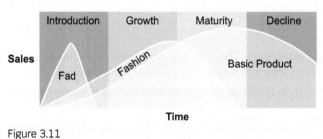

Figure 3.11

Fashion Product Life Cycle

people can adopt a style at a particular time. "Fashions fade, style is eternal," said Yves Saint Laurent (Fashion Beauty News, 2022). When it is no longer adopted by many, the fashion product life cycle ends, and fashion products see a steep decline once they reach their highest sales. An example would be a classic garment which is introduced and will stay permanently in the maturity stage; other examples include the Chanel suit and Ralph Lauren polo shirt.

Basic products like T-shirts and blue denim jeans are classic items that are sold for many years with few style changes. Style obsolescence is not limited to the fields of fashion and apparel; they can also affect other commodities (e.g., cars, music, and architecture).

3.5.7.4 The Fashion Celebrity Life Cycle

"The fashion cycle begins when a particular look emerges and is highly sought after. Usually after a popular celebrity is photographed wearing it. Emulation (imitation), the second phase, begins as the style is adopted by consumers through exposure, magazine covers and the mass media and social media marketing. This then leads to market saturation, the proliferation of low-cost fashion knockoffs in the market, which marks the end of the fashion cycle" (Edwards, 2016). (See Figure 3.12.)

Below are different stages relating to the celebrity product fashion life cycle:

❑ Introduction – Designer launches fashion and works with a celebrity and the celebrity wears it.

❑ Growth and early recognition – The celebrity has worn the fashion and it starts to trend. It is now available in up-market stores, and the consumer will go to great lengths to adopt the style at this stage.

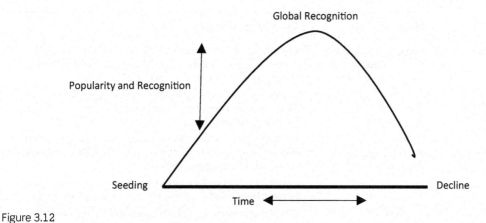

Figure 3.12

Product Life Cycle Applied to a Celebrity's Career

❏ Mass-market adoption and exposure – Global recognition is achieved, and the fashion is now at the height of demand. It is available in high street.

❏ Decline or withdrawal – The style goes out of fashion or circulation.

❏ Resurrection or reinvention of the style – The style will return to the public arena with subtle changes and will be worn and promoted by various celebrities in the entertainment, fashion, and music sectors first.

Figure 3.12 shows a product life cycle applied to the celebrity. Fashion success is determined by greater acceptance from fashion consumers and can be enhanced by a variety of sources including celebrities. This is because they assist in promoting brands and styles and have the influence to make them fashionable, as shown as stages in Table 3.6.

The curves illustrate the innovation of a new product in stages and shows the adoption rates by consumers through the number of sales. However, after closer investigation, the model fails to include the following information:

❏ The needs of fashion consumers

❏ Components of the behaviour of fashion consumers (levels, capability, the position, factors, and need theme levels)

❏ How meanings are transferred from a fashion celebrity to a fashion product and then to the fashion consumer and what these meanings are determined by

This further supports the lack of a coherent model and a need to develop a Human Fashion Brand Model that focuses on the different levels, capability maturity and positioning, and fashion classifications.

Stage	Cycle Stage Diffusion
Introduction/Early Recognition of Celebrity Fashion	Celebrities at their growth stage are becoming more exposed and well known. As they grow in popularity and stature, brand recognition grows with them.
	Examples – Lily Allen (British singer) was picked up by New Look at a very early stage in her career, and Emma Watson (British actress) by Burberry.
Global Recognition Acceptance	When a celebrity has global recognition, an associated brand will also become global. It can develop and enter new and emerging markets.
	Example – Nicole Kidman (Australian actress) was reputed to have been paid £5 million for her Chanel No. 5 adverts.
Decline	The popularity of a celebrity may decline because of fading public interest. This could be due to changes in popularity, public taste or the celebrity choosing to withdraw from the public gaze.
Resurrection and Reinvention	Twiggy (British actress, model, and singer) for Marks and Spencer (M&S).

Cycle stage diffusion of the celebrity fashion lifestyle stages

Table 3.6 The Celebrity Fashion Life-Cycle Stages

3.5.7.5 Summary of Fashion Celebrity and Celebrity Marketer (Industry) Models and Tools

The models and tools described in the first part of this chapter may be used by celebreters (celebrities who market themselves) and by the fashion celebrity marketer (industry). These models describe the relationship between the celebrity and celebrity marketers on consumer behaviour. However, for this book on the analysis of the models and tools, there are notable inefficiencies as they do not make the link connecting the celebrity to the consumer and to the marketer. In Roger's fashion innovation and adoption model, new fashion trends that a celebrity wears are shown by the measurement of time, and the curves will show as either narrow or fuller (see Figure 3.11). They do not highlight what impact celebrity fashion made on the fashion consumer. Celebrities such as Pharrell Williams (American singer, rapper, and fashion designer; see Figure 1.4) can create instant fashion trends even by wearing a simple hat on an album cover. This can be termed as a fad fashion over a short-term period (up to three months). In contrast, singer Amy Winehouse's (Figure 1.5) trademark 60s style, beehive, and flicked eyeliner with tattoos made her instantly recognisable. Amy's impact and influence on popular culture (Jors, 2016) are seen as more than a fad but viewed as a 'total look' and a 'lifestyle' for consumers who aspired to be like her and emulated her in their creation of their personal identity. This type of influence has a longer lasting effect, and it changes fashion identity and behaviours and creates new consumer groups. Amy Winehouse challenged and changed society's stigmas against women wearing tattoos openly to express themselves. This type of celebrity fashion, if examined long term, makes a deeper and longer connection

on the fashion cycle, and it further emphasises the need for this research and a Human Fashion Brand Model that analyses celebrities and their fashions in the context of emulation and their impact on fashion consumer behaviour.

3.6 Conclusion

Chapter 3 introduced the area of investigation in this thesis from the perspective of the celebrity fashion marketer. This chapter provided an analysis of celebrity fashion marketing and theory from a celebrity to marketer perspective and marketer to consumer perspective. It highlighted that the successful implementation/adoption of any new fashion technology and innovation is principally determined by user/consumer attitudes and feelings about the new technology and how those feelings could influence fashion consumers to either adopt or reject the technology. Much of the existing literature analysing celebrity fashion and consumers is based on theoretical findings on celebrity endorsements. These models all have their own relative benefits and limitations. As discussed in earlier sections of the book, there is little published work connecting the emulation of celebrity fashions by fashion consumers. Thus, this conclusion affirms the gap left by previous research efforts and further highlights the need to develop a celebrity fashion classification model that positions the interrelationship of the symbionts. In the next chapter, we will discuss the fashion consumer and its interdependence with the other symbionts.

References

Aaker, J. L. (1997). Dimensions of brand personality. *Journal of Marketing Research, 34*, 347–356.

Agrawal, J., & Kamakura, W. A. (1995). The economic worth of celebrity endorsers: An event study analysis. *Journal of Marketing, 59*(3), 56–62.

Ahluwalia, Rohini, Burnkrant, Robert E., & Unnava, H. R. (2000). Consumer response to negative publicity: The moderating role of commitment. *Journal of Marketing Research, 37*(2), 203–214. doi:10.1509/jmkr.37.2.203.18734

Amos, C., Holmes, G., & Strutton, D. (2008). Exploring the relationship between celebrity endorser effects and advertising effectiveness: A quantitative synthesis of effect size. *International Journal of Advertising, 27*(2), 209–234.

Bahman, M. (2014). *The self.* Retrieved from www.slideshare.net/bmoghimi/consumer-behavior-self-ch05-solomonbook-by-bahman-moghimi

Bailey, R. (2011). Letting children be children: Report of an independent review of the commercialisation and sexualisation of childhood. *The Stationery Office, 8078.*

Banister, E. N., & Hogg, M. K. (2004). Negative symbolic consumption and consumers' drive for self-esteem: The case of the fashion industry. *European Journal of Marketing, 38*(7), 850–868.

Barnes, L., & Lea-Greenwood, G. (2010). Fast fashion in the retail store environment. *International Journal of Retail & Distribution Management, 38*(10), 760–772.

Belleau, B. D., Summers, T. A., Xu, Y., & Pinel, R. (2007). Theory of reasoned action purchase intention of young consumers. *Clothing and Textiles Research Journal, 25*(3), 244–257.

Betz, F., Carayannis, E., Jetter, A., Min, W., Phillips, F., & Shin, D. W. (2016). Modeling an innovation intermediary system within a Helix. *Journal of the Knowledge Economy, 7*(2), 587–599. doi:10.1007/s13132-014-0230-7

Brainy Quote. (2022a). *Coco Chanel: In order to be irreplaceable one must always . . .* Retrieved from brainyquote.com

Brainy Quote. (2022b). *Ralph Lauren: I don't design clothes, I design dreams*. Retrieved from brainyquote.com

Carroll, A. (2009). Brand communications in fashion categories using celebrity endorsement. *Journal of Brand management, 17*(2), 146–158. doi:10.1057/bm. 2008.42

Choi, S. M., Lee, W., & Kim, H. (2005). Lessons from the Rich and famous: A cross-cultural comparison of celebrity endorsement in advertising. *Journal of Advertising, 34*(2), 85–98.

Cope, J., & Maloney, D. (2016). *Fashion promotion in practice*. London: Fairchild Books.

Davis, F. D., Bagozzi, R. P., & Warshaw, P. R. (1989). User acceptance of computer technology: A comparison of two theoretical models. *Management Science, 35*(8), 982–1003.

Duncan, T. R. (2001). *IMC: Using advertising and promotion to build brands with powerweb*. New York: McGraw-Hill.

Edwards, S. M., & La Ferle, C. (2009). Does gender impact the perception of negative information related to celebrity endorsers? *Journal of Promotion Management, 15*(1–2), 22–35. doi:10.1080/10496490902837940

Edwards, T. (2016). *Men in the mirror: Men's fashion, masculinity, and consumer society*. London: Bloomsbury Publishing.

Egcoa. (2014). *Maslow's hierarchy of needs*. Retrieved from http://thefutureofgolf.eu/maslows-hierarchy-needs/

Engle, Y., & Kasser, T. (2005). Why do adolescent girls idolise male celebrities? *Journal of Adolescent Research, 20*(2), 263–283. doi:10.1177/0743558404273117

Erdogan, B. Z. (1999). Celebrity endorsement: A literature review. *Journal of Marketing Management, 15*(4), 291–314. doi:10.1362/026725799784870379

Euromonitor. (2014). *Celebrity power and its influence on global consumer behaviour: Video*. Retrieved from http://blog.euromonitor.com/2014/04/celebrity-power-and-its-influence-on-global-consumer-behaviour.html

Evans, M. (1989). Consumer behaviour towards fashion. *European Journal of Marketing, 23*(7), 7–16.

Fairhurst, A. E., Good, L. K., & Gentry, J. W. (1989). Fashion involvement: An instrument validation procedure. *Clothing and Textiles Research Journal, 7*(3), 10–14.

Fashion Beauty News. (2022). *Fashions fade, style is eternal*. Yves Saint Laurent – Fashion Beauty News.

Fichman, R. G., & Kemerer, C. F. (1999). The illusory diffusion of innovation: An examination of assimilation gaps. *Information Systems Research, 10*(3), 255–275.

Fishbein, M., & Ajzen, I. (1977). Belief, attitude, intention, and behavior: An introduction to theory and research. *Philosophy and Rhetoric, 10*(2).

Fisher, K. (2016). *Liam Hemsworth defends his engagement to Miley Cyrus*. Retrieved from www.eonline.com/news/775539/liam-hemsworth-defends-his-decision-to-get-engaged-to-miley-cyrus-at-a-young-age

Fleck. (2012). Celebrities in advertising: Looking for congruence or likability? *Psychology & Marketing, 29*, 651–662.

Forbes. (2018). *Forbes releases 2018 celebrity 100 list of the world's highest-paid entertainers*. https://www.forbes.com/sites/forbespr/2018/07/16/

forbes-releases-2018-celebrity-100-list-of-the-worlds-highest-paid-entertainers/?sh=5d38def923b5

Fournier, S., & Yao, J. L. (1997). Reviving brand loyalty: A reconceptualization within the framework of consumer-brand relationships. *International Journal of Research in Marketing, 14*(5), 451–472.

Gibson, P. C. (2012). *Fashion and celebrity culture* (vol. 1). London: Berg.

Gobé, M. (2001). *Emotional branding.* Allworth Press. Retrieved from http://marketingpedia.com/Marketing-Library/Quotes/Emotional%20Branding_quotes.pdf

Good Reads. (2022). *Quote by Karl Lagerfeld: 'One is never over-dressed or under-dressed with . . .'* Retrieved from goodreads.com

Greenwood, D. N., & Long, C. R. (2011). Attachment, belongingness needs, and relationship status predict imagined intimacy with media figures. *Communication Research, 38*(2), 278–297. doi:10.1177/0093650210362687

Guide, B. M. (2014). *The brand prism as part of brand identity.* https://brandmanager guide.wordpress.com/2014/11/24/the-brand-prism-as-part-of-brand-identity/

Hancock, J. (2009). *Brand story: Ralph, Vera, Johnny, Billy, and other adventures in fashion branding.* New York: Fairchild Books.

Hoekman, M. L. L., & Bosmans, A. M. M. (2010). *Celebrity endorsement. How Does Celebrity Endorsement Influence The Attitude towards The Brand and How Does Negative Publicity Affect This Relationship.*

Hoekman, M., & Bosmans, A. (2016). *Celebrity endorsement* (International Business Administration). Tilburg University.

Ilicic, J., & Webster, C. M. (2014). Eclipsing: When celebrities overshadow the brand. *Psychology & Marketing, 31*(11), 1040–1050. doi:10.1002/mar.20751

Jan Alsem, K., & Kostelijk, E. (2008). Identity based marketing: a new balanced marketing paradigm. *European Journal of Marketing, 42*(9/10), 907–914.

Joerges, B. (1988). Technology in everyday life: Conceptual queries. *Journal for the Theory of Social Behaviour, 18*(2), 219–237. doi:10.1111/j.1468-5914.1988. tb00124.x

Jors, B. (2016). *The influence of amy winehouse.* Retrieved from https://burrunjor. com/2015/03/22/the-influence-of-amy-winehouse/.

Journalpsyche. (2016). *Revisiting Carl Rogers theory of personality.* Retrieved from http://journalpsyche.org/revisiting-carl-rogers-theory-of-personality/

Jyothi, K. T., & Rajkumar, C. S. (2005). An empirical study on the effectiveness of celebrity advertisements. *Asia Pacific Business Review, 1*(2), 50–62.

Kaiser, S. B., & Chandler, J. L. (1985). Older consumers' use of media for fashion information. *Journal of Broadcasting & Electronic Media, 29*(2), 201–207.

Kapferer, J. (2000). *Strategic brand management-creating and sustaining brand equity long term.* Kogan Page Publishers.

Kapferer, J.-N. (2008). *The new strategic brand management: Creating and sustaining brand equity.*

Kaur, K., & Singh, M. (2011). Comparative effectiveness of film star and sports celebrity endorsement on purchase decision of consumer durables-An empirical analysis. *International Journal of Marketing and Management Research, 2*(8), 51–67.

Knittel, C. R., & Stango, V. (2009). Shareholder value destruction following the Tiger Woods scandal. *Retrieved on January 5,* 2010.

Kowalczyk, C. M., & Royne, M. B. (2013). The moderating role of celebrity worship on attitudes toward celebrity brand extensions. *Journal of Marketing Theory and Practice, 21*(2), 211–220.

Kurzman, C., Anderson, C., Key, C., Lee, Y. O., Moloney, M., Silver, A., & Van Ryn, M. W. (2007). Celebrity status. *Sociological Theory, 25*(4), 347–367. doi:10.1111/j.1467-9558.2007.00313.x

Le Bon, C. (2015). *Fashion marketing: influencing consumer choice and loyalty with fashion products.* New York, NY: Business Expert Press.

Lea-Greenwood, G. (2012). *Fashion marketing communications.* Somerset, NJ: John Wiley & Sons.

Lee, J. Y. (2015). *The impact of ideal-self congruity with celebrity endorsers on advertising effectiveness: The moderating role of message frame.* Retrieved from https://repositories.lib.utexas.edu/bitstream/handle/2152/31710/LEE-THESIS-2015.pdf?sequence=1

Lockwood, L. (2001). A brand new world: Marc gobe believes brands connect with people on a personal level. *WWD,* 10B.

Lowrey, T. M., Englis, B. G., Shavitt, S., & Solomon, M. R. (2001). Response latency verification of consumption constellations: Implications for advertising strategy. *Journal of Advertising, 30*(1), 29–39.

Malik, A., & Sudhakar, B. D. (2014). Brand positioning through celebrity endorsement: A review contribution to brand literature. *International Review of Management and Marketing, 4*(4), 259–275.

Manross, G. G., & Rice, R. E. (1986). Don't hang up: Organizational diffusion of the intelligent telephone. *Information & Management, 10*(3), 161–175.

Marketing-School.org. (2016). *Celebrity marketing.* Retrieved from www.marketing-schools.org/types-of-marketing/celebrity-marketing.html

Marc Jacobs Advertisement. (2022). *Clothes mean nothing until someone lives in them: Marc Jacobs.* YouTube.

Marshall. (2006). *The celebrity culture reader.* New York, NY; London: Routledge.

McCracken, G. (1989). Who is the celebrity endorser? cultural foundations of the endorsement process. *Journal of Consumer Research, 16*(3), 310–321.

Meyers, E. (2009). 'Can you handle my truth?': Authenticity and the celebrity star image. *The Journal of Popular Culture, 42*(5), 890–907.

Mind Zip. (2022). *I make a lot of money and I'm worth every cent. by Naomi Campbell MindZip.*

Mintel. (2016). *Teens and tweens technology usage UK July 2016.*

Misani, N., & Capello, P. V. (2017). The recent evolution of fashion. In *Fashion collections: Product development & merchandising.* Bocconcini University Press.

Mishra, A. S., Roy, S., & Bailey, A. A. (2015). Exploring brand personality-celebrity endorser personality congruence in celebrity endorsements in the Indian context. *Psychology & Marketing, 32*(12), 1158–1174. doi:10.1002/mar.20846

Molas-Gallart, J. (1997). Which way to go? Defence technology and the diversity of 'dual-use' technology transfer. *Research Policy, 26*(3), 367–385. doi:10.1016/S0048-7333(97)00023-1

Mukherjee, D. (2009). *Impact of celebrity endorsements on brand image.* Retrieved from http://www.slideshare.net/brandsynapse/impact-of-celebrity-endorsement-on-brand-image

Niinimäki, K. (2010). Eco-clothing, consumer identity and ideology. *Sustainable Development, 18*(3), 150–162. doi:10.1002/sd.455

Noar, S. M., Willoughby, J. F., Myrick, J. G., & Brown, J. (2014). Public figure announcements about cancer and opportunities for cancer communication: a review and research agenda. *Health Communication, 29*(5), 445–461. doi:10.1080/10410236.2013.764781

O'Cass, A. (2004). Fashion clothing consumption: Antecedents and consequences of fashion clothing involvement. *European Journal of Marketing, 38*(7), 869–882.

O'Mahony, S., & Meenaghan, T. (1997). The impact of celebrity endorsements on consumers. *Irish Marketing Review, 10*(2), 15.

Okonkwo, U. (2007). *Luxury fashion branding: trends, tactics, techniques*. Basingstoke: Palgrave Macmillan.

Pantano, E., & Di Pietro, L. (2012). Understanding consumer's acceptance of technology-based innovations in retailing. *Journal of Technology Management & Innovation, 7*(4), 1–19.

Pashaeypoor, S., Ashktorab, T., Rassouli, M., & Alavi-Majd, H. (2016). Predicting the adoption of evidence-based practice using 'Rogers diffusion of innovation model'. *Contemporary Nurse, 52*(1), 85–10. doi:10.1080/10376178.2016.1188019

Perteh. (2022). *I've always thought of accessories as the exclamation point of a woman's outfit*. Perteh.

Ponnam, A. (2007). Comprehending the strategic brand building framework of kingfisher in the context of brand identity prism. *The Icfai Journal of Brand Management, 4*(4), 63–71.

Pringle, H. (2004). *Celebrity sells*. Chichester: Wiley.

Property, W. I. (2013). Brands – Reputation and image in the global marketplace. *WIPO Economics & Statistics Series*. Retrieved from www.wipo.int/edocs/pubdocs/en/intproperty/944/wipo_pub_944_2013.pdf

Randazzo, S. (1992). The power of mythology helps brands to endure. *Marketing News, 26*(20), 16.

Rawtani, K. J. (2010). *Celebrity endorsements and brand building*. MBA.

Rogers, E. M. (1983). *Diffusion of innovations* (vol. 3). New York, NY; London: Free Press.

Rogers, E. M. (1995). Diffusion of innovations. *New York*, 12.

Rook, D. W. (1985). The ritual dimension of consumer behavior. *Journal of Consumer Research*, 251–264.

ahin, D. Y., & Atik, D. (2013). Celebrity influences on young consumers: Guiding the way to the ideal self. *Izmir Review of Social Sciences, 1*(1).

Sharma, S., & Singh, R. (2014). Celebrity brand endorsement in India. *International Journal of Applied Services Marketing Perspectives, 3*(4), 1385.

Sheth, J. N., Mittal, B., & Newman, B. I. (1999). *Consumer behavior and beyond*. New York: Harcourt Brace.

Simmel, G. (1957). Fashion. *American Journal of Sociology*, 541–558.

Sirgy, M. J. (1982). Self-concept in consumer behavior: A critical review. *Journal of Consumer Research*, 287–300.

Solomon, M. R., Bamossy, G. J., & Askegaard, S. e. (1999). *Consumer behaviour: A European perspective*. New York, NY; London: Prentice Hall Europe.

Solomon, M. R., & Rabolt, N. J. (2009). *Consumer behavior: In fashion*. Upper Saddle River, N.J: Pearson/Prentice Hall.

Thwaites, D., Lowe, B., Monkhouse, L. L., & Barnes, B. R. (2012). The impact of negative publicity on celebrity ad endorsements. *Psychology & Marketing, 29*(9), 663–673.

Till, B. D., & Shimp, T. A. (1998). Endorsers in advertising: The case of negative celebrity information. *Journal of Advertising, 27*(1), 67–82.

Tripp, C., Jensen, T. D., & Carlson, L. (1994). The effects of multiple product endorsements by celebrities on consumers' attitudes and intentions. *Journal of Consumer Research, 20*(4), 535–547. doi:10.2307/2489757

Turnbull, P. W., & Meenaghan, A. (1980). Diffusion of innovation and opinion leadership. *European Journal of Marketing, 14*(1), 3–33.

Um, N.-H., & Lee, W.-N. (2015). Does culture influence how consumers process negative celebrity information? Impact of culture in evaluation of negative celebrity information. *Asian Journal of Communication, 25*(3), 327–347. doi:10.1080/01292986.2014.955860

Vincent, L. (2012). *Brand real: How smart companies live their brand promise and inspire fierce customer loyalty* (vol. 1). New York, NY: American Management Association.

Vogue. (2022). *'Fashion is like eating. You shouldn't stick to the same menu' – Kenzo Takada*. Retrieved from https://www.vogue.pt/english-version-accessories-special-quote-issue

Wigley, S. M. (2015). An examination of contemporary celebrity endorsement in fashion. *International Journal of Costume and Fashion, 15*(2), 1–17.

Wow Report. (2022). *#QueerQuote: 'The ultimate customer is stylish, not fashionable. To be fashionable all you need is money.'* Retrieved from worldofwonder.net

Wu, F. (2015). The influence of non-mainstream culture on the aesthetic judgement of fashion trends. *Research Journal of Textile and Apparel, 19*(2), 42–47.

Chapter 4

The Fashion Consumer

4.0 Introduction

Chapter 4

The Fashion Consumer

4.0 Introduction

Celebrity brands can forge powerful bonds with their customers as explained in Chapters 2 and 3. This is because fashion marketers seek to present products to fashion consumers in ways that appeal to their idealized and desirable lifestyles. This chapter will investigate the role of the fashion consumer and provide an overview of how celebrity fashions are created, adopted, and diffused throughout society, as well as how it impacts consumers. It will explore how "consumer reactions to endorsed brands are affected by their evaluations of the advertising and their feeling about the celebrity themselves" (Vignali & Vignali, 2009).

Social critics such as Theodor Adorno and Max Horkheimer suggest that the lifestyles of celebrities are part of the larger 'culture industry' and a coercive force that shapes society. They argue that

> the celebrity image is the centre of false value that works to deceive audiences into equating real life with the movies or other media culture industry fabrications . . . they are not a real person, but merely a commodity, an image without substance, used to control the consciousnesses of a malleable public and elevated to celebrity status by society.
>
> (Meyers, 2009)

This is because the media glamourises celebrities and promotes their fashions and bodies. Product/fashion choices are often motivated by a desire to identify with a particular idealised lifestyle (Englis & Solomon, 1995). Thus, an examination of how and why celebrity fashions and their images generate social meaning and their significance offers new ways of understanding the cultural power of media in contemporary western culture (Rojek, 2001).

"Successful celebrity fashion in commercial terms is based on providing what customers want" (Lea-Greenwood, 2012). Individuals prefer to buy fashionable products such as clothing, more for what they mean than for their literal utility "such that they use fashion to communicate their individual identity" (Le Bon, 2015) and their clothing is used to make a statement (usually regarding some characteristic of the wearer). Donatella Versace once

DOI: 10.4324/9781003175360-4

said, "What is comfortable fashion? To be comfortable – that can't be in the vocabulary of fashion. If you want to be comfortable, stay home in your pyjamas" (Quote Fancy, 2022a). Furthermore, for marketers to run a successful celebrity campaign, they need information on fashion consumers to better understand why individuals feel the need to have celebrities in their lives and their fashions.

Discussion:

What do the fashion choices of your friends and family reveal to you? How do you value their fashion? And what statement does their fashion make to others?

What governs your choice of fashion?

Which celebrities influence your fashion choices and why? How do celebrity fashions impact your behaviour?

Which brands influence your fashion choices and why? How do brands impact your behaviour?

Do you have a particular brand that you had an affiliation with as a teenager that you still use today? If so, what is it, and why do you think you still use it?

4.1 Consumer Assignment of Meaning and Possessions

A definition of fashion can be described as "a popular or the latest style of clothing, hair, decoration, or behaviour" (Oxford Dictionary of English, 2005). Fashion is a way in which people like to display their clothes as possessions but to also confirm their identity to others and themselves. Oscar de la Renta said, "Fashion is about dressing according to what's fashionable. Style is more about being yourself" (Kaityg, 2022). For a dress to function as a means of communication, individuals need to assign meaning to that dress. What meanings are tied to what aspects of dress are learned over the individual's lifetime and are tied to marketing as well as cultural and symbolic attitudes held by personalities (Berg, 2016). People purchase products that they like so they can express themselves through them. Thus, they often define themselves and others in terms of their possessions. These possessions have come to serve as key symbols for personal qualities, attachments, and interests (Belk, 1988; Berg, 2016; Escalas, 2013). "An individual's identity is influenced by the symbolic meanings of his or her own material possessions, and the way in which they

relate to those possessions" (O'Cass, 2004). Anna Wintour said, "Create your own style . . . let it be unique for yourself and yet identifiable for others" (Style Barista, 2014).

4.2 How Is Personality Developed?

It's important to uncover the reasons why a fashion consumer behaves in a particular manner. Their individual choices, actions, style, and behaviours are shaped by their personality and what they have learned throughout their lives. Personality is referred to as "a person's consistent ways of responding to the environment in which they live" (Sheth et al., 1999). Human beings cultivate personalities to build a standard selection of responses to one's given environment, rather than create a new response every time a situation arises. Customer personality is a function of two factors: genetic make-up and environmental conditioning. Thus: Personality = Genetics x Environment

Escalas (2013) stated that "consumers purchase brands in part to construct their self-concepts and, in so doing, form self-brand connections." Below are examples of this concept.

- ❏ "She's got her mother's looks" – This person alludes to the genetic determination of personality.
- ❏ "She has expensive tastes" – This person is referring to the environmental determinants of personality.

"Playing dress-up begins at age 5 and never really ends," said Kate Spade (Must Have Dress, 2018). When a consumer purchases a product, the behaviour of the consumer is determined by the interaction of the buyer's personality and the image they have of the product to be purchased. This is where their personality becomes meaningful for marketers as there is a relationship between the personality of an individual, the image of a celebrity, and the created fashion personality which is acquired over a period of time by the fashion consumer that eventually forms their own personal identity (Richins, 1994).

4.2.1 Personal Characteristics of an Individual

According to Sheth et al. (1999), there are three types of personal characteristics of the individual.

- ❏ **Genetics** – Genetics deal with the hereditary and chemical/biological characteristics of organisms. Moreover, genetic researchers have identified DNA on the behaviour patterns of individuals and their likes.
- ❏ **Biogenics** – Biogenics provides another determinant of needs and consists of the biological characteristics that people possess at birth, such as gender and race.

❑ **Psychogenics** – Psychogenics refers to individual states and traits originating in the brain and includes things such as:

▪ Moods

▪ Emotions

▪ Perceptions

▪ Cognitions and experiences

▪ The need for social conversion and interaction

▪ The need for affection

▪ The need to succeed

▪ The need to feel in control

▪ The need for recreation

▪ The need to express oneself

These entities are psychogenic needs, and a useful investigation would be to analyse how these psychogenic needs influence the individual's decision to purchase a celebrity's fashion.

4.2.2 Psychographics and Values

As members of a large society, individuals tend to share the same cultural values or strongly held beliefs about the way in which the world should be structured. Members of subcultures or smaller groups within the culture also share values and possessions. "Possessions and fashion can also serve a social purpose by reflecting social ties to one's family, community, and/or cultural groups, including brand communities" (Muniz & O'guinn, 2001). Levy and Rook (1999) asserted that "people do not buy products just for what they do, but also for what the product means." Thus, brands can be symbols whose meanings are used to create and define a consumer's self-concept (Escalas & Bettman, 2005). McCracken's model of meaning transfer (section 3.5.4)

> declares that such meaning originates in the culturally constituted world, moving into goods via the fashion system, word of mouth, reference groups, subcultural groups, celebrities, and the media . . . thus, reference group usage of a brand provides meaning via the association's consumers' hold regarding that group.
>
> (Muniz & O'guinn, 2001)

4.2.3 Opinion Leaders and Reference Groups

"Opinion leaders are key members of society that are crucial in disseminating information on the latest fashion trends to the rest of the population" (Weisfeld-Spolter & Thakkar, 2011). They are people who influence the opinions, attitudes, beliefs, motivations, and behaviours of others and are the people in a social network who have the greatest influence on consumers' acknowledgement or adoption of products/services in the diffusion process of technological innovation (Valente and Pumpuang, 2007; Cho et al., 2012).

4.2.4 The Dream Formula

Celebrity reference groups incorporate the use of their public figure likeness for the purpose of selling a product/service. More specifically, the celebrity's overall credibility, attractiveness, and star power are said to attract everyday consumers, making them feel an ideal likelihood to the celebrity, thus leading them to be drawn to the product and towards a final purchase.

A growing area recognised by Barnes et al. (2006) is consumer behaviour in copied celebrity fashion. This is where consumers "take their self, their fantasies/desires, the need to imitate, owning, wearing and/or acquiring replicas of catwalk looks and celebrity fashions." Dubois and Paternault (1995) refer to this as the 'dream formula' where awareness, imagination, and fantasy lead to self-styling purchase. Here, "the pleasures of fantasy and fashion meet celebrity news and images which are strategically tailor made to tease the eyes and are designed to influence the natural human craving of the self to feel beautiful, important and recognised" (Madichie, 2016).

4.2.5 The-Self and Consumption

Most scholars seem to agree that the term 'the-self' denotes the "totality of the individual's thoughts and feelings having reference to himself as an object. Individuals can form themselves not only from their actual self-image – (the person who they are but also from their ideal self-image) – (the person who they wish to be)" (Sirgy, 1982). Self-image congruence models can show how consumers rate themselves to match perceptions, for example, a purchase of their new car can be a symbol of status and to show the amount of money they have.

Table 4.1 shows how, subsequently, we can become like the product we consume. We may describe an object and then that description may match ourselves and our acquired lifestyle (Hamilton, 2010). In the context of fashion, it is when a fashion consumer "purchases products, brands, or services not only for a products' functions but also to express one's personal and social meaning" (Lee, 2015). Manolo Blahnik understood this correlation and was quoted as saying in a magazine, "People tell me that I've saved their marriages. It costs them a fortune in shoes, but it's cheaper than a divorce. So I'm still useful, you see" (Glamour, 2021).

Table 4.1 shows how, subsequently, we can become like the product we consume.

Figure 4.1 is a powerful conform sign image of an advert by marketers. The extended-self is when we consider external objects as being a part of us and can happen on various levels:

❑ Individual-level – with the use of personal possessions, cars, and fashion items
❑ Family level – residence and furnishings
❑ Community – neighbourhood or town where you live
❑ Group/social – celebrities followed or other groups (Bahman, 2014)

Type of Self	Trait of the Individual
The Self Concept	The attitude a person holds towards herself/himself and the beliefs about those attributes.
Self Esteem	The positivity of one's attitude towards oneself. Marketing can alter this by triggering social comparison.
Ideal Self	A person's conception of how she/he would like to be; partially based on elements of one's culture. Example: **"I want to be better"**
Actual Self	A person's realistic appraisal of his/her qualities.
Fantasy	A self-induced shift in consciousness, often focusing on some unattainable or improbable goal; sometimes a fantasy is a way of compensating for a lack of external stimulation or for dissatisfaction with the actual self.
The Looking-Glass Self	The process of imagining the reaction of others towards oneself – **"You think I'm sexy, don't you?"**
Symbolic Self-Completion Theory	The perspective that people who have an incomplete self-definition in some context will compensate by acquiring symbols associated with desired social identity.
Self-Image Congruence Models	Based on the prediction that products/services will be chosen when their attributes match some aspect of the self.

Table 4.1 Types of The-Self and the Effects on an Individual's Attitude

Figure 4.1

A conform advert showing that marketers want us to become what we consume

4.2.5.1 Consumer Influence by Fashion Celebrities

Consumers are drawn to the glamour in celebrity-connected advertisements. Figure 4.2 is an advertisement that depicts a large poster of Kim Kardashian at the

Figure 4.2

Kim Featured in Calvin Klein Advertisement

beach modelling Calvin Klein bikini beach wear in a mall (American celebrity famed for reality TV, social media, and fashion design) for Calvin Klein. Kim Kardashian is the focal point and is used to draw consumers towards the brand where the advertiser's message is intended to manipulate consumers. Consumers are influenced by the style, shape, and colour of a product as well as by the choice of a celebrity used by a magazine or brand. These judgements are affected by, and often reflect, the way a society feels that people should define themselves. Coco Chanel said, "Dress shabbily and they remember the dress; dress impeccably and they notice the woman" (Town & Country, 2021).

From an everyday perspective, a customer driven by Maslow's second needs level – safety and security (see section 3.5.6) – might be enticed to buy a new fashion item or a look and style that they like. Someone driven by the need for self-esteem, in needs level four, is looking for recognition and validation. This consumer follows a particular celebrity avidly and belongs to their reference group. They are convinced that a particular celebrity's outfit and shoes (e.g., Kim Kardashian, American media personality, socialite, and businesswoman) will elevate their fashion status and make them look good in society and their social circles. This book aims to investigate how celebrities connect best to fashion consumers in Kardashian a meaningful way and how they convince them that they can fulfil their needs (Chapter 5).

The top three stages of the Maslow's hierarchy of needs (see section 3.5.6) are social needs, esteem needs, and the self-actualisation/meaningful needs. We will analyse the symbionts (the fashion celebrity, fashion celebrity marketer, and fashion consumer behaviour) using these stages because they are useful as a way of understanding the psychological link between the individual's self in the context of the symbolic value of the goods they purchase and their behaviour in the marketplace. This analysis allows us to understand that there are factors beyond personality that extend to the critical element of how the individuals perceive themselves in their emulation of fashion celebrities. This provides meaning for the association of the celebrity. The self evolves through the process of social experience (Grubb & Grathwohl, 1967).

These factors are useful when analysing the effect of the celebrity and his or her fashion impact on consumer attitudes as a consequence of multiple product endorsements. These concepts introduce new questions concerning our understanding of how consumers respond to celebrities (Tripp et al., 1994), and thus we investigate questions such as what "kind of person the consumer perceives they will be if they wear a celebrity fashion outfit and who is responsible for specifying the meaning, aim and self-image of the brand" (Kapferer, 2008).

4.2.5.2 Celebrity Consumer Pre-Purchase Cost and Decision Making

In Chapter 5, we will present a model which highlights entities as factors, sub-factors, and need-theme levels of celebrities and celebrity fashion products which are bought and consumed not just for their physical function but also for social benefits. For the user, these benefits can be social and emotional values and include sensory enjoyment, attainment of desired mood states, and achievement of social goals (e.g., social status or acceptance by one's reference groups).

❏ **Social Value** – This exists when products come to be associated with positively perceived social groups. Consumers driven by social value choose products that convey an image congruent with the norms of their friends and associates or that convey the social image they wish to project and be like.

❏ **Emotional Value** – Most experiential consumption offers emotional value. Experiential consumption represents pleasure but also the status of an individual's acquired choice of lifestyle. This occurs when products and activities offer desired emotions and arouse and satisfy emotions or enhance confidence from wearing the same fashion trends as a favourite celebrity. These emotions are often positive and enjoyable; for example, wearing a particular style which is celebrity-endorsed. Vera Wang said, "A woman is never sexier than when she is comfortable in her clothes" (Maxfield, 2015). Consequently, the meaning and value of a brand are not just connected to its ability to express the self, but also to its role in helping consumers create and build their self-identities and lifestyles (J. E. Escalas & Bettman, 2005; McCracken, 1989; Muniz & O'guinn, 2001).

Understanding how consumers make decisions is important for fashion celebrity marketers so they can ensure that their advertising message targets the right consumer groups and influences their purchase decisions. These individuals are aged under 30; 50% of those individuals are under 25 and five times more likely than the average adult to buy products from companies who sponsor TV programmes (Powell, 2015). A sense of looking good, standing out, and having fun are key for this celebrity-influenced group. Sponsorship is another means of reaching these celebrity-influenced individuals (Powell, 2015).

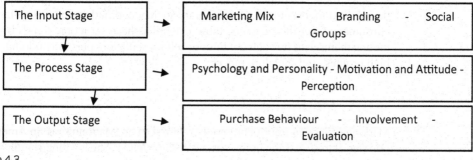

Figure 4.3

The Three Influential Levels of the Consumer Decision-Making Process (Okonkwo, 2007)

4.2.5.3 Summary and Link

"Celebrities are aspirational examples [who] can offer more ordinary people a useful role model" (Pringle, 2004). Fashion consumers look towards the media which is saturated by images of celebrity styles and brands that carry an enormous appeal, and these items encourage individuals to aspire to be like their favourite celebrities. Given that celebrities and their values are understood to be a powerful force in terms of influencing consumer behaviour (Lynch & De Chernatony, 2004), it seems appropriate to consider the celebrity as a human fashion brand, because they influence identity and how consumers perceive a brand proposition (Ross & Harradine, 2011). Such a model helps marketers take into consideration the needs and choices of fashion consumers when they shop. This is because consumers are seeking benefits through what they are buying. The factors and need levels vary among groups of consumers but may include the following:

- ❑ "Looking cool"
- ❑ "Feeling special"
- ❑ "Fitting in"

These factors are useful for those wanting to gain a deeper understanding of why consumers emulate celebrity fashions (Chapters 1, 2, and 3). It is, however, a difficult task to trace consumer behaviour in terms of celebrity influences, motivation, and lifestyle in the literature. The authors will draw on their extensive research on the consumer as well as their industry experience as they attempt to build on theory and develop a 'Human Fashion Brand Model' (Chapter 5).

4.3 Case Study Analysis – Iconic Celebrity Trendsetters

This section highlights the relationship between fashion and celebrities by giving examples of celebrities who have been labelled "iconic" because of their fashions. These celebrities have shaped and made significant changes to fashion, design, and innovation in contemporary society and had an impact on fashion consumers. Over their careers, these celebrities have set iconic trends by promoting themselves through continuous self-presentation, persona building, their high profiles, and signature pieces.

4.3.1 Madonna

Madonna Ciccone (more commonly referred to as 'Madonna') is an American pop star, actress, fashion innovator, and fashion leader. She is a long-standing cultural icon who has had an enormous global influence on fashion style and looks by inventing and reinventing herself. Since becoming famous in the mid-1980s,

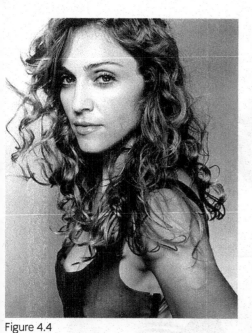

Figure 4.4

Madonna at 50 Years Old

Madonna has used clothes as a cultural signifier to communicate her persona du jour (Blanco, 2014) to fans, fashion critics, designers, and scholars. Obsessed with self-creativity, Madonna has offered new versions of herself over the years from virgin queen to sexual provocateur. "This narcissistic self-invention of the famous depends upon short term, fluid and mobile constructions of identity and constructions of selfhood that can be adopted" (Elliott, 2003).

As a celebrity, Madonna has mastered the ability to regularly transform her look. Her styles have encompassed everything from punk to androgynous, S&M (sadism and masochism), Hip-Hop, geisha, western, and military, to name only a few. Considered an icon of popular culture (Webber-Hanchett, 2017), Madonna pioneered an image in the 1980s showcasing elaborate hair, rara skirts, navel-baring fashions, underwear as outerwear, leggings, leg warmers, overstated necklaces, loud eye make-up, classic red lips, coiffured bleach-blonde hair, and thick eyebrows (Anon, 2016). These styles have affected the clothing choices of both the public at large and of other celebrities. Influences from her 80s look can be seen on the high streets today where stores like H&M, Topshop, and Zara have fashion products highly influenced by that era. It has been argued that Madonna reflects the ephemeral nature of fashion and the redefinition of femininity. Her styles are watched by millions and followed on MTV and numerous fashion-magazine covers, and they are a fixture at runway shows around the world. Madonna herself has worn haute couture, supported both known and unknown designers, and marketed mainstream fashions. The ubiquity of her unique and highly individual style makes Madonna an icon of modern fashion (Webber-Hanchett, 2017).

4.3.2 Run DMC – Hip-Hop Casual Fashion

Marlon Brando (American actor and 50s icon) transformed T-shirts, which were previously considered a male undergarment, into acceptable outer garments. His example led to the introduction of many types of casual attire and inspired generations of men to break down cultural norms and barriers and emulate his casual style of dress (Wolf, 2015). These casual trends spread into the 1970s in all areas, especially when Hip-Hop evolved into a truly multifaceted phenomenon. Hip-Hop at the time was perceived as an expression of the South Bronx with origins in the disenfranchised communities which first birthed the genre. Soon it would become the defining symbol of popular culture worldwide. This introduction of Hip-Hop on the blocks of Harlem, USA, saw a new mode of music and dress. Bronx styles reflected the current trends in Hip-Hop at the time – including baggy jeans, oversized T-shirts, sport jerseys, hoodies, and tracksuits. Run-DMC (Figure 4.5a and b) introduced Hip-Hop into the fashion

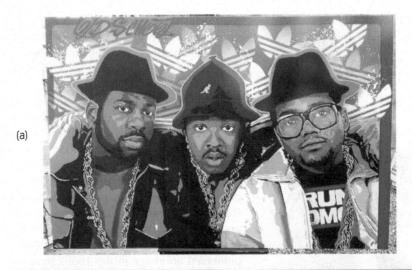

(a)

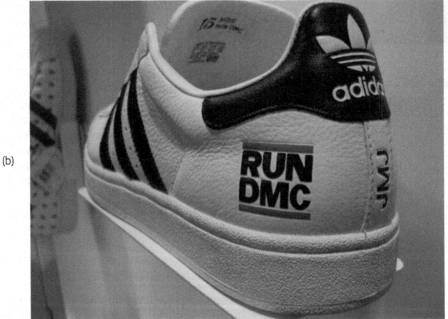

(b)

Figures 4.5a and 4.5b

Run-DMC and Influence on Fashion

world when the commercially successful group brought the music's athletic style to the mainstream and helped define the future of casual fashion.

Hip-Hop clothing brands emerged in the 1990s in response to a growing acknowledgement among its artists that fashion was an important part of the culture. The brands possessed aspirational connotations by their association with Hip-Hop celebrities who had reached levels of unprecedented success

with a new sound and style (Lewis & Gray, 2013). Consumers embraced aspi-rational fashion which provided a sense of escape – much the same way the music did.

These definitive street styles started to appeal to middle-class youth and, as a consequence, to mainstream brands and labels like Adidas and Nike, who formed relationships with rappers to exploit their commercial potential and the Hip-Hop consumer. These rappers, DJs, and other evangelists of the movement went on to attain spectacular wealth, and their clothing took on an additional symbolic status. This created even more diversity in the scene and – for the early-adopting retailers – massive profits (Smith-Strickland, 2016).

Today, this music has grown into a billion-pound industry where Hip-Hop artists have become some of the biggest commercial influencers and work with leading brands and luxury houses. Consumption of luxury brands like Gucci, Fendi, Louis Vuitton, and Prada were not new to Hip-Hop artists. However, the idea of creating brands specifically for Hip-Hop consumers was a new idea.

Furthermore, Hip-Hop fashion continued to challenge societal dress codes by adopting a more sophisticated, tailored look that contrasted with its urban roots but signified the entrepreneurial success of some of Hip-Hop's iconic celebrities (Lewis & Gray, 2013; Wolf, 2015). This has now created multi-million-pound pioneering brands like Rocawear with Jay-Z (American rapper and record execu-tive) and Sean John for Puff Daddy/Puffy/P. Diddy/ Diddy (American rapper, pro-ducer, and record executive; Lewis & Gray, 2013).

In this way, both Hip-Hop and fashion became a comfort for fans and fash-ion consumers amid the harsh realities of life. Even if they couldn't afford a mansion, private jet, or a Bugatti [car], they could still have a piece of that luxury from the inspired clothing (merch) or by living vicariously through their favourite rapper's music. "Hip-Hop was one of the first music genres that was born of the common working-class person. With any other genre of music there was potentially a costume or some sort of uniform that separated the enter-tainer from the average person. Hip-Hop was the genre of music where it was accepted, promoted, and preferred that the artist looked like the fan" (Smith-Strickland, 2016).

Encouraging the fan to be like the celebrity is useful to marketers, producers, and designers in their investigations, as they are able to analyse the motivations, desires, values, behaviours, and emotions of consumers who purchase celebrity-inspired fashions and the impact on their consumer-self and personal appear-ance. Lewis and Gray (2013) argue that Hip-Hop is a powerful mix of influences, especially because its clothing allows for the interaction of two theories of fash-ion diffusion: both trickle down and trickle up (see section 2.3.1). The trickle-down, or upper-class, theory of fashion leadership proposes that new styles are adopted or started by groups in higher social classes and these styles are later adopted by those in the lower social classes and the trickle up the opposite.

4.3.3 Audrey Hepburn

Audrey Hepburn was one of Hollywood's most stylish and enduring icons, and she has embodied an ideal of femininity for generations of women. Audrey

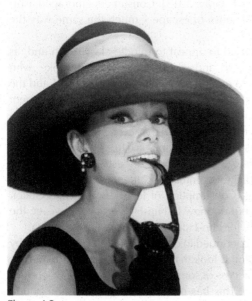

Figure 4.6

Audrey Hepburn

Hepburn's appeal to a female audience grew from the creation and circulation of her image that was constructed from the sum of information available on the star, including film roles, stills, gossip, press, publicity, and her personal life (Moseley, 2002). She became an inspirational style icon, and her unforgettable face in movies propelled designers and their styles into the limelight for many years (Werle, 2009). Givenchy's most widely recognised iconic design for Hepburn was the little black dress worn by the British actress in the 1961 romantic comedy *Breakfast at Tiffany's*. In the famous opening scene of Blake Edwards' movie, Hepburn's character, Holly Golightly, is filmed getting out of a yellow cab in a long black satin dress and with a coffee and croissant in hand while observing the luxury jewellery store. Considered one of the most influential dresses in the history of 20th century clothing and costume design, Givenchy's black cocktail-style frock was the most modern interpretation of the little black dress (Cavallo, 2022).

As a major fashion influencer, her portrayal of Holly Golightly in the film *Breakfast at Tiffany's* popularised straight, black-cropped pants; boatneck tops; and comfortable, slip-on loafers (Bazaar, 2015). Throughout her acting career, Audrey Hepburn captivated her audience with her understated sense of style and courage. She was one of the first celebrities to wear the 'mini' style, also known as the Chelsea look, which was credited to Mary Quant (Brainy Quote, 2022b). The controversial fashion trend of the mini "took off because it was so different and to wear it well you had to be youthful to get away with an outfit that was so controversial, particularly among adults" (Thomas, 2016).

4.3.4 David Beckham – Brand It Like Beckham, Icon of Outerwear, Underwear, and Hair

David Beckham (British, former professional footballer) has become an immortal figure in the world of sports, and he also is a style icon appearing in fashion campaigns and launching clothing all over the world.

> The quintessential modern man, his fame far exceeding that of a sportsman . . . from his 1995 debut for Manchester United, his career went from strength to strength, his on-field brilliance matched only by his soaring marketing appeal in a sport that massively commercialised in the 1990s.
>
> (Vincent et al., 2009)

David Beckham projects qualities such as global popular appeal, recognition, credibility, overall fitness, physical attractiveness, trustworthiness, expertise, and

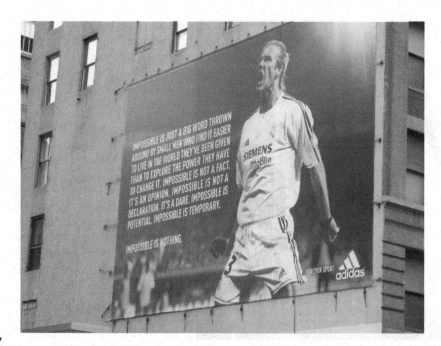

Figure 4.7

David Beckham for Adidas

a lucrative cultural meaning transfer which match what companies look for in athletes who endorse their products and services (Till & Busler, 2000). Together with his wife, Victoria, they have their own 'dVb' (David and Victoria Beckham) brand label (Cashmore & Parker, 2003).

David is recognised as a universal icon – an icon of modern masculinity who attracts international corporations. Marketers like to feature David on sports endorsements, as fans equate the image of the athlete with their products and services (Stone et al., 2003). A Beckham endorsement will add significant value to their products and services. As a consequence, his brand image extends far beyond the sports arena into multiple areas, with each representing a profit centre for exploitation. He is, in effect, not one brand, but an entire portfolio of brands, each representing a part of the chameleon-brand that is David Beckham (Vincent, 2012).

4.3.5 Catherine, Princess of Wales

When his father ascended the throne as Charles III in 2022, William was named Prince of Wales, and Catherine became the Princess of Wales. Catherine became an ambassador of British fashion overnight and was seen as an icon for many females. Fashion designers try to regularly recreate the designs she wears and produce replicas (Barnes et al., 2013). The "Kate effect" became quickly

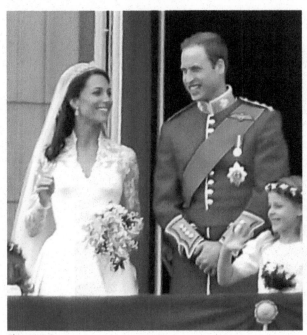

Figure 4.8

Royal Wedding of William and Catherine, Prince and Princess of Wales

apparent as the royal blue Issa dress Kate wore to announce her engagement subsequently sold out within hours. Her wedding dress, designed by Sarah Burton and Alexander McQueen, also gained much attention (Figure 4.8).

4.4 Conclusion

In summary, this chapter analysed the fashion consumer and illustrated how important it is to recognise the influence celebrity fashion choices have on consumer behaviours. We live in a world where society and individuals create their own meaning for products, symbols, and possessions by accepting or rejecting the social values embodied by celebrity images we see in the media (Meyers, 2009). This chapter analysed how the consumer fashion-self plays an important role when an individual purchases fashion products – in particular, celebrity-inspired fashions. Thus, Chapters 2, 3, and 4 provided an analysis of the extensive literature that reviews three key facets (symbionts): the fashion celebrity, the fashion celebrity marketer, and the fashion celebrity consumer. Knowledge of these groups and how they impact celebrity fashion, social influences, clothing, identity, meaning, culture, social media, purchasing, and consumer behaviour will have important implications for retailers and marketers alike.

It is important to understand how these facets/symbionts and fashion celebrity branding and endorsement work and to identify the decisive factors in their effectiveness (Fleck, 2012; N. Fleck et al., 2012). The Human Fashion Brand Model will be presented in Chapter 5 as a positioning tool which considers the prevalent fashion impact of celebrities on the fashion clothing choices of consumers that choose to follow and imitate them.

References

Anon. (2016). *What do you think of, when you think of Madonna?* Retrieved from www.fancydressball.co.uk/fancy-dress-ideas/august/madonnas-birthday-fancy-dress-ideas/

Bahman, M. (2014). *The self.* Retrieved from www.slideshare.net/bmoghimi/consumer-behavior-self-ch05-solomonbook-by-bahman-moghimi

Barnes, L., Lea-Greenwood, G., Bruce, M., & Daly, L. (2006). Buyer behaviour for fast fashion. *Journal of Fashion Marketing and Management: An International Journal, 10*(3), 329–344.

Barnes, L., Lea-Greenwood, G., & Miller, K. (2013). Hedonic customer responses to fast fashion and replicas. *Journal of Fashion Marketing and Management: An International Journal, 17*(2), 160–174.

Bazaar, H. (2015). *Women who changed fashion: The style icons.* Retrieved from www.harpersbazaar.com/culture/features/g6476/style-icons-who-changed-fashion/

Belk, R. W. (1988). Possessions and the extended self. *Journal of Consumer Research, 15*(2), 139–168.

Berg, F. L. (2016). *The social psychology of dress.* Bloombsbury. Retrieved 22 September 2016, from www.bergfashionlibrary.com/page/The$0020Social$0020Psychology$0020of$0020Dress/the-social-psychology-of-dress

Blanco F, J. (2014). How to fashion an archetype: Madonna as anima figure. *The Journal of Popular Culture, 47*(6), 1153–1166. doi:10.1111/jpcu.12203

Brainy Quote. (2022a). *Gianni Versace – That is the key of this collection, being . . .* Retrieved from brainyquote.com

Brainy Quote. (2002b). *Mary Quant – The fashionable woman wears clothes.* Retrieved from brainyquote.com

Cashmore, E., & Parker, A. (2003). One David Beckham? Celebrity, masculinity, and the soccerati. *Sociology of Sport Journal, 20*(3), 214–231.

Cavallo, A. (2022). *The legacy of Audrey Hepburn's Givenchy little black dress.* Retrieved from https://www.lofficielusa.com/fashion/audrey-hepburn-givenchy-little-black-dress-history

Cho, Y., Hwang, J., & Lee, D. (2012). Identification of effective opinion leaders in the diffusion of technological innovation: A social network approach. *Technological Forecasting and Social Change, 79*(1), 97–106.

Dubois, B., & Paternault, C. (1995). Understanding the world of international luxury brands: the 'dream formula.' (Special issue: Research input into the creative process). *Journal of Advertising research, 35*(4), 69–77.

Elliott, A. (2003). *Celebrity* (vol. 37, pp. 618–619). Cambridge: SAGE Publications.

Englis, B. G., & Solomon, M. R. (1995). To be and not to be: lifestyle imagery, reference groups, and the clustering of America. *Journal of Advertising, 24*(1), 13–28.

Escalas, J. (2013). Self-identity and consumer behavior. *Journal of Consumer Research, 39*(5), xv–xviii. doi:10.1086/669165

Escalas, J. E., & Bettman, J. R. (2005). Self-construal, reference groups, and brand meaning. *Journal of Consumer Research, 32*(3), 378–389.

Fleck. (2012). Celebrities in advertising: Looking for congruence or likability? *Psychology & Marketing, 29,* 651–662.

Fleck, N., Korchia, M., & Le Roy, I. (2012). Celebrities in advertising: Looking for congruence or likability? *Psychology & Marketing, 29*(9), 651–662. doi:10.1002/mar.20551

Glamour. (2021). *26 best fashion quotes of all time.* Glamour UK. Retrieved from glamourmagazine.co.uk

Grubb, E. L., & Grathwohl, H. L. (1967). Consumer self-concept, symbolism and market behavior: A theoretical approach. *the Journal of Marketing,* 22–27.

Hamilton. (2010). *The self.* Retrieved from http://k3hamilton.com/cb/cb5.html

Kapferer, J.-N. (2008). *The new strategic brand management: Creating and sustaining brand equity.* London: Kogan Page Publishers.

Kaityg. (2022). *Style.* KG. Retrieved from kaityg.com

Le Bon, C. (2015). *Fashion marketing: Influencing consumer choice and loyalty with fashion products.* New York, NY: Business Expert Press.

Lea-Greenwood, G. (2012). *Fashion marketing communications.* Somerset, NJ: John Wiley & Sons.

Lee, J. Y. (2015). *The impact of ideal self-congruity with celebrity endorsers on advertising effectiveness: The moderating role of message frame* (Doctoral dissertation).

Levy, S. J., & Rook, D. W. (1999). *Brands, consumers, symbols and research: Sidney J Levy on marketing.* Sage Publications.

Lewis, T., & Gray, N. (2013). The maturation of hip-hop's menswear brands: Outfitting the urban consumer. *Fashion Practice: The Journal of Design, Creative Process & the Fashion Industry, 5*(2), 229–244. doi:10.2752/175693813X13705243201531

Lynch, J., & De Chernatony, L. (2004). The power of emotion: Brand communication in business-to-business markets. *Journal of Brand Management, 11*(5), 403–419.

Madichie, N. O. (2016). *Luxury Brands: In non-luxury times. A Review & Commentary.* Retrieved from www.lsbm.ac.uk/assets/pdf/Luxury-Brands-in-Non-Luxury-Times-Madichie.pdf

Maxfield, C. (2015). Retrieved from https://claremaxfield.com.au/a-woman-is-never-sexier-than-when-she-is-comfortable-in-her-clothes/

McCracken, G. (1989). Who is the celebrity endorser? Cultural foundations of the endorsement process. *Journal of Consumer Research, 16*(3), 310–321.

Meyers, E. (2009). 'Can you handle my truth?': authenticity and the celebrity star image. *The Journal of Popular Culture, 42*(5), 890–907.

Moseley, R. (2002). Trousers and tiaras: Audrey Hepburn, a woman's star. *Feminist Review* (71), 37–51.

Muniz, A. M., & O'guinn, T. C. (2001). Brand community. *Journal of Consumer Research, 27*(4), 412–432.

Must Have Dress. (2018). *Playing dress up begins at age 5 & never truly ends – Kate Spade.* Retrieved from musthavedresses.com

O'Cass, A. (2004). Fashion clothing consumption: antecedents and consequences of fashion clothing involvement. *European Journal of Marketing, 38*(7), 869–882.

Okonkwo, U. (2007). *Luxury fashion branding: Trends, tactics, techniques.* Basingstoke: Palgrave Macmillan.

Oxford Dictionary of English (2005) (revised ed.). Oxford: Oxford University Press.

Powell, J. (2015). *The influence of celebrities on consumer decision making.* Retrieved from www.brandrepublic.com/article/1040754/influence-celebrities-consumer-decision-making

Pringle, H. (2004). *Celebrity sells.* Chichester: Wiley.

Richins, M. L. (1994). Valuing things: The public and private meanings of possessions. *Journal of Consumer Research, 21*(3), 504–521.

Rojek, C. (2001). *Celebrity.* London: Reaktion.

Ross, J., & Harradine, R. (2011). Fashion value brands: The relationship between identity and image. *Journal of Fashion Marketing and Management: An International Journal, 15*(3), 306–325. doi:10.1108/13612021111151914

Sheth, J. N., Mittal, B., & Newman, B. I. (1999). *Consumer behavior and beyond.* New York: Harcourt Brace.

Sirgy, M. J. (1982). Self-concept in consumer behavior: A critical review. *Journal of Consumer Research, 9*(3), 287–300.

Smith-Strickland, S. (2016). How rappers took over the world of fashion. *High Snobiety.* Retrieved from www.highsnobiety.com/2016/01/15/hip-hop-fashion-history/

Stone, G., Joseph, M., & Jones, M. (2003). An exploratory study on the use of sports celebrities in advertising: A content analysis. *Sport Marketing Quarterly, 12*(2).

Style Barista. (2014). *Create your own style... let it be unique for yourself and yet identifiable for others – Anna Wintour.* Style Barista.

Thomas, P. W. (2016). *The 60s mini skirt – 1960s fashion history.* Retrieved from www.fashion-era.com/the_1960s_mini.htm

Till, B. D., & Busler, M. (2000). The match-up hypothesis: Physical attractiveness, expertise, and the role of fit on brand attitude, purchase intent and brand beliefs. *Journal of Advertising, 29*(3), 1–13.

Town & Country. (2021). *20 famous fashion quotes 2022 – Quotes from fashion icons*. Retrieved from townandcountrymag.com

Tripp, C., Jensen, T. D., & Carlson, L. (1994). The effects of multiple product endorsements by celebrities on consumers' attitudes and intentions. *Journal of Consumer Research, 20*(4), 535–547. doi:10.2307/2489757

Valente, T. W., & Pumpuang, P. (2007). Identifying opinion leaders to promote behavior change. *Health Education & Behavior, 34*(6), 881–896.

Vignali, G., & Vignali, C. (2009). *Fashion marketing & theory*. UK: Access Press.

Vincent, J., Hill, J. S., & Lee, J. W. (2009). The multiple brand personalities of David Beckham: A case study of the Beckham brand. *Sport Marketing Quarterly, 18*(3), 173.

Vincent, L. (2012). *Brand real: How smart companies live their brand promise and inspire fierce customer loyalty* (vol. 1). New York, NY: American Management Association.

Webber-Hanchett, T. (2017). *Madonna's influence on fashion*. Retrieved from http://fashion-history.lovetoknow.com/fashion-history-eras/madonnas-influence-fashion

Weisfeld-Spolter, S., & Thakkar, M. (2011). Is a designer only as good as a star who wears her clothes? Examining the roles of celebrities as opinion leaders for the diffusion of fashion in the US teen market. *Academy of Marketing Studies Journal, 15*(2), 133–144.

Werle, S. (2009). *Fashionista: A century of style icons*. Munich; London: Prestel.

Wolf, C. (2015). *10 fashion rebels who changed how men dress today*. Retrieved from https://news.yahoo.com/10-fashion-rebels-changed-men-170055722.html

Chapter 5

The Human Fashion Brand Model

5.0 Introduction

Chapters 1 to 4 discussed the literature related to celebrities and their fashions and highlighted that "in addition to relations with family and peers; consumers often form secondary attachments to figures they encounter in the popular media, such as celebrities" (Pringle, 2004). Chapter 1 identified the growth of the fashion celebrity and the need to understand the phenomena in the context of fashion, and it identified a connection among the three symbionts: the fashion celebrity, the fashion celebrity marketer, and the fashion consumer. This chapter presents the results of in-depth investigations of the literature in celebrity fashion marketing and examines the celebrity and his or her effectiveness in endorsing and promoting fashions as a coercive force in shaping the identity of consumers and defining their symbiotic relationship (Chapters 2, 3, and 4). Chapter 5 also examines how the Human Fashion Brand Model was developed, which can be used as an assessment and positioning tool for those studying/working with/ having interest in fashion, celebrities, marketing, media, and business.

Research has been undertaken in consumer behaviour literature using reference groups to study peer group influences on purchase behaviour. However, this book will open a new dialogue about the critical symbiotic relationships and how celebrity fashion culture impacts the lifestyle determinants of fashion consumer groups which in turn impact emulation. The model will show how and why celebrities are seen as fashion trendsetters and how they "elicit certain emotional responses" (Malär et al., 2011). It will show how, through fashion celebrity marketers utilising these fashion celebrities, consumers are able to, in their minds, get closer to the celebrity and view the celebrity as someone in their life. Thus, this model demonstrates how consumers build personal relationships with celebrities and their fashions and how fashion celebrities are an influential source of value to fashion celebrity marketers and fashion consumers.

5.1 Model Definition

To understand what constitutes a 'model,' it is important to first understand the term. A model is, to some extent, a map to reach a final point (De Backre &

DOI: 10.4324/9781003175360-5

Miroudot, 2014). Nilsen (2015) states that a model indicates "a structure, overview, outline, system or plan consisting of various descriptive categories." These definitions are applicable to the development of the Human Fashion Brand Model which will serve as a positioning guide in celebrity fashion marketing.

Bright (2000) claims that marketing has a social side and "individuals and groups obtain what they want and need through creating, offering and exchanging products of value with others." This definition matches the principles of the Human Fashion Brand Model where the fashion celebrities are seen to market themselves socially because they continuously create, update, exchange, and produce fashions. As a consequence of this growth in celebrity fashions, there has been a call for a wider focus model/study. This book will help understand how the stakeholders identified are connected symbiotically (the fashion celebrity, the fashion celebrity marketer, and the celebrity fashion consumers), and how they work together to promote a better understanding of the key issues in the fashion industry, and why consumers are driven to imitate their favourite celebrities.

5.2 The Human Fashion Brand Model Symbionts

Chapters 1, 2, 3, and 4 further affirmed the relationship among the symbionts and why it is important to consider influences that motivate or hinder consumers from adopting celebrity fashions. It's important to understand why people choose to adopt a celebrity-inspired fashion product and how they feel its personality somehow corresponds to their own. A favourable attitude towards the celebrity and his or her fashion trends is a key prerequisite for fashion celebrity marketers. Adopting a particular celebrity fashion product to sell depends on many factors when implementing strategies of diffusion. Celebrity fashion brands ensure values, and the values drive consumer behaviour towards adjusting their individual tastes and updating their fashions. These drivers are seen as a form of stability (for example, economic, safety, physical and social, and quality of life), not only for a product's function but also as an expression of one's personal and social meaning (Lee, 2015). As the exposure to fashions of a celebrity grows, so does their celebrity fashion influence (Lea-Greenwood, 2012) (sections 1.1, 1.2, 2.2, 2.2.1, 3.2.1, 4.1, and 4.2.3). This directly impacts individual consumer attitudes and also enhances their self-image, enabling consumers to feel closer to celebrities and their glamorous lifestyle affiliations. (Pringle, 2004).

We believe that this research addresses a gap in the current field, and the developed model can be used as a positioning guideline to help celebrities, marketers, and others such as academics recognise the interrelationship. There is an increasing need to understand the growth of the role of the celebrity in fashion, media, and advertising as a symbiont and how they can transform products into brands by creating brand characters, experiences, places, and feelings. Celebrities are especially effective when the feelings consumers have of them, validate the emotional or psychological benefits associated with the product (Randazzo, 1992).

Previous models do not measure how a celebrity's fashion impacts consumers. The Human Fashion Brand Model in Chapters 1, 2, 3, and 4 identifies stakeholders (symbionts) based on the discussion and results of the literature reviews, which listed the stakeholders as having a key impact on celebrity fashion marketing communications and celebrity fashion emulation. At the beginning of the research, it was perceived that the fashions of the celebrity would be analysed to understand why fashion consumers needed and adopted celebrity fashions. However, it became increasingly clear from the immense amount of literature that there was a relationship and continuous thread linking the three symbionts that needed to be explored individually before understanding how they worked together. These were then split into literature review chapters (one per symbiont) and further investigated on how they and/or relied on and needed each other.

At the start, it wasn't clear if the model required a graph or table format, or if we needed multiple models, or if the model would have subsections (this concept will be discussed in section 5.4). However, due to the rich data identified in the literature reviews, one thing was certain from the outset: it was important to ensure that the model was clear and explained the different components identified and how they could be applied according to the different levels, factors, and need themes. With this in mind, the final model was projected to synthesise aspects of the key symbionts which would assist in positioning and assessing/quantifying fashion celebrities and fashion companies to better understand their symbiotic relationship in celebrity fashion and their role as a:

❏ **Fashion Celebrity Symbiont** – The fashion celebrity crafts and exploits their (fashion) image (Pringle, 2004) and forges commercial relationships with fashion brands (Euromonitor, 2014) in advertising campaigns for the exposure of the celebrity's fashions to fashion consumers (Lea-Greenwood, 2012; Okonkwo, 2007).

❏ **Celebrity Fashion Marketer Symbiont** – Marketers employ celebrities as fashion personalities to showcase their fashion brands (Carroll, 2009; Thomson, 2006). Their images are disseminated widely with the aim of increasing sales (Tripp et al., 1994). Thus, the consumer is exposed to the fashion celebrity and manipulated by fashion brands to feel a need to imitate the fashion celebrity.

❏ **Celebrity Fashion Consumer Symbiont** – When the consumer follows a celebrity for the purpose of fashion emulation, it can take many forms and is usually done as a consequence of the exposure (Rojek, 2001). Hence,

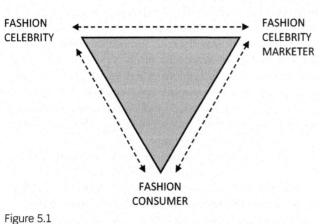

Figure 5.1

Illustration of the Symbiotic Relationship between the Fashion Celebrity, the Fashion Celebrity Marketer, and the Fashion Consumer

the transfer of meaning here consumes two symbionts: first, the fashion celebrity, and second, the fashion celebrity marketer who has worked on a strategy to manufacture and produce imitated fashions which are then diffused and adopted by the celebrity fan-consumer (Lea-Greenwood, 2012).

5.3 Description of the Human Fashion Brand Model

The Human Fashion Brand Model was created based on the critical assessment conducted by the authors and because of the significant growth in the number of fashion celebrities and the growth in celebrity fashion emulation impacting consumer behaviour (Chapter 4). The Human Fashion Brand Model will assimilate the symbionts (the fashion celebrity, fashion celebrity marketers, and celebrity fashion consumers). This assimilation allows a levels arrangement classification of 1 to 5 for the different categories. Each would be dichotomised based on their roles and effects on each other. A template was developed (Figure 5.2) to explain and break down the Human Fashion Brand Model by each symbiont. It describes prominent areas that increase the capability, positioning, rank, the popularity of celebrities in celebrity fashion marketing and they appear on the template with the addition of sub-factors and need theme levels per symbiont category (explained in Figure 5.2).

SYMBIONT CATEGORY						
Fashion Celebrity / Fashion Celebrity Marketers / Fashion Celebrity Consumers						
FACTOR – e.g., Influence / Exposure / Need						
Description	SUB FACTORS Level 1		level 2	level 3	level 4	level 5
	Need Theme Levels Entities under each factor stating key functions, e.g.: - Meaning of celebrity fashion clothing to the consumer (clothing is functional and has a basic meaning). - Celebrity fashion impact on fashion consumer identity (minimal impact or none). - Emotional attachment level (no attachment towards fashion or celebrities). - Consumption level (pays basic prices for their clothing which are not seen as fashionable). - Emulation impact (consumer doesn't want to emulate fashions of celebrities).					
	Examples of celebrities, fashion celebrity brands, and fashion celebrity consumers					

Figure 5.2

Template – Explanation of the Human Fashion Brand Model Terms and Layout

- ❏ **Fashion Celebrity Symbiont** – Category: influence, exposure, and impact, including sub-factors and need theme levels.
- ❏ **Fashion Celebrity Marketer Symbiont** – Category: exposure and endorsement, including sub-factors and need theme levels.
- ❏ **Fashion Celebrity Consumer Symbiont** – Category: needs and identification, including sub-factors and need theme levels.

This initial outline was important in identifying the input required to form a Human Fashion Brand Model. From the critical analysis, it was apparent that several authors had examined the celebrity, but their discussions appeared to be about celebrities and not their fashions and not on the role of marketers and fashion consumers (Chapters 2, 3, and 4). The majority of authors that are mentioned in the literature review, although recognised the role of the fashion celebrities, marketers, and consumers individually did not encompass:

- ❏ A symbiotic relationship between all three stakeholders.
- ❏ The celebrity as a human fashion brand.
- ❏ Research on celebrity fashion emulation.
- ❏ Deliberations on the celebrity that went beyond endorsements.
- ❏ A fashion classification format for the symbionts.
- ❏ A need to capture the experiential experience of celebrities on consumer feelings.

In summary, the models presented in the literature (Chapter 3) are only descriptive, but they do add value to the existing knowledge base. However, it is important to note as stated there is no universally accepted fashion classification model encompassing celebrities, fashions, and brands. In the examination, it became apparent that there were lots of theories that existed in isolation for the symbionts but none that brought them together. The colossal amount of literature allowed for a theory-building approach explained in section 5.5. Therefore, the process the authors took was to assimilate the existing information and combine it with industry experience into the Human Fashion Brand Model.

This need for a Human Fashion Brand Model also stems from the enhanced growth of social media. As lifestyles are changing, consumers are turning to the Internet and smart technology. They are following celebrities on social media throughout the day and watch their programmes to learn how to be stylish and beautiful and for an escape. The advent of globalisation and increase in international travel, digital media, fashion magazines, and intercultural influences have impacted consumers and led to a rise in the number of ways the media have constructed icons. It is important to understand why and how celebrities choose to communicate their fashions through technology (sections 3.1.1, 3.2, 3.2.2, and 3.2.1). It is also important to note that literature about celebrities and fashion does not quantify a clear understanding of the impact of social media on the symbionts. However, the Human Fashion Brand Model does do this and is able to measure its effectiveness for celebrities and marketers.

5.4 The Benefits of the Human Fashion Brand Model

The Human Fashion Brand Model displays the different parameters of the diverse celebrity fashions through factors, sub-factors, and need theme levels (section 5.3 and Figure 5.2). The model also encompasses various details so it can measure and encapsulate the following:

❑ Access information on patterns of why and how fashion consumers follow their favourite fashion celebrities.

❑ Describe the correlation between the symbionts.

❑ Monitor and understand celebrity fashion trends.

❑ Assess why fashion celebrities support and recommend fashion products and brands for fashion consumers to buy.

❑ Analyse fashion consumer behaviour and consumption choices.

❑ Obtain information about celebrities and fashion consumers to target new consumer groups which are not currently available.

❑ Determine what celebrity loyalty means in the context of fashion (how do celebrities maximise loyalty rewards and codes).

❑ Determine how fashion consumers purchase their latest fashion trends and repeat purchases of celebrity-endorsed fashion products and services.

❑ Describe the implementation of chosen fashion celebrities into a fashion consumer's lifestyle.

❑ Gain understanding of the factors that connect celebrities' fashions, fashion celebrity marketers, and fashion celebrity consumers through entities and need theme levels.

❑ Identify the capability and maturity levels of celebrity fashions.

❑ Describe the set of constituents which forms a successful celebrity and fashion campaign for fashion celebrity marketers to target fashion celebrity marketers.

❑ Provide information on celebrity fashions which can be examined by grouping celebrities based on their appeal.

❑ Tabulate successful celebrity fashions and document them with the experience of fashion consumers.

❑ Provide information on the level of influence of fashion trends and the fashion celebrities' fashion promotion activities.

The Human Fashion Brand Model will provide information and help to answer some of the rhetorical questions raised above. It can be useful for fashion celebrities, fashion celebrity marketers, and celebrity fashion consumers alike in helping them understand and evaluate the impact, success, diffusion, and adoption of a celebrity's fashion.

5.5 The Use of the Capability Maturity Model (CMM)

The CMM (capability maturity model) was used as a guide for structuring the Human Fashion Brand Model. The CMM was useful because it allowed us to understand the capability and maturity of the fashion symbionts and the various factors as progressive stages. This section will examine the CMM which was published in 1988 by Watts Humphrey and is viewed as a core theory that allows developers to repeat their successes and avoid repeating their failures. One of the key characteristics of a maturity model is that it employs a sequence of maturity, which are shown in levels for a particular object. It also represents the anticipated, desired, or the typical evolutionary path of the objects in stages. The maturity model demonstrates that, in order for an object (e.g., service, person, or company) to migrate from one maturity level to another, it must develop the necessary capabilities that are required by that particular level.

The CMM divides evolutionary steps into five maturity levels, as shown in Figure 5.3. These levels lay successive foundations for continuous process improvement (Sarshar et al., 2002), show the possible improvements that can be achieved, and identify the most appropriate actions to be taken in order to increase performance in companies (Battista & Schiraldi, 2013). This type of maturity modelling has been defined by Klimko (2001) as a generic approach with the development of an 'entity' over time, of which the 'entity' can be anything of interest. The entity's development is normally described in a simplified way and in a limited number of maturity levels. Each level is described by a set of criteria that characterise an entity at that particular level. These maturity levels

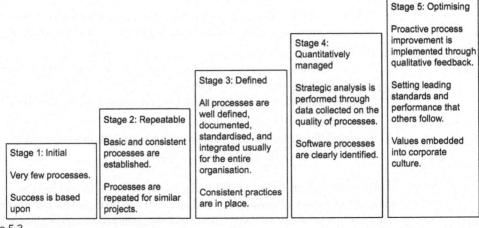

Figure 5.3

The Capability Maturity Model (CMM)

do not provide guidance on how to run an organisation; rather, they are a way to measure how mature an organisation is based on key processes and practices. Furthermore, a maturity level is indicative of the effectiveness and efficiency of the organisation and the probable quality of its outcome.

Various researchers have since adopted the CMM for other application domains (Rogers, 2003; Yeo & Ren, 2009), including SPICE (standardised process improvement for construction enterprises) which describes a systematic step-by-step process improvement framework for the construction industry. For the purpose of this book, the authors believed that the CMM could provide the most appropriate model structure for depicting those celebrities who can develop and successfully implement new fashion innovations using the level classifications of 1 to 5:

1. The Highest Level in the Maturity Model

 ■ Effective and efficient fashion celebrities and fashion brands leading to a large number of sales and impact on fashion consumers and followers.

2. The Lowest Level in the Maturity Model

 ■ Fashion celebrities and fashion brands which in theory lack the exposure and are unable to influence fashion consumers to adapt to new changes.

5.6 The Human Fashion Brand Model

The following section presents the developed Human Fashion Brand Model, describing which prominent factors increase the rank and popularity of celebrities, alongside the assimilation of symbionts into it.

❑ Influence
❑ Exposure
❑ Endorsement
❑ Impact
❑ Needs
❑ Identification

5.6.1 The Fashion Celebrity Human Fashion Brand Model Influence Factors

The factors, sub-factors, and need theme levels on the Human Fashion Brand Model evolved from the need to analyse the symbionts. They are grouped by entities under the subject which evolved from the literature review and the authors' industry experience.

The Fashion Celebrity

Fashion Celebrity Influence Level by Motive and Need

Influence	Influence Level 1 Limited/ local-level influence	Influence Level 2 Regional/ national market influence	Influence Level 3 National/ international mass value market influence	Influence Level 4 National/ international luxury mass market influence	Influence Level 5 Global fashion creator (fad/ trendsetter)
Whilst there are different types of celebrities, the level the celebrity wants to influence consumer fashion varies. Celebrities are individuals that can consist of; actors, singers, reality stars, celebrity chefs and Internet stars (self-made). Their desire to impact consumer fashion can range from short term fad/ fashion to longer term style/ identity. Not every celebrity wants to influence fashion.	*Influence level* – celebrity has minimal attention to media and influence on consumer fashion. *Fashion level* – celebrity dresses presentably. *Activity level* – celebrity doesn't follow fashion consciously. *Promotion level* – celebrity has low fashion inspiration. *Attachment and conforming level* – consumers don't look to fashion-follow and /or have a low fashion attachment to the celebrity.	*Influence level* – celebrity is recognised on a regional/ national level. They are not identified alone by influencing and driving fashion. *Fashion level* – celebrity is stylish but not identified for their fashion alone. *Activity level* – celebrity has a fan base and following that likes what they wear and what they stand for. *Promotion level* – at this level, the celebrity's popularity and marketing communications motivate the public's acceptance and/or aspiration to pursue the celebrities and/or their fashion. *Attachment and conforming level* – (low to medium level) The celebrities' popularity allows their style to be noticed and they are developing fashion styles. Celebrity holds a desire for consumers to conform to their fashion.	*Influence level* – celebrity is identified by their fashion and attempts to capture national and international value/ mass markets. *Fashion level* – celebrity is fashion active in all aspects of their visual image. *Activity level* – celebrity not only promotes existing fashion trends but also try to create new fashion styles. *Promotion level* – celebrity holds a great desire to be fashionable and work with fashion brands. The celebrity wears a fashion and the fan/consumer believes it is good for them too (Euromonitor, 2014). *Attachment and conforming level* – medium to high attachment by consumers- They are verified as an established fashion contributor alongside work with international fashion brands. The individual wants to conform to the celebrity and their fashion.	*Influence level* – celebrity is known by their fashion, having captured the international luxury mass market; *Fashion level* – celebrity is viewed as highly fashionable, wearing items that are popular and stylish. *Activity level* – celebrity constructs new styles *Promotion level* – considered to be an international phenomenon and are seen wearing trends. They use the global fashion market place as a platform to share their celebrity fashion. *Attachment and conforming level* – High level attachment - celebrity influences mass luxury markets and have capitalised on a fashion -following who want to conform to the attitude or behaviour of the celebrity. They want to know new stories, gossip and pictures.	*Influence level* – celebrity is a high-end global influencer that not only shapes and influences fashion trends but creates them. *Fashion level* – this celebrity creates successful fashions intentionally or unintentionally which are adapted and manipulated to become a fashion fad/ style or longer-term fashion identity and imitated. *Activity level* – celebrity is purposely being provocative and manipulative in their fashion to directly influence consumers globally. Frequent use of social media, being in the news regularly and wanting to be caught by the paparazzi to become the inspiration for what to wear. *Promotion level* – outstandingly fashionable and stylish, the celebrity creates successful fashions intentionally or unintentionally, which are adapted and manipulated to become a fashion fad/ style or longer-term fashion identity and imitated. *Attachment and conforming level* – powerful and prominent attachment of the celebrity by the consumer. The celebrity is a fashion trendsetter and whatever they choose to wear works. Their fashion has become a public form of human research and development. Consumers look at this celebrity fashion to develop their own fashion selves.
Celebrity Fashion Trend Appeal Examples	Adele - Adele (British singer, songwriter) has acquired mass fame, she doesn't purposely try to influence fashion. Her statement black colour and coats are used more for comfort and functional styling.	Liam & Noel Gallagher (British brothers, formally of the rock band Oasis) – Hold a distinct image that is associated with their music and lifestyle e.g (casual everyday wear, rough Mancunian).	Beyoncé (American singer, songwriter, actress) – Beyoncé has launched a range with Top Shop called Ivy Park. It retails her casual / urban wear and allows her celebrity inspired fast fashion to be accessible to consumers widely.	Kate Middleton (Now Princess of Wales, member of the British royal family) - Regularly wears British designers such as Mulberry and Alexander McQueen, each time she does so, it increases sales.	Kim Kardashian (American socialite, model and business woman) –Kim does care to influence fashion and consumers will take inspiration from her own wardrobe e.g., her trench coats and macs. Fashion critics and consumers spend time reviewing outfits that she wears and her fashion styles feedback onto the high street and wearable fashion trends.

Figure 5.4

Fashion Celebrity Influencer Factors

Influence

The definition of influence is "the capacity to have an effect on the character, development, or behaviour of someone or something, or the effect itself" (Oxford Dictionary of English, 2005). Influence can also be described as a function and influence, "a connecting fibre . . . a commodity that possesses in it humanness, familiarity and an affective link of products with a celebrity" (Taylor & Harris, 2008).

Influence factors and sub-factors are discussed previously in sections 2.1, 3.1, 3.3, 4.0, 4.4, and Figure 5.2, which illustrate how celebrities have become role models and influencers (Bailey, 2011; Le Bon, 2015). Furthermore, technological influences have also allowed celebrities and their fame to become more immediate and instant (sections 3.2 and 3.6). Their images are marketed, sold, and disseminated rapidly (Taylor & Francis, 2015). These images, in turn, have transmuted celebrities into commodities and helped them to personalise fashion trend information towards fashion consumers (Neimark, 2016).

Star power can generate public interest in many issues and even result in behavioural change (Noar et al., 2014). Perceived as 'perfect,' celebrities create excitement for their fans as they live lives that others could only imagine. Influencing factors such as the ideals of beauty in fashion (section 3.1), brand lifestyle personality (section 3.3.2), and the dream formula (section 4.2.4) are all evidence that celebrities can lead individuals to have strong feelings about them as they see them as a source of value and influence (Euromonitor, 2014; Mathys et al., 2016; Pappas, 1999; Şahin & Atik, 2013). Seen as a reference group, celebrities are a form of symbol/attachment and are followed by fashion consumers because their fashion influences are innovative and are updated frequently (section 4.2.3).

5.6.2 The Fashion Celebrity Human Fashion Brand Model Influence Need Levels

Influence Level – A and B list celebrities update their fashions their fashions frequently on a wide international level where they are highly active. These fashion celebrities become brands unto themselves (sections 1.1, 2.4, and 4.2.5.2). They work in collaboration with fashion celebrity marketers who use them to manipulate the desires of fashion consumers to encourage them to emulate the celebrities. Consumers do this by copying their clothes, make-up, hairstyles and place attention to their media exposure and influences.

Fashion Level – Identifies the celebrity's fashion level (note: not all fashion celebrities choose to dress for the purpose of fashion) (section 2.1).

Activity Level – This refers to having a conscious involvement with the fashion consumer and how much the consumer follows a fashion consciously. The level of activity is directed by exposure of celebrity styles in order for fashion followers to accept them. This is done by fashion celebrities sharing their activities, their plans, and information about upcoming projects and trends to keep fans and followers in the know.

Promotion Level – The promotion levels describe how fashion celebrities use platforms such as social media to self-promote with daily fashion tweets, status updates, or photos keeping them and their fashions in the public eye.

Attachment and Conforming Level – Analyses how the media are forcing individuals to lose their own identities and conform to the fashions of celebrities. A fashion celebrity attracts and engages with consumers, so they attach themselves to the idea and eventually decide to purchase the fashions of the celebrities they fashion-follow and/or have the need to fashion conform.

Fashion Celebrity Factor Benefits – Not only must the fashion celebrity be popularly recognised, but he or she must also possess social or cultural currency to motivate popular interest (Wigley, 2015). The fashion celebrity influence factors can identify a celebrity who has no fashion impact or very little fashion impact on the model compared to a celebrity with an extremely high fashion impact who would fit into influence level 5 and is a global fashion creator (fad/trendsetter). The model illustrates how more and more celebrities are using social media to promote themselves and their fashions. It also can reveal the following information:

- ❑ What being an A- to D-list celebrity entails for levels 1 to 5 on the Human Fashion Brand Model.
- ❑ Short-term or longer-term effects on a fashion brand of a celebrity.
- ❑ What exposure a fashion celebrity generates.
- ❑ The appeal of marketing the fashion celebrity.
- ❑ Celebrity level promotion.
- ❑ Activity levels whereby fashions are communicated.
- ❑ Fashion consumers' demand levels.
- ❑ Attachment and conforming level (how and why consumers follow fashion).
- ❑ The measurable impact of the celebrity's influence on consumer emulation.
- ❑ How fashion celebrities' new fashions and trends are diffused and can be adopted by consumers.
- ❑ Types of fashion markets, from value mass markets to luxury (the most popular celebrity brands concentrating on luxury but also on value brands).
- ❑ Why it doesn't matter if you are an A-list or a D-list celebrity (not all have the same need).
- ❑ Why there are fashion A-list celebrities that want people to emulate them as well as fashion pushers and those that don't want people to emulate them.
- ❑ Why luxury brands are not specific to A-list celebrities.
- ❑ Analyses of A-list celebrities wearing high street/mass-market brands.

The model accounts for cases when a successful A-list celebrity does not try to influence others in fashion. For example, people enjoy the music and identify with the experiences of an A-list celebrity like Adele. But this does not necessarily mean that people want to emulate her fashion style. In these cases, the model allows a deeper understanding of how celebrity fashion classifications fans/consumers want to or don't want to look like particular celebrities.

The Fashion Celebrity

Exposure Levels (how much does the celebrity want to push fashion)

Celebrity Fashion Exposure — This exposure is done by celebrity events, which serves as a source of information on the 'private lives'. The higher their frequency of exposure determines how successful and active they are in fashion.	Exposure Level 1 — Fashion-puller with limited consumer reach	Exposure Level 2 — Fashion puller and pusher with regional/national consumer reach	Exposure Level 3 — Profiler fashion-pusher with national consumer reach	Exposure Level 4 — Influencer fashion-pusher with international consumer reach	Exposure Level 5 — Provocative innovator fashion-pusher with global market consumer reach
	Activity level – celebrity not active in pushing their fashions. *Audience* – celebrity consumer influence is small and localised. *Fashion style* – celebrity not noted for their fashion style *Interaction level* – celebrity not highly involved in fashion but still influence fashion. *Media exposure level* – celebrities don't really use the media *Inspiration level* – Doesn't promoting their fashion.	*Activity level* – celebrity occasionally updates their fashion style and have a regional/ national following. *Audience* – celebrities have a national audience fashion *Fashion style* – celebrities both pull and push fashion through their existing work profile. *Interaction level* – celebrity has exposure and increased interaction with their followers e.g. a 10-minute video compared to other high-end fashion pushers who would only have a picture in a magazine *Media exposure level* – celebrities hold the desire to be identified by their fashion. *Inspiration level* – celebrity is recognised as inspirational.	*Activity level* – celebrity is an active fashion pusher and is recognised for their style. *Audience* – celebrity has a surge of interest from consumers. *Fashion style* – celebrity fashion shown in magazines to influence the way that everyday people dress. *Interaction level* – Interaction is derived from the celebrities' way of wearing the product. *Media exposure level* – celebrity uses their profile to influence fashion. *Inspiration level* – consumers follow the trends	*Activity level* – celebrity is an active fashion pusher that has a wide international consumer demand. *Audience* – celebrity has an active home/ international audience. *Fashion style* –celebrity creates innovative fashions *Interaction level* – social media is a huge part of a celebrity's everyday life to interact with fans and update them with their latest fashion. *Media exposure level* – celebrity is a trendsetter and viewed as a fashion influencer). *Inspiration level* – celebrity creates distinct trends	*Activity level* – celebrity is highly effective in influencing fashion consumer choices and they drive innovation globally. *Audience* – celebrity is seen frequently /the audience are dynamic and global consumers hold good knowledge of their fashions and lifestyles and feel the desire to imitate them to fulfil their own means and desires. *Fashion style* – fashion trends are developed and showcased globally. Sometimes purposely provocative to create a reaction. *Interaction level* – engages with promotional activities to communicate fashion messages in various ways of interaction through social media, TV, movies, blogs, advertisements, awards, and shows. *Media exposure level* – celebrity attempts to change their fashions and define their style which is at an outstanding high-level and gains awareness as a fashion influencer/ leader. They stimulate and excite the fashion industry. *Inspiration level* – At this level the celebrity successfully Influences how we look, how we dress, and how we think.
Celebrity Fashion Trend Appeal Examples	- Adele (British singer, songwriter) doesn't use twitter for her fashion, it's more about her music.	Look up to fashion from high end fashion contributors and pull from them in order to push their own target demographics.	-Liz Hurley (English model, actress) The Versace safety pin dress made her an overnight celebrity.	Celebrities rapidly gain followers and fans on Facebook and Twitter because their fans want to stay updated on their lives and fashion.	This celebrity on a daily or weekly basis uses snap chat / Instagram and encourages the media and individuals to follow them e.g Kim Kardashian (American socialite, model and business woman).

Figure 5.5

Fashion Celebrity Exposure Factors and Sub-Factors

The model also is adaptable to different fashion media campaigns where, for example, an A-list celebrity could be at level 3. Their fashions could allow them to shift between levels 2 or 3, and this movement can be illustrated with arrows going up and in different directions, showing that there are divergent levels of the celebrity's fashion emulation.

At level 5, the fashion celebrity receives a high level of emulation by fashion consumers because they are seen as fashion leaders. They may choose to target the masses on social media and through other communication methods. The Human Fashion Brand Model is about understanding the influences and impacts of the fashions of celebrities on fashion consumers and how they actively exert their influence in each of the stages. At this point of the development, it isn't about moving [to higher] levels but recognising what each level is (levels 1 to 5).

5.6.3 The Fashion Celebrity Human Fashion Brand Model Exposure Factors

This section refers to exposure factors that affect celebrities and their need themes and how fashion celebrities can successfully express themselves in fashion trends and development to achieve high recognition and create a strong product perception (section 1.1.4). This exposure allows the celebrity to vastly raise the profile of a product or fashion trend (Jamil & Rameez ul Hassan, 2014; Shaw & Koumbis, 2014). Exposure plays a very important part in the role of a celebrity (section 1.1). The ultimate aim for any fashion celebrity is to have an impact on the fashion choices that consumers make, and high exposure ensures that consumers only need to see a celebrity wear something once, and they will want to wear it too.

Activity Level – Some celebrities are not active, but they are still extremely famous. In contrast, others are extremely active in communicating their fashions on a mass global scale, and they exert significant influence. For these celebrities, the media offer them a platform to air their fashion styles and views.

Audience – The audience size can vary from a very small to a large global following. As discussed in sections 2.1 and 3.3, not all fashion celebrities choose to dress for the purpose of influencing fashion.

Fashion Style Level – There are different levels of exposure and some celebrities are more active in promoting their fashion styles (sections 2.4 and 4.1). Fashion celebrities at level 5 are seen as creative forces behind fashion innovation, and they are seen as trendsetters, creators, artists, and designers. At a high level, the celebrity pulls and pushes fashion and actively communicates fashions of their ingenious style for a reaction that contributes to changes in the fashion industry. The celebrity uses strategies such as being active on the red carpet and attending events such as the Oscars (section 2.4.1).

Media Exposure Level – Some celebrities don't use the media and have no desire to be associated with fashion style. For marketers', successful exposure of celebrities relies on much more than just the celebrity personality holding a product. At a high level, exposure allows the audience to believe the relationship between the brand and the celebrity (sections 2.1, 2.4, 3.3, 4.2.3, 4.2.4, and 4.2.5.1).

Interaction Level – Online social media and fashion magazines publicise celebrity lives and fashions which attract much attention from fans and people recognising their fame (levels 1 to 5) (section 2.4.1).

Inspiration Level – This is where the fashion celebrity uses his or her profile to influence fashion consumers. Rojek's Classification, the Ulmer Scale, and the David Brown Index (sections 2.2.1.1–2.2.1.3) could not be used alone for the model because they didn't fully describe the relationships that co-existed between celebrities and fashion. To overcome this, the authors took some aspects from the David Brown Index, Rojek's Classifications, and McCracken's meaning transfer model as they were found to be useful in categorising classifications for the fashion celebrity in the creation of the Human Fashion Brand Model. The authors amalgamated the theory and built on it in addition to using information from the literature reviews related to fashion and celebrity activity levels.

Thus, it was anticipated that the final model would describe the types of fashion celebrities, fashion celebrity marketers, fashion celebrity consumers, and celebrity fashion trend appeal examples to study. For example, in Chapter 3, we saw how a fad of a celebrity is exposed, and we compared a short-lived fashion trend such as Pharrell Williams's hat to the late Amy Winehouse's fashion innovations which are termed a 'complete look.' We further discussed how this effect is used by fashion consumers emulating Winehouse in their own fashion-self presentation. (Figure 1.5; English singer/songwriter admired the 1960s and based her style on the classic beehive hairstyle and teahouse dress)

5.6.4 The Fashion Celebrity Human Fashion Brand Model Impact Factors

The information on understanding why people choose to adopt a celebrity-inspired fashion product and how they feel its personality somehow corresponds to their own is important to understand. Celebrities, in their quest for fame, ultimately want to increase their fame and longevity, with some using provocative tactics to achieve this. The aim is to make an impact through media exposure and recognition of their identity and fashions.

Media Exposure/Likes Level – Some celebrities are not interested in a social media following and an increase in traffic from followers liking them. However, for some, it becomes a matter of survival and a continuous need to hunt for attention because the media is hungry (Forbes, 2016).

Celebrity Fashion Innovation – Celebrities are seen as influential and are the earliest visual communicators of a new style. Within the Human Fashion Brand Model, there are categories describing how active they are at communicating their profile through the number of likes and followers on social media. At a high level, they become fashion leaders that showcase their latest offerings and influence people through their individual manufactured styles.

The Fashion Celebrity The Effects = Impact					
	Impact Level 1 Fashionability	**Impact Level 2** Fashion coverage	**Impact Level 3** Growth in celebrity fashion/ acceptance	**Impact Level 4** Celebrity inspired lifestyle	**Impact Level 5** Enhanced fantasy & impact on identity formation
Celebrities have become human fashion brands where they are synonymous with a styled/ad and they have the power for it to become an identity. They create new styles which are adapted to become fashions and accepted by consumers and then feedback in to the process for new influences, inspirations and trends.	*Media exposure / likes level* – low level numbers following and no social-media. *Celebrity fashion innovation level* – None. *Celebrity inspiration level* – consumers do not aspire to the celebrity's fashion. *Fashion adoption level* – celebrity is a laggard similar to the fashion consumer. *Impact on identity* – celebrity impact is minimal.	*Media exposure / likes level* – celebrity is well-known and seen as fashionable. They have a social media following of 10,000 and under. *Celebrity fashion innovation level* – celebrity develops new fashions. *Celebrity inspiration level* – fashion consumers take inspiration from celebrities they admire. *Fashion adoption level* – celebrity fashions are watched and available in high-street stores. *Impact on identity* –celebrity provides stimulus for how people want to dress.	*Media exposure / likes level* – celebrity shapes people in fashion by the styles of clothes they choose to wear. They are a sign of quality and a means of identification to the fashion product, brands. Likes- 50,000-250,000. *Celebrity fashion innovation level* – celebrity fashions connect with the fashion consumer. *Celebrity inspiration level* – celebrity re-defines style. *Fashion adoption level* – celebrity influences fashion and then fashion critics and the general public spend time reviewing their outfits and adapting them to be wearable. *Impact on identity* – educating consumers on the meaning of fashion is done here by the celebrities' way of wearing the product and their continuous change and updating.	*Media exposure / likes level* – celebrity is distinctive, an arbiter of taste in style and public opinion. Celebrity endorsed lines enhance customer retention as consumers aspire to be like the celebrity. Likes 250,000-3million. *Celebrity fashion innovation level* – celebrity shapes and influences fashion trends. *Celebrity inspiration level* – celebrity seen as aspirational examples and archetypes. Their fashions have the power to inspire and educate. *Fashion adoption level* – celebrity fashion products are regarded as high involvement and are adopted. Use of Social media allows the celebrity and their current fashion trends to be infographic. *Impact on identity* – fashion consumers want to access the fantasy life of the celebrity and their fashions.	*Media exposure / likes level* – celebrity strengthens their fans' loyalty and brings awareness to themselves by eliciting positive emotional responses from the public (Rindova et al., 2006). Likes 3m and over. *Celebrity fashion innovation level* – celebrity is a high-level fashion innovator who drives the total fashion look with accessories, makeup and hairstyles. *Celebrity inspiration level* – celebrity fashions influence and educate consumers heavily through brands, fashions, styles, and images of the celebrity. *Fashion adoption level* – celebrity fashion incites consumer purchases to be adopted as they are closely connected to sentiments of self-image, social status and cultural identity (Fairhurst et al., 1989). Extreme high involvement. Global recognition. *Impact on identity* – celebrity becomes a global fantasy, an ideal construct, a 'mirror reflection' Dubois and Patemault (1995), refer to this need as the 'dream formula' (chapter 4) where awareness, imagination and fantasy lead to self-styling and purchase.
Celebrity Fashion Trend Appeal Example		Tom Hanks (American actor) - not a fashion figure but uses social media for tweeting.	Princess Kate (Duchess of Cambridge, member of the British royal family) Brings British designs to the forefront. - David Beckham (former British footballer) - Well known and seen as a fashion icon.	Gigi Hadid (American socialite and model) with Hilfiger Gigi being a young 21-year-old fits in the target demographic, displaying how hip and trendy the clothing brand is.	-Madonna has invented so many new identities to promote her musical style. -Kim Kardashian (American socialite, model and business woman) Built her career and empire on social media.

Figure 5.6

Fashion Celebrity Impact Factors and Sub-Factors

Celebrity Inspiration Level – The celebrity brand starts to have a personality and, through social media, celebrities increase their brands' popularity. Consumers get a closer look at a celebrity's everyday life, what they look like, how they act, and what they do.

Fashion Adoption Level – Consumers follow the fashion celebrities' affordable styles and want to incorporate them into their everyday lives. These celebrity fashion innovations are used in both high-price-point fashion and diffused to lower price points to achieve more influence and sales (Fiore & Hyejeong, 2013).

Impact on Identity – Part of the secret of the success of fashion celebrities from the viewpoint of fashion consumers is how much they can interact with the fashion celebrities' lifestyle. What some fans want is to pursue the lifestyle of their favourite celebrity because they are curious as to who they are, how they live, and what they wear so they can emulate them and live out their dreams through them.

Fashion Celebrity Impact Factor Benefits:

❑ Identifying fashion fads and long-term fashions of celebrities.

❑ Determining the celebrity's level of fame, which is also based on their activity in fashion communications.

❑ Presenting levels of diffusion of the celebrity's fashions and the adoption groups of fashion consumers.

❑ Recognising what a celebrity is doing. Celebrities such as former professional footballer David Beckham can help endorse/launch fashion brands, and the model can encompass and recognise what he is doing and what he can do and display it on levels 1 to 5.

❑ Predicting the staying power of an innovation will be instant successes or last over a period of time. Celebrities such as Pharrell Williams (American singer, rapper, songwriter, record producer, and fashion designer) can improve sales, but the trend may stop within three months. Kim Kardashian (American media personality, socialite, and model) wearing a tight all-in-one suit may produce results that last longer, but that doesn't mean the trend had a stronger impact when she first wore the suit.

❑ Assessing celebrity fashion impact through the use of visual images.

5.6.5 The Celebrity Fashion Marketer Human Fashion Brand Model Exposure Factors

There has been a rise in the number and dominance of social media sites (section 3.2) such as Instagram, Twitter, and TikTok. This trend suggests that continual exposure of celebrities does have an impact on individuals, their aspirations, and their sense of identity, especially in terms of how they behave and how they should look (sections 3.2, 3.2.1, 4.2.4, and 4.2.5). These types of exposures by fashion celebrities allow fashion consumers to connect with those fashion celebrities they feel best represent them. Marketers want to exploit their

The Fashion Marketer

Celebrity fashion + Need of the fashion consumer = Exposure for fashion marketers

Exposure	Exposure Level 1 Fashion celebrities	Exposure Level 2 Fashion media communications	Exposure Level 3 Celebrity endorsing	Exposure Level 4 Celebrity is designing to inspire a lifestyle	Exposure Level 5 Enhanced fantasy & impact on identity formation
The celebrity's exposed media image and public self is how marketers promote and communicate their fashions to consumers. This is done from the celebrity's transformation and continuous developments of their fashions	*Exposure level* – Not showcased for their fashions *Celebrity profile attractiveness* – celebrity does not focus on new fashion trends. *Celebrity fashion collaborations* – fashion consumers do not aspire to dress like them. *Market levels of fashion brands* – celebrity doesn't work with fashion brands. *Celebrity fashion promotion using marketing tools and media channels* – celebrities have little or no activities to promote their fashion.	*Exposure level* – celebrities hold the desire for their fashion and style to be accepted. *Celebrity profile attractiveness* – celebrity is building on an emergent fashion promotional strategy *Celebrity fashion collaborations* – fashion consumers take inspiration from the celebrity. *Market levels of fashion brands* – low to value market (Primark and Matalan). *Celebrity fashion promotion using marketing tools and media channels* – celebrities hold the desire to promote their fashion and latest trends.	*Exposure level* – marketers use the celebrity's to style. *Celebrity profile attractiveness* – marketers are aware of attention and build a fashion promotional strategy. *Celebrity fashion collaborations* – celebrity endorses fashion lines for a fashion company / brand e.g. Kate Moss with Topshop. *Market levels of fashion brands* – mass market High-street (H&M and New Look). *Celebrity fashion promotion using marketing tools and media channels* – celebrity is active and their fashion consumers are fashion enthusiasts that purchase magazines because the celebrity is exposed in them e.g. Grazia and Glamour. Celebrity endorses designs exclusively.	*Exposure level* – celebrity is a fashion socialite who is essentially exposed by marketers for being famous because they are watched for their style choices. *Celebrity profile attractiveness* – celebrity endorses fashion products on social media and other platforms. *Celebrity fashion collaborations* – fashion lines are designed with celebrities' that are a high-level global fashion influencer exclusively by brands. *Market levels of fashion brands* – mid-level mass market High-street (Topshop, M&S and River Island). *Celebrity fashion promotion using marketing tools and media channels* – celebrities use several marketing communication tools to target their fashions and lifestyle to fashion consumers with information and entertainment combined called 'infotainment'.	*Exposure level* – marketers recognise the celebrity is a persuasive instrument in influencing the mass media on body image and socio-cultural factors. *Celebrity profile attractiveness* –celebrity is seen as a fashion icon and brand empire. Celebrity holds characteristics such as being a fashion leader, attractiveness and an extraordinary lifestyle. *Celebrity fashion collaborations* – celebrities market their fashion with luxury fashion brands. They are A-list actors, musicians and entertainment stars. *Market levels of fashion brands* – high end street brands (All Saints and Karen Millen). Luxury brands – Ready to wear and couture e.g. Marc Jacobs, Dior and Chanel. Celebrity becomes metamorphosed into brands. *Celebrity fashion promotion using marketing tools and media channels* – the celebrity is a brand and a means of identification for the fashion brand and is distinctive. These celebrities are fashion innovators.
Celebrity Fashion Trend Appeal Examples		Examples of market exposures: -Social media (internet) exposure. -Gossip magazines. -YouTube Vloggers. - Newspaper and radio exposure	-Kate Moss (British model) endorsing with Topshop -Adidas with David Beckham (former British footballer). -Beyoncé (American singer, songwriter) Ivy Park with Topshop. -Stella McCartney (British designer) and GAP kids -Kendall Jenner (American socialite and model) with Estée Lauder.	-Celebrity in fashion magazines (e.g. Vogue, Grazia, GQ and Elle) and are global players for the fashion conscious. - Launch own lines/ design e.g. Rhianna (Barbadian singer, actress) with River Island. Kylie Jenner (American socialite) with Puma. -TV- Highly targeted satellite channels such as MTV and E! News to show fashions (Emma Watson and Burberry).	The internationalisation of the celebrity and their fashion. -A brand champion as an endorser (Kardashian-Jenner's). -Celebrity becomes the brand. -Madonna and Louis Vuitton have become synonymous. -Cinema advertising – Chanel with Nicole Kidman. -Outdoor ambient media – Billboards. -Social media /luxury brand marketing/ brand endorsers. -Press releases/sponsorship/red-carpet events/fashion shows/ smart technology.

Figure 5.7

Fashion Celebrity Marketer Exposure Factors and Sub-Factors

exposure because it gives celebrities a media platform where they can showcase their fashions. This allows them to interact with their fan base and share their lives with the world (sections 1.1, 2.0, 2.1, 2.4, 2.4.1, 3.1, 3.3, 4.1, and 4.2.3).

Exposure Level – At level 5, the celebrity is famous, and their exposure level is high. They showcase their fashions, and those fashions are identified as a sign of quality. The level-5 celebrity has built and strengthened his or her own personal brands through mass, strategised exposure in the media and through social media.

Celebrity Profile Attractiveness – Exposure allows the celebrity to hold a strong attraction for consumers and unleash impressive power to pursue and target the audience. At level 1, the celebrity is not really focused on new fashion trends. However, as discussed in section 2.4.1, at levels 3, 4, and 5 the celebrity can use his or her likeness, fashion, attractiveness, glamour, novelty, consumption, and trust to establish their congruency with a brand.

Celebrity Fashion Collaborations – Fashions have been influenced by popular culture, and since the classic Hollywood era, designers and brands have collaborated with social celebrities to expose their fashion designs to fashion consumers who aspire to be like them and emulate celebrity fashion (sections 1.1.3, 2.4.1, 3.3.4). Luxury fashion brands such as Ralph Lauren, Tommy Hilfiger, Versace, and Armani have opened doors for celebrities to launch their own fashion styles (Chapter 3). Most recently, Virgil Abloh (American fashion designer) collaborated with Louis Vuitton, and Kanye West (American rapper, record producer, and fashion designer) connected with Adidas. Others have followed suit, and today it is common to see A-list celebrities featured in fashion high-street brand campaigns.

Market Levels of Fashion Brands – These market levels, as explained in section 2.3.1, segment fashion celebrities into groups in which there are three main levels: haute couture, designer wear, and street fashion/mass markets for fashion consumers. At level 1, the celebrity doesn't work actively with fashion brands. However, at level 5, the celebrity is a fashion innovator such as former professional footballer David Beckham and the Kardashians-Jenners (sections 1.1.2, 2.4, and 2.0). On the high street is Rita Ora (British singer and actress) with Adidas, Rihanna (Barbadian singer, actress, and fashion designer) with Vogue/River Island (sections 2.4.1 and 3.3.4), and Pharrell (American singer, rapper, songwriter, record producer, and fashion designer) with Gstar (sections 1.1 and 3.5.7.5).

Celebrity Fashion Promotion Using Marketing Tools and Media Channels – Marketers need to understand that designs are built on the images of the celebrities they use (sections 3.3, 3.3.2, and 3.3.4). We live in an era of celebrity collaborations/ambassadors (section 3.3.4), representing one of the most comprehensive uses of exposure in fashion advertising. Level 1 celebrities are seen as late style adopters, and level 5 celebrities are seen as innovators of fashion (sections 3.5.7 and 3.5.7.5).

Exposure Factors Benefits – More and more people use celebrities but that doesn't mean the trend had a stronger impact for their image and brand.

The Fashion Marketer					
Celebrity fashion + Need of fashion consumers = Exposure by marketers					
Endorsement	Endorsement Level 1 Selection of celebrity endorser	Endorsement Level 2 Endorsement level fit	Endorsement Level 3 Explicit & implicit endorsements	Endorsement Level 4 Fashion & social media marketing	Endorsement Level 5 Human fashion brand promotion
Celebrity endorsements have the potential to transform a brand. From a marketer's perspective celebrities are chosen based on their appeal to a mass or specific market with a brand image in order for it to match a consumer's lifestyle to sell.	*Brand match / congruence* – C- D list celebrities. *Celebrity endorsement level* – a short stint by celebrities. *Celebrity endorsement pay* – usually gifting and/or none or relatively moderate payment for the celebrity *Transference* – short term and not long lasting. *Celebrity endorsement influence level* – local promotions in store to target consumers on how they look and feel.	*Brand match / congruence* – celebrity endorsers measured by how they exert their fashion influence. *Celebrity endorsement level* – celebrity is a testimonial used by marketers because the celebrity is socially prominent. *Celebrity endorsement pay* – celebrity is paid a notable sum. *Transference* – celebrities have fashion trends which fashion consumers want to follow. *Celebrity endorsement influence level* – celebrity is enduring and offers the public new styles and fashion-forward variations in high street stores.	*Brand match / congruence* – attractive celebrity images reinforce an ideal that fashion marketers match with fashion brands. *Celebrity endorsement level* – implicit and explicit endorsement. *Celebrity endorsement pay* – celebrities have a paid endorsement contract and given merchandise to wear. *Transference* – celebrity endorses a brand linked to their profession e.g. Nike and athletes. *Celebrity endorsement influence level* – celebrity uses media to become a creative force in shaping fashion and style for fashion consumers.	*Brand match / congruence* – celebrities whose fan base and fashion followers aspire to be like them in their fashions. *Celebrity endorsement level* – celebrity has been matched with a fashion brand for a promotional strategy. *Celebrity endorsement pay* – brand signs a celebrity to represent the label in a fashion advertising campaign. *Transference* – celebrity endorsement strategy can be an effective way to differentiate among similar products, the meaning they attach are transferred to the consumer through consumption. *Celebrity endorsement influence level* – celebrity has a clear and popular fashion image and the impact of the product is strong.	*Brand match / congruence* –A-list celebrities used to match the fashion brand and the fashion consumer has an insatiable desire to know the very latest on the celebrity circuit. *Celebrity endorsement level* – celebrity fashion endorsement is part of the epitome of the celebrity at this level. The endorsement is at the front of all marketing strategies so that consumers can make a visual connection. *Celebrity endorsement pay* – celebrities are paid a colossal sum (millions) to endorse brands and now a human fashion brand. *Transference* – consumers are better able to identify products that are associated with celebrities; GAP has used Madonna, Missy Elliott, and Sarah Jessica Parker who added a new dimension to endorsements. *Celebrity endorsement influence level* – global recognition, the famous celebrity faces capture attention and are processed more efficiently by the brain than 'ordinary' faces. A confluence of media coverage on celebrity fashions increase awareness for fashion consumers. The image of the celebrity matches the identity of the brand he/she is endorsing.
Celebrity Fashion Trend Appeal Examples	-Kerry Katona & Peter Andre (both British singers) for Iceland. -TV and Soap Reality stars -Car crash couture is a feature of Grazia.	- Vloggers - Social Media	An example of explicit endorsement can be seen through Beyoncé's sponsorship deal with PepsiCo in 2012, worth approx. $50 million reach as one of the world's biggest female pop stars.	-Roger Federer (Swiss tennis player) with Nike. -Cristiano Ronaldo (Portuguese footballer) with Nike -Usain Bolt (Jamaican athlete) with Puma	A- List -Beyoncé (American singer, songwriter, actress), Justin Bieber (Canadian singer), Kim Kardashian (American socialite). Beats by Dr Dre have been used by many celebrities in music videos.

Figure 5.8

Fashion Celebrity Marketer Endorsement Factors and Sub-Factors

Fashion celebrity marketers need to choose their celebrities wisely and should gather statistics on how a celebrity will help their brand and why they can increase sales. Choosing the right celebrity is a critical choice, because a celebrity can completely ruin a brand in one day. The story of celebrity Danniella Westbrook provides a sobering warning to any company considering using a celebrity (section 3.4).

It is important to understand the symbiotic relationship among the symbionts as consumers emulate the behaviour of celebrities who affect a brand's image (sections 1.1, 1.3, and 5.2). Celebrities can generate mass income for themselves, and more money means more exposure and fame. Celebrity fashions are important for fashion celebrity marketers because they allow an understanding of how much outreach the celebrity will get and if the celebrity will be able to achieve the following:

❑ Have a high impact.
❑ Have a quick impact.
❑ Have monetary value.
❑ Have information on the cost of fashions and a fashion celebrity.
 Celebrity fashion marketers are aiming to achieve:
❑ The time to market.
❑ The reach and diffusion spread of celebrity fashion innovations.
❑ If a celebrity fashion is a trend, fashion, or a fad.
❑ How fashion bloggers, vloggers, and influencers are now becoming celebrities and how their banner ads can generate large amounts from advertising.
❑ Information on the groups and ages (people who want to dress like celebs). Does this influence affect different age groups (section 3.4.1)?
❑ Changes in the links between the designer and muse.

5.6.6 The Celebrity Fashion Marketer Human Fashion Brand Model Endorsement Factors

Brand Match/Congruence – Traditionally, celebrities would endorse a product and just give their face to it. Now, they can actually become the product and the brand (sections 1.1 and 3.3.1). Celebrity selection in endorsement is very important, and how marketers select the right celebrity can shape or change a whole fashion business model (sections 3.2 and 3.3).

Celebrity Endorsement Level – This can be short-term level 1 to extensive involvement at level 5. The aim here is to match the celebrity with the fashion brand and seek new ways for the fashion celebrities to differentiate themselves (section 3.3). When a fashion celebrity endorses fashions/brands in advertisements, consumers equate that product with the star quality of the celebrity, bringing the potential to boost sales dramatically. Celebrities are also using new ways to endorse paid and sponsored product ads

Fashion Consumer
Celebrity Influence = Need

Celebrities as Opinion Leaders	Need Level 1 Reference group identity	Need Level 2 Aspirational	Need Level 3 Influence	Need Level 4 Effects on behaviour	Need Level 5 Self-actualisation using the celebrity to self-emulate
The opinion leaders in this category are key members of society that are crucial in disseminating information on the latest fashion trends to the rest of the population, giving them a sense of belonging.	*Need to identify with a reference group* – the need to wear clothes and shoes are more for necessity and functionality and not really for fashion or to follow a celebrity. *Physiological need level* – consumer wears clothes for comfort and functionality. *Affiliation need level* – consumers don't affiliate to fashion celebrities. *Need for admiration/ esteem level* – consumers don't hold the need for society to admire what they wear. *Using the fashion celebrity to self-emulate*- consumer isn't fashion conscious.	*Need to identify with a reference group* – fashion consumers seek structure and stability from following a celebrity. *Physiological need level* – consumers want to try new ways of their clothes looking different. *Affiliation need level* – low-medium level affiliation. *Need for admiration/ esteem level* – fashion consumer wants to look presentable. *Using the fashion celebrity to self-emulate*- low-medium level of emulation	*Need to identify with a reference group* – fashion consumers hold a desire to follow the fashions and trends of their favourite popular celebrities. *Physiological need level* – fashion consumer clothes themselves to dress towards addressing a particular audience. *Affiliation need level* – fashion consumers look to identify with fashion celebrities and their lifestyle through all aspects, not just fashion. *Need for admiration/ esteem level* – wants to be seen and noticed for their fashion. *Using the fashion celebrity to self-emulate*- fashion consumers want to conform to the fashion celebrity as they connect to them.	*Need to identify with a reference group* –fashion consumers have a strong need to follow fashion. *Physiological need level* – need up-to-date fashion. They feel like they must look and behave a certain way. *Affiliation need level* – fashion consumers belong to a group or celebrity reference group because the individual has trust and acceptance with them. *Need for admiration/ esteem level* – fashion consumers want to be seen as fashionable by their personal reference groups. *Using the fashion celebrity to self-emulate*- fashion consumer loves to fashion follow celebrities and uses their fashion styles to improve their own self presentation. They are up to date on trends and feel great wearing what they do.	*Need to identify with a reference group* – at a high level the fashion consumer looks up to fashion opinion leaders because they feel that they are innovative, trendsetters, interesting and knowledgeable about fashion. *Physiological need level* – highly fashion conscious the consumer wears clothing to show their fashions. *Affiliation need level* – facilitated by mass advertising and pressure to be like their favourite fashion celebrities. A human response is instigated and a desire to conform to the celebrity. *Need for admiration/ esteem level* – fashion consumers feel that they must have the latest fashion that their favourite celebrity is wearing as it is a luxury status for them. *Using the fashion celebrity to self-emulate*- the celebrity at this level fulfils a personal gap within the consumer. The fashion consumer loves and needs to have everything they have; their style, image and what they stand for. The identity of the fashion celebrity matches the fashion consumer and they want to use them to emulate. They fulfil multiple interests which are related to the consumer's real or aspirational identity /personality or lifestyle in which celebrities are playing a role in helping fans that consume their fashions define and accentuate who they are and what they want to be.
Celebrity Fashion Trend Appeal Examples			Consumers want to associate with someone they connect with (For example Towie stars have mass appeal but are D-listers).	"I love the outfits and shoes Kim wore".	

Figure 5.9

Fashion Consumer Need Factors

on social media which allow much more exposure and an insight into their lives and what they wear (section 3.3.2, Table 3.1, and Figure 3.2).

Celebrity Endorsement Pay – Endorsements allow marketers to understand the market reach and value of celebrities and what their potential is. Most celebrities want to be at level 5, but marketers may only value their positioning to be at level 3 or 2.

Transference – A celebrity endorsement strategy can be an effective way to differentiate among similar products. The meanings they attach are transferred to the consumer through consumption. Hence, some celebrities endorse a brand linked to their profession; for example, Nike, Adidas, and Puma by athletes (Figures 3.3 and 4.7).

Celebrity Endorsement Influence Level – By following celebrity endorsements, the consumer receives a positive feeling of security and association since their idol is recommending the product. The images of the celebrities become associated with the products through endorsement images, and the assumption is made that they are quality products (sections 1.1, 2.4.1, 3.2, 3.3, and 3.3.3). Several marketer models and tools can be found in section 3.5. They are used either by a short endorsement stint at level 1 or for a global level fashion celebrity campaign at level 5 to attract fashion consumers by using a confluence of media coverage and celebrity fashions (sections 3.2, 3.3, and 3.3.1).

5.6.7 The Fashion Consumer Human Fashion Brand Model Influence Need Factors

Celebrities endorse many different types of products, and their fans use them so they can be like them (sections 1.1, 1.1.3, 2.1, 2.3, 2.4, and 3.3). Celebrities are an aspirational reference group that many individuals wish they belonged to (sections 1.1.1 and 4.1). Typically, these reference groups are made up of role models or idolised figures (sections 1.1, 2.1, and 4.2.3) that are admired and respected. The consumer's reference group exerts a strong influence on his or her behaviour, but this may not be the case for everyone. Marketers should consider the different types of reference groups and how these influences overlap and interact with each other.

Need to Identify with a Reference Group – Many consumers feel that wearing particular fashions positively enhances the interactions they have with others. The most obvious way in which imitation occurs is through the use of products that the consumer believes their role models also use and approve of.

Physiological Need Level – Consumers feel the need to conform because they are motivated by desires to preserve or enhance self-esteem (section 4.2.5 and Table 4.1). A physical bond is made with a product through its use, but a psychological bond is also formed that can positively or negatively affect one's perception of the self (sections 1.1, 1.1.4, and 3.5.1).

Affiliation Need Level – At level 1, an individual could have a negative to non-expectation when using celebrity fashion products. This expectation

Fashion Consumer Celebrity Influence = Fashion Identification					
The Meaning of Fashion & Self Identity	**Identification level 1 Meaning**	**Identification level 2 Fashion Brand User Level**	**Identification level 3 Transference**	**Identification level 4 Consumer Desires for a Changed Lifestyle**	**Identification level 5 The Human Fashion Brand Co-Creating the Self-Brand**
Fashion consumers seek self-expressive meaningful values from the fashions of the celebrities they like and taking influences from their clothing is a method of announcing their own individual identity.	*Meaning of celebrity fashion clothing to the consumer* – Clothing is functional and has a basic meaning. *Celebrity fashion impact on fashion consumer identity* – Minimal impact or none *Emotional attachment level* – no attachment towards fashion or celebrities. *Consumption level* – Pays basic prices for their clothing which are not seen as fashionable. *Emulation impact* – consumer doesn't want to emulate fashions of celebrities	*Meaning of celebrity fashion clothing to the consumer* – consumer wants to identify with fashions and trends. *Celebrity fashion impact on fashion consumer identity* – Consumers are exposed to mass advertising and are using fashion and celebrities to self-express themselves. *Emotional attachment level* – consumer views celebrity fashion appealing and is influenced by them. *Consumption level* – consumer will spend money to be notice as fashionable amongst own reference groups. *Emulation impact* – medium	*Meaning of celebrity fashion clothing to the consumer* – fashion has a meaning to the day to life of the consumer. *Celebrity fashion impact on fashion consumer identity* – consumer views the celebrity as an aspirational fashion figure. *Emotional attachment level* – consumer assigns meaning to the celebrity and desires to identify with their idealised fashions. *Consumption level* – consumer will pay money to get the right fashion and look that represents a celebrity. *Emulation impact* – active in seeking to emulate and holds fashion celebrities in high regard.	*Meaning of celebrity fashion clothing to the consumer* – high-level meaning given to clothing in the consumer's life to be fashionable. *Celebrity fashion impact on fashion consumer identity* – fashion consumer looks to imitate celebrity looks. *Emotional attachment level* – Has a high emotional attachment one or many celebrities and wants to look like them. *Consumption level* – fashion consumer's purchasing is high and determined by the interaction of the buyer's personality and the image of the celebrity. *Emulation impact* – Fashion consumer vigorously wants to connect to the fashions of the celebrity.	*Meaning of celebrity fashion clothing to the consumer* – a new level and need of understanding clothing the fashions a celebrity wears is driven by media and advertising. *Celebrity fashion impact on fashion consumer identity* – the celebrity means something to the consumer and they adopt and imitate the fashions and looks of them. *Emotional attachment level* – fashion attachment to the celebrity becomes so important in the role of the consumer's life that it becomes part of their extended self and forms their identity and the consumer thus visually looks like the celebrity through emulation and through their mannerisms. *Consumption level* – much of their taste and choices in fashion consumes their life, specifically purchasing which can be attributed to their desire to improve presentation and desirability from fashion celebrities. *Emulation impact* – at this level there are elements of the 'dream formula' (chapter 4) purchasing where consumers take their individual self -fantasies and hold a strong need to imitate. Level of imitation is high- this consumer looks for celebrity products for status, needs and a relationship to embrace, attach and belong to for their imagined intimacy with their celebrity.
Celebrity Fashion Trend Appeal Examples	Consumer doesn't feel the need to look at fashions of celebrities.	Consumer is fashion conscious.	Fashion consumer actively fashion follows celebrities.	Fashion consumer looks towards being highly fashionable and emulates.	Imitation level is high: -David Beckham -Kim Kardashian / Kardashian-Jenner sisters Hadid sisters.

Figure 5.10

Fashion Consumer Identification Factors and Sub-Factors

contrasts with level 5, where a consumer would have positive expectations when using celebrity fashion brands. Therefore, when individuals admire an aspirational figure such as a celebrity, they are comparing them to their actual self (i.e., what they are) with their ideal self (i.e., what they want to be) (sections 4.2, 4.2.1, 4.2.4, 4.2.5.1, and Table 4.1). Neuroimaging studies have shown that when some individuals view a well-known fashion brand (e.g., Zara) and a particular fashion celebrity, their brains respond in a similar way to individuals viewing something which activates reward and pleasure centres such as the orbitofrontal cortex (sections 1.1.3 and 4.2).

Need for Admiration/Esteem Level – Fashion celebrities influence purchasing because the consumer feels the need to use them as an act of social comparison (sections 2.3 and 3.1.1). Goethals study (1986) suggests that individuals compare themselves to others, such as celebrities, as a means of self-evaluation.

Using the Fashion Celebrity to Self-Emulate – Here the consumer feels that the fashion celebrity that they follow holds a value-expressive influence on their purchasing behaviour (sections 1.1.1, 2.4, 4.2, and 4.2.5.1) This is because the celebrity is someone they would like to emulate, and they think their advertised products are fashionable and stylish (Park & Lessig, 1977).

Celebrities are used to promote the sales of products because their presence motivates consumers to reach their ideal-self, and they are particularly effective at stimulating the natural tendency towards getting fans to imitate behaviour. By doing so, they prime the consumer to behave in a certain way (i.e., to purchase products).

5.6.8 The Fashion Consumer Human Fashion Brand Model Identification and Meaning Factors

The ability of a celebrity to influence consumer purchasing behaviour comes not only from how they look or how they are, but rather from the consumer's ability to identify with or relate to them. "Celebrities earn mass income from endorsements and this is why they actively seek such opportunities . . . these images are a function of the inferences that consumers make based on the knowledge that they have about the celebrity" (Keller, 1993). This three-way celebrity fashion marketing can be seen in the model and can be analysed by what fashion a celebrity wears, which types of fashion shops they go to, and at what level the fashion consumer wants to imitate the fashion of the celebrity (sections 2.4, 4.2, 4.2.1, 4.2.4, 4.2.5.1, and Table 4.1).

Meaning of Celebrity Fashion Clothing to the Consumer – Consumers take meanings from celebrity fashions and look at fashion celebrities as brands themselves and not as just endorsers (section 1.1.3).

Celebrity Fashion Impact on Consumer Identity – Fashion celebrities are individuals that consumers compare themselves to, and they can influence how a consumer perceives a product. They exert an informational influence by affecting what the consumer values and how they aspire to be.

Emotional Attachment Level – For some consumers, depending on their personality and social impact, they may purposely opt to become level 5. At this level, they aspire to behave and look like fashion celebrities and have a strong desire to emulate the fashion celebrity (sections 2.1, 3.5.7.5, and 4.2.4).

Consumption Level – Subsequently, if the fashion celebrity wants to target the masses, he or she can work with high-street fashion companies (section 2.4) and fast fashion to create a fad and allow consumption by consumers to be more accessible and affordable. Another factor to consider is that a fashion celebrity can also target luxury brands. They can also not target the masses [consumers] but a purposefully select group of consumers instead. This positioning can be seen in the fashion marketer endorsement model on level 4 which designates the market levels of celebrity fashion brands (section 2.3.1).

Emulation Impact – The model illustrates at a high level what this means for the fashion consumer obtaining information and access to everything that the fashion celebrity wears and how fast they can get it and what lengths they will go to get it. In comparison, a consumer at level 1 or 2 probably doesn't realise that they are exerting little influence or no influence at all.

5.7 Conclusion

This chapter presented the formation and development of the Human Fashion Brand Model and explained how "in effect, celebrities display the same elements that constitute a brand and, therefore, are viable as human fashion brands" (Seno & Lukas, 2007). Chapter 2 described the celebrity and his or her effectiveness in endorsing and promoting fashions as a coercive force in shaping the identity of fashion consumers. Chapter 3 identified the growing need for celebrity marketers to measure celebrity fashion marketing with an analysis of existing models. Chapter 4 analysed the fashion consumer-self and the meaning and attachments individuals place on their reference groups and celebrities as opinion leaders in their consumption of human-fashion-branded products to create their own self-brand. The objective of this chapter was to evaluate how celebrity fashion factors and need theme entities can impact fashion consumers in the context of emulation.

This chapter combined all the findings discussed thus far in this book to develop a model that helps assess the effectiveness of the celebrity human. The Human Fashion Brand Model allows us to:

❑ Measure the symbiotic relationship and effectiveness of fashion celebrities/fashion celebrity marketers and how they create new fashion innovations.

❑ Analyse why fans/consumers purchase trends which their favourite celebrities are wearing.

❑ Understand the positioning of fashion consumers who emulate fashion celebrities.

❏ Understand the positioning of fashion celebrities and fashion celebrity marketers.

❏ Assess the level of celebrity influence among fashion consumers.

❏ Monitor celebrities and their popularity levels.

❏ Understand fashion celebrity inspiration.

❏ Measure how many fashion items consumers purchase to purposely imitate a celebrity.

❏ Investigate why fashion consumers store messages containing the fashion celebrity's idealised images of beauty and physical attractiveness and feel the desire to imitate them.

❏ Analyse the impact of celebrity fashions on the fashion consumer and what constitutes successful fashion.

❏ Analyse how fashion celebrities are human fashion brands and effectively become embedded in the consumer psyche.

The Human Fashion Brand Model (sections 5.2, 5.3, and 5.6) is a positioning and assessment guide for understanding celebrity fashion marketing, the relationship among the symbionts, and how the symbionts work together. The goal of this model is to promote a better interpretation of the key factors that influence fashion consumers to emulate the fashions of celebrities. This goal was achieved from the key findings and through the literature reviews by the assimilation of the theory into one model that demonstrates the varying complexities among the symbionts (Chapters 2, 3, and 4).

Currently, the nature of the fashion industry means that companies do not have any form of documentation to tabulate performance or to understand the relationship of the symbionts/stakeholders or celebrities as a human fashion brand. Because this is a theoretical model, it is not designed to be picked up and directly implemented at this stage. The model is primarily targeted at celebrities, designers, and fashion marketers to assimilate theory. However, from it, celebrities/endorsers, consumers, academics, and anyone interested in celebrity fashion emulation can understand that there is a relationship among the symbionts/stakeholders. The Human Fashion Brand Model is envisaged to be a guide for anybody interested in celebrity fashion marketing and can be further dissected to show how fashion is dictated by different age groups, religions, and cultures. It has been designed to be adaptable to any place or culture. This is because it doesn't define what the style/fashion is or who the celebrity is.

References

Bailey, R. (2011). Letting children be children: Report of an independent review of the commercialisation and sexualisation of childhood. *The Stationery Office, 8078.*

Battista, C., & Schiraldi, M. M. (2013). The logistic maturity model: application to a fashion company. *International Journal of Engineering Business Management, 5,* 29.

Bright, A. D. (2000). The role of social marketing in leisure and recreation management. *Journal of Leisure Research, 32*(1), 12.

Carroll, A. (2009). Brand communications in fashion categories using celebrity endorsement. *Journal of Brand Management, 17*(2), 146–158. doi:10.1057/bm.2008.42

De Backre, K., & Miroudot, S. (2014). *Mapping global value chains.*

Euromonitor. (2014). *Celebrity power and its influence on global consumer behaviour* [online]. Retrieved from http://blog.euromonitor.com/2014/04/celebrity-power-and-its-influence-on-global-consumer-behaviour.html

Forbes. (2016). *Forbes releases 2016 celebrity 100 list of the world's highest-paid celebrities*. Retrieved from www.forbes.com/sites/forbespr/2016/07/11/forbes-releases-2016-celebrity-100-list-of-the-worlds-highest-paid-celebrities/#9939681570f5

Jamil, R. A., & Rameez ul Hassan, S. (2014). Influence of celebrity endorsement on consumer purchase intention for existing products: a comparative study. *Syed Rameez ul Hassan, RAJ (2014). Influence of celebrity endorsement on consumer purchase intention for existing products: a comparative study. Journal of Management Info, 4*(1), 1–23.

Keller, K. L. (1993). Conceptualizing, measuring, and managing customer-based brand equity. *Journal of Marketing, 57*(1), 1–22.

Klimko, G. (2001). *Knowledge management and maturity models: building common understanding*. Paper presented at the Proceedings of the Second European Conference on Knowledge Management. Bled, Slovenia.

Le Bon, C. (2015). *Fashion marketing: influencing consumer choice and loyalty with fashion products*. New York, NY: Business Expert Press.

Lea-Greenwood, G. (2012). *Fashion marketing communications*. Somerset, NJ, USA: John Wiley & Sons.

Lee, J. Y. (2015). *The impact of ideal-self congruity with celebrity endorsers on advertising effectiveness: The moderating role of message frame*. Retrieved from https://repositories.lib.utexas.edu/bitstream/handle/2152/31710/LEE-THESIS-2015.pdf?sequence=1

Malär, L., Krohmer, H., Hoyer, W. D., & Nyffenegger, B. (2011). Emotional brand attachment and brand personality: The relative importance of the actual and the ideal self. *Journal of Marketing, 75*(4), 35–52. doi:10.1509/jmkg.75.4.35

Mathys, J., Burmester, A. B., & Clement, M. (2016). What drives the market popularity of celebrities? A longitudinal analysis of consumer interest in film stars. *International Journal of Research in Marketing, 33*(2), 428–448.

Neimark, J. (2016). *The culture of celebrity: The nature of fame has changed in modern times, and celebrities, and their fans, are diminished by the process*. Retrieved from www.psychologytoday.com/articles/199505/the-culture-celebrity

Nilsen, P. (2015). Making sense of implementation theories, models and frameworks. *Implementation Science, 10*(1), 53. doi:10.1186/s13012-015-0242-0

Noar, S. M., Willoughby, J. F., Myrick, J. G., & Brown, J. (2014). Public figure announcements about cancer and opportunities for cancer communication: A review and research agenda. *Health Communication, 29*(5), 445–461. doi:10.1080/10410236.2013.764781

Okonkwo, U. (2007). *Luxury fashion branding: trends, tactics, techniques*. Basingstoke: Palgrave Macmillan.

Oxford Dictionary of English (2005) (revised ed.). Oxford: Oxford University Press.

Pappas, B. (1999). Star power, star brands. *Forbes, 163*(6), 188.

Park, C. W., & Lessig, V. P. (1977). Students and housewives: Differences in susceptibility to reference group influence. *Journal of Consumer Research, 4*(2), 102–110.

Pringle, H. (2004). *Celebrity sells*. Chichester: Wiley.

Randazzo, S. (1992). The power of mythology helps brands to endure. *Marketing News, 26*(20), 16.

Rogers, E. M. (2003). *Diffusion of innovations* (vol. 5). New York, NY; London: Free Press.

Rojek, C. (2001). *Celebrity*. London: Reaktion.

ahin, D. Y., & Atik, D. (2013). Celebrity influences on young consumers: Guiding the way to the ideal self. *Izmir Review of Social Sciences, 1*(1).

Sarshar, M., Amaratunga, R. D. G., & Haigh, R. P. (2002). *Structured process improvement in facilities management organisations using the SPICE FM approach.*

Seno, D., & Lukas, B. A. (2007). The equity effect of product endorsement by celebrities: A conceptual framework from a co-branding perspective. *European Journal of Marketing, 41*(1/2), 121–134.

Shaw, D., & Koumbis, D. (2014). *Fashion buying: From trend forecasting to shop floor*. London: Fairchild Books.

Taylor, & Harris. (2008). *Critical theories of mass media: Now and then*. Buckinghamshire: Open University Press.

Taylor & Francis. (2015). *Celebrity studies cultural report.*

Thomson, M. (2006). Human brands: Investigating Antecedents to consumers' strong attachments to celebrities. *Journal of Marketing, 70*(3), 104–119. doi:10.1509/jmkg.70.3.104

Tripp, C., Jensen, T. D., & Carlson, L. (1994). The effects of multiple product endorsements by celebrities on consumers' attitudes and intentions. *Journal of Consumer Research, 20*(4), 535–547. doi:10.2307/2489757

Wigley, S. M. (2015). An examination of contemporary celebrity endorsement in fashion. *International Journal of Costume and Fashion, 15*(2), 1–17.

Yeo, K., & Ren, Y. (2009). Risk management capability maturity model for complex product systems (CoPS) projects. *Systems Engineering, 12*(4), 275–294.

Chapter 6

Concluding Remarks

6.0 Overview

This book commenced with an overview of the fashion celebrity and the fashion industry. It investigated how celebrities could demonstrate their pioneering fashions, choices, trends, and styles to their fanbase in order to generate sales from fashions and new innovations they have created. Previous chapters emphasised that there were several existing theories that were rather isolated, but none were combined and described the symbiotic relationships among the fashion celebrity, fashion celebrity marketer, and fashion celebrity consumer presented in Chapters 2, 3, and 4. As a result of this and to fill in the above-described gap in the existing literature, a Human Fashion Brand Model was developed and presented. This final chapter draws conclusions and provides recommendations for future research.

6.1 Findings of the Book

"As exposure of the celebrity grows, so does celebrity influence" (Moulard et al., 2015). The Human Fashion Brand Model was presented in this book to illustrate how consumers build personal relationships with celebrities and their fashions, brands, and innovative products, and it showed how they are an influential source of value to fashion celebrity marketers and fashion consumers. Fashion celebrity marketers and brands utilise fashion celebrities to allow consumers to, in their minds, get closer to the celebrity and view the celebrity as someone in their life. Celebrities are then used by consumers/individuals as a reference point for entertainment and to fill a gap or numerous gaps in their lives (Rojek, 2001).

The book examined marketing as having a social side, where "individuals and groups obtain what they want and need through creating, offering and exchanging products of value with others" (Bright, 2000). The model can act as a positioning guide for anybody interested in celebrity fashion marketing, but it is primarily targeted at fashion celebrities, fashion brands, designers, fashion celebrity marketers, and academics. Designed to be comprehensive (adaptable to celebrities, fashions, and cultures), the Human Fashion Brand Model does not define who the celebrity is or what the fashion style is. Thus, the model allows greater levels of detail if needed in order to thoroughly test its workability and efficiency in the celebrity fashion field and in celebrity fashion emulation targeted campaigns.

DOI: 10.4324/9781003175360-6

Celebrities "display the same elements that constitute a brand and, therefore, are viable as human fashion brands" (Seno & Lukas, 2007). This need for a Human Fashion Brand Model also stems from the tendency of celebrities and their fans to frequently use social media. The model will help with understanding the motivational factors behind what makes them choose a particular fashion (displayed as influence consumer factors in the model). The Human Fashion Brand Model also reveals how adopting a particular celebrity fashion product to sell depends on many factors, and it captures this information through different levels and themes of needs. This information is presented in the fashion consumer needs section which recognises consumers' needs to identify with a reference group and be affiliated with a celebrity (section 5.9). Today, celebrities and marketers are under increasing pressure to understand the critical factors of the impact of celebrities and their fashions on consumers (sections 1.1, 2.1, 2.2.1.5, 2.3, 3.1 – 3.5, 4.1, 5.7, and 6.4). Such a model allows marketers to map and see where a celebrity fits within which symbiont and at what stage.

6.2 Social Media Appeal, Demographics, and Data Analytics

Today's consumers require fashionable products and easier access to their favourite celebrity's fashions, intimate exposure to their favourite celebrities, and faster consumption and convenient transactions. Moreover, as presented in Chapter 3 and in the Human Fashion Brand Model in Chapter 5, influences of technology have allowed celebrities and their fame to become more immediate and instant (Taylor & Francis, 2015). Consumers articulate their personal identity and promote social interaction with others via celebrity fashion brands and the use of social media (Lee, 2015). Celebrities are often used to advertise and promote the sales of products because their mere presence motivates consumers to reach their ideal self. In addition, they are also particularly effective at stimulating the natural tendency towards imitated behaviour (section 4.2.4).

Undoubtedly, the success of a brand's performance is tied to the celebrity exposure it receives. According to a Marketwatch claim in 2011, one celebrity endorsement can almost instantly increase sales by 4% even if it was just an announcement of a collaboration. In 2013, 85% of people stated that a celebrity endorsement increased their confidence in brands, while the other 15% mentioned that endorsements affected their purchasing decisions. Brands should be in the know about those behaviours and how they can help them gain more customers. However, they are left in the dark when it comes to "natural affinity," which happens when a celebrity just happens to use the product without any form of compensation. This is where data analytics steps in (Serena, 2017). Data analytics is the "science of analysing raw data to make conclusions about that information. Many of the techniques and processes of data analytics have been automated into mechanical processes and algorithms that work over raw data for human consumption" (Frankenfield, 2021).

Gathering intelligence on fashion celebrity exposure factors (section 5.5) helps companies understand the celebrity as an influencer and fashion pusher with international consumer reach and how they create innovative fashions to be diffused and adopted by fashion consumers. It would be useful to marketers and fashion consumers to know that consumers can be categorised according to age and location demographics. For example, where were they born, and where do they belong as a consumer? What exposure have they had? Are they male or female? Gathering this information and breaking down consumers even more through their interests and hobbies can provide more useful information.

Information gathered from social media platforms is global and allows billions of people around the world to stay connected (Walton, 2021). Each platform appeals to different types of users and offers unique services or features to consumers. Thus, they allow a lot more access for celebrities to communicate what they have, where they purchase things from, what they are wearing, and where they go.

Social media sites and their appeal to different user demographics can be summarised as follows:

- ❏ Facebook, Twitter, TikTok, YouTube, and Instagram are all popular social media platforms used by people around the globe.
- ❏ Each appeals to different types of users and offers unique services or features.
- ❏ Facebook has a broad appeal: 68% of adult Americans report using the platform.
- ❏ Twitter users are more likely to be college graduates, affluent, and live in a city.
- ❏ Instagram users tend to be young. About 1 billion users check in with Instagram monthly.

(Walton, 2021)

The book discusses fashion and branding in social media (sections 3.2 and 3.3), and it explores how, in turn, "these advances have transmuted celebrities into commodities and have helped them to personalise information towards fashion consumers" (Neimark, 2016). This type of celebrity fashion dominance on social media sites such as Instagram and Twitter promotes the continual exposure of celebrities. Thus, celebrities on social media can affect consumer behaviour by suggesting how fashion consumers should behave and how they should look. The Human Fashion Brand Model (Chapter 5) could provide the most appropriate model structure to depict those celebrities which can develop and successfully implement new fashion innovations using the model's level classification from 1 to 5.

The fashion celebrity marketer exposure (section 5.7) illustrates entity as a need theme for a celebrity's profile attractiveness. It illustrates if the celebrity endorses products on social media and other platforms on a local, national, or global scale. A fashion consumer gave their opinion on this issue:

I would say I use Instagram for the celebrities that I follow . . . for example, I can look at him (Daniel Craig) and admire him, his physique etc. there are such a lot of fusion of elements that I can relate to personally. The benefits are you know what the celebrity is wearing, where they got it from and how much it is and some sites will come up with alternatives of versions of the

same product but the prices will vary and these make my search easier in comparison to searching in a store which is difficult.

(Anonymous)

Thus, the Human Fashion Brand Model can analyse:

❑ **Fashion Celebrity** – Influence, Exposure, and Impact
❑ **Fashion Celebrity Marketer** – Exposure and Endorsement
❑ **Fashion Consumer** – Need and Identification

The Human Fashion Brand Model opened a new dialogue about the symbionts and how celebrity fashion culture impacts the lifestyle determinants of fashion consumer groups and defines the symbiotic relationships for celebrity fashion emulation. Thus, the book demonstrates how consumers build personal relationships with celebrities and their fashions and how fashion celebrities are an influential source of value to fashion celebrity marketers and fashion consumers. With this in mind, the final model outcome synthesises aspects of the key symbionts, incorporating the key roles: positioning, assessment, influences, and impacts of celebrity fashions adopted by consumers for the purpose of emulation. It can be used as a positioning guideline for celebrities, marketers, and others such as academics in recognising the interrelationships among the key roles. The Human Fashion Brand Model displayed different parameters of the diverse celebrity fashions through factors, sub-factors, need theme levels in Chapter 5 and can measure and encapsulate the following:

❑ Measure the symbiotic relationship and effectiveness of fashion celebrities/ fashion celebrity marketers and how they create new fashion innovations.
❑ Analyse why fans/consumers purchase trends which their favourite celebrities are wearing.
❑ Analyse the positioning of fashion consumers who emulate fashion celebrities.
❑ Analyse the positioning of fashion celebrities and celebrity fashion marketers/ brands.
❑ Assess the levels of celebrity influence among fashion consumers.
❑ Monitor celebrities and their popularity levels.
❑ Assess fashion celebrity inspiration.
❑ Measure how often the direct purchasing of fashion consumer items is done with the intention of looking fashionable and to purposely imitate the celebrity.
❑ Investigate why fashion consumers store messages about the fashion celebrity's idealised images of beauty and physical attractiveness and feel the desire to imitate them.
❑ Measure the impact of celebrity fashions on the fashion consumer and what constitutes successful fashion.
❑ Analyse why fashion celebrities can become human fashion brands and why those brands then become embedded in the consumer psyche.

The model and questions also uncovered an increase in the number of consumers viewing products that they considered "ethical" and in keeping with their fashion morals. One celebrity stated, "The fashion campaigns I have done, I guess were because they were big named brands/very famous brands and I felt it would be good to be associated with those types of brands that I believed in that were ethical." The Human Fashion Brand Model provides information and helps to answer some of the essential questions raised and can be useful for fashion celebrities, fashion celebrity marketers, and celebrity fashion consumers alike in evaluating the success, diffusion, and adoption of a celebrity's fashion. The model also promotes a better understanding of the key issues in the fashion industry and why consumers are driven to imitate their favourite celebrities. The model is about understanding these influences and the impacts of the fashions of celebrities on fashion consumers and how fashion celebrities actively engage in influencing consumers at each of the stages. As mentioned before, at this point, it isn't about moving levels for all celebrities but recognising what each level represents. Determining these extremities from levels 1 to 5 ensures a broader range and depth of validation in each stakeholder group.

6.3 Recommendations for Future Research

Overall, this book presents the Human Fashion Brand Model that defines the critical symbiotic relationships for celebrity fashion emulation. The model is complex and is based around the development of theory and theory building.

The Human Fashion Brand Model highlighted the following recommendations:

1. The model's effectiveness can be enhanced by creating software and adapted to build around the profile of a fashion celebrity/fashion brand/fashion consumer in a more usable format (digital interface) for industry to use and for marketers and celebrities to understand. However, at this stage, it is a positioning tool which draws together existing theories into a cohesive model. One way the model can be adapted is to use the model to map an individual's consumer life in progressive stages (youth to older age). This technique will be useful for extracting purchasing information to monitor the celebrity fashion consumer behaviour choices of fashion consumers by measuring:

 ■ Their favourite celebrities that they follow or have followed over a period of time.
 ■ What fashion brands they have used.
 ■ Their exposure.
 ■ Their shopping experiences.
 ■ Their buyer behaviour.
 ■ Loyalty.
 ■ How they have been impacted

The Human Fashion Brand Model allows retail outlets to understand how they can work with celebrity-fashion-led campaigns to build on displays, merchandising, mannequins, and atmospherics for the whole consumer experience. They can take the consumer's experience one step beyond just seeing a fashion product on the phone or a small screen to seeing how it visually appeals to the fashion consumer in a retail fashion environment. This can have a positive outcome as fashion celebrity marketers are able to promote other connected products and lines to increase sales for a celebrity and his or her fashion, thus creating a brand story that the fashion consumer can connect to.

Online fast-fashion sites like Boohoo.com, ASOS, Pretty Little Thing, Nasty Gal, and Missguided offer clothing at significantly low prices and trade on frequently renewing collections which are regularly updated more rapidly than on the high street. In August 2018, there was a 50% rise in sales and increased numbers of social media followers for such sites. This in turn gave rise to the "wear it once" trend which is alarming officials in the United Kingdom because of the growing fast fashion's effect on the environment. The trend arose because so many people were posting outfits on social media that some women felt they couldn't wear the same thing more than once. This trend made news when one person stated, "We see celebrities doing that – all the big influencers you barely see them wearing the same thing twice" (BBC, 2018). Such clothing often ended up in landfills or was sent as aid to developing countries such as Rwanda. However, Rwanda, Kenya, Tanzania, Uganda, and Burundi announced their intention to phase out imports of second-hand clothing and shoes from western countries by 2019 as part of the "to protect our people" campaign. More recently, there have been reports that people risk catching diseases in developing countries if they wear second-hand clothing due to the conditions in which they are stored, and therefore, they have opted to not wear it. Future research is necessary to explicate this phenomena (Gambino, 2017). Concern about "wear it once" clothing has become an issue and more such stories are exposed in the press. Now, a growing number of consumers are becoming educated and are purchasing ethical and sustainable products.

6.4 Influencers, Vloggers, and Bloggers

The model highlighted the growth in a new genre of celebrity, where celebrities are sharing the spotlight with self-proclaimed celebrities called influencers, vloggers, and bloggers. Influencers make money from their blogs and vlogs through banner ads, but they can also make a lot more by posting sponsored content (write-ups that brands pay for). This then allows them to earn a portion from the sales that come from their fan base. This approach has many advantages, because these influencers are able to command money (up to £50,000) to host events and work with A-list brands such as YSL, Ralph

Lauren, and CK (Piazza, 2016). This opens the discussion to the following questions:

❏ Are influencers/vloggers and bloggers credible celebrities in their own right?
❏ What does celebrity loyalty mean through media and its impact on fashions?
❏ How can online celebrities maximise loyalty rewards and codes for future trends?
❏ What is the meaning of celebrity fashion beauty to the fashion consumer?
❏ How far will consumers go in their quest to be like their favourite fashion celebrity that they are influenced by?

Figure 6.1

Beyoncé Ivy Park

Moreover, the investigation found that there is also a new "era of power given to celebrities and fashion brand collaborations" (Stanford, 2016). Audrey Hepburn said, "My look is attainable. Women can look like Audrey Hepburn by flipping out their hair, buying the large sunglasses, and the little sleeveless dresses" (Berrington, 2015). This further supports the introduction of a new influx of celebrities dictating not only how we dress, but also how our children dress and making celebrity babies such as Beyoncé's become celebrities themselves. Beyoncé is a fashion icon and recently expressed her own personal appreciation for workout clothes by starting a fashion line (Ivy Park) with Topshop (Gilliland, 2016). Ivy Park is a typically 'Beyoncé-esque' brand and Beyoncé said the following about her fashion brand: "True beauty is in the health of our minds, hearts and bodies. I know that when I feel physically strong, I am mentally strong and I wanted to create a brand that made other women feel the same way."

The Human Fashion Brand Model also has the future potential to be used to identify the disadvantages related to following celebrities; for example, the increasing uptake of plastic surgery which is becoming popular because individuals want to look like their favourite celebrity. Thus, the media and celebrities are creating ideals of beauty that are making the same look popular and making everyone look the same. Moreover, consumers are going one step beyond imitating the clothes of their favourite celebrities; they are actually willing to go into financial debt in the process. One celebrity was very passionate about this and said,

> Celebrities should be positive role models and present themselves more carefully as it isn't just about the fashion it is about the whole image and package. Because sometimes followers and fans can not differentiate between the two (the fantasy image and the reality).

Thus, is the media forcing fashion consumers to have an impossible image of beauty? (Pringle, 2004)

The Human Fashion Brand Model illustrates how consumers emulate trends as they diffuse and become more accepted because of the exposure to celebrity fashions. It can also be applied to specific celebrities, individuals, and reference

groups to further analyse how consumers store messages of the celebrity's idealised images of beauty and physical attractiveness and why they feel the desire to imitate them through levels of attachment and conforming (dream formula). The following statement encapsulates a fashion consumer's perspective.

> "I can't get the celebrity Victoria Beckham's lifestyle and I can't get her millions; I can't get her houses or her beautiful husband but I can get her clothes and if they are too expensive, I can get something similar on the High Street or online."

6.5 Final Words and the Future Direction of Celebrity Fashion

At a high level on the Human Fashion Brand Model, there is a prominent attachment of the celebrity by the consumer; where the celebrity is a fashion trendsetter and whatever they choose to wear works. This is when the celebrity's fashion has now become a public form of human research and development. Finally, the authors also made a personal observation during the process of this research. To some extent it appears that the media and society are instilling a godless society by suggesting "an absence or lack in existence, which is probably ultimately related to the decline of organised religion" (Rojek, 2001). However, human beings, it appears, still have an innate need for a sense of belonging, a need to follow and to feel worthy, and a need to be recognised. Individuals still feel the need to follow something or belong to a reference group and have now made celebrities into idols to fill that gap. The extent to which this is the case needs to be substantiated by further research.

Today, fashion consumers are placing more emphasis on purchasing celebrity fashions, and they perceive these brands and products associated with celebrities as being more prestigious, of higher quality, or otherwise more desirable (Batra & Homer, 2004; Keller, 1993; Spry et al., 2011). "This narcissistic self-invention of the famous depends upon short term, fluid and mobile constructions of identity and constructions of selfhood that can be adopted" (Elliott, 2003).

It is proposed that the future of celebrity fashion will depend on the evolving needs of the consumer:

- ❑ Consumers will buy directly from brands.
- ❑ Generation Z will have more influence.
- ❑ Education will be more valued.
- ❑ Storytelling is now king.
- ❑ Unisex fashion will become more popular.
- ❑ Personalisation will continue to dominate.

- ❑ Sustainability and ethical consumption will become an even hotter topic than it is today.
- ❑ Consumers will continue to depend on social media to connect.
- ❑ COVID and other issues affecting society will continue to change the way we wear clothes.
- ❑ Celebrity ethics and sustainable brand practices will continue to affect consumer choices.
- ❑ Purchasing celebrity endorsed products on the Internet/online will continue to grow and change.
- ❑ Celebrities will promote Licensing, NFTs, blockchains, and cryptocurrencies and this market will continue to grow.

Furthermore, through fashion celebrity marketers utilising these fashion celebrities, consumers can, in their minds, get closer to the celebrity and view the celebrity as someone in their life. "This means for the consumer and fans, the possessing of a deep attraction for given celebrities that as a result re-moulds both lifestyle and embodiment . . . requiring the individual to be desirable" (Rojek, 2001). These trends will result in more and more fashion consumers wanting to pursue sameness and shopping to create cloned looks inspired by celebrities and their fashions.

References

Batra, R., & Homer, P. M. (2004). The situational impact of brand image beliefs. *Journal of Consumer Psychology, 14*(3), 318–330.

BBC. (2018). *Can you be sustainable if you're into fast fashion online?* Retrieved from https://www.bbc.co.uk/news/newsbeat-45766366

Berrington, K. (2015). *Audrey Hepburn's life lessons.* Retrieved from https://www.vogue.co.uk/gallery/audrey-hepburn-best-quotes

Bright, A. D. (2000). The role of social marketing in leisure and recreation management. *Journal of Leisure Research, 32*(1), 12.

Elliott, A. (2003). *Celebrity* (vol. 37, pp. 618–619). Cambridge: SAGE Publications.

Frankenfield, J. (2021). Data analytics. *Investopedia.* Retrieved from https://www.investopedia.com/terms/d/data-analytics.asp#:~:text=Data%20analytics%20is%20the%20science,raw%20data%20for%20human%20consumption.

Gambino, L. (2017). *'It's about our dignity': Vintage clothing ban in Rwanda sparks US trade dispute.* Retrieved from www.theguardian.com/global-development/2017/dec/29/vintage-clothing-ban-rwanda-sparks-trade-dispute-with-us-united-states-secondhand-garments

Gilliland, N. (2016). *Style or sell-out: Three examples of celebrity fashion collaborations.* Retrieved from https://econsultancy.com/style-or-sell-out-three-examples-of-celebrity-fashion-collaborations/

Keller, K. L. (1993). Conceptualizing, measuring, and managing customer-based brand equity. *Journal of Marketing, 57*(1), 1–22.

Lee, J. Y. (2015). *The impact of ideal-self congruity with celebrity endorsers on advertising effectiveness: The moderating role of message frame.* Retrieved from https://

repositories.lib.utexas.edu/bitstream/handle/2152/31710/LEE-THESIS-2015.
pdf?sequence=1

Moulard, J. G., Garrity, C. P., & Rice, D. H. (2015). What makes a human brand authentic? Identifying the antecedents of celebrity authenticity. *Psychology & Marketing, 32*(2), 173–186.

Neimark, J. (2016). *The culture of celebrity: The nature of fame has changed in modern times, and celebrities, and their fans, are diminished by the process.* Retrieved from www.psychologytoday.com/articles/199505/the-culture-celebrity

Piazza, J. (2016). *The '80s had Christie, Elle, and Iman. The '90s had Cindy, Heidi, Kate, and Naomi. The Victoria's Secret girls dominated the 2000s. But these days, runway phenoms Gigi and Kendall share the spotlight with a new cadre of young, hyper-chic so-called influencers.* Retrieved from www.marieclaire.com/fashion/news/a22091/business-of-style-stars/

Pringle, H. (2004). *Celebrity sells.* Chichester: Wiley.

Rojek, C. (2001). *Celebrity.* London: Reaktion.

Seno, D., & Lukas, B. A. (2007). The equity effect of product endorsement by celebrities: A conceptual framework from a co-branding perspective. *European Journal of Marketing, 41*(1/2), 121–134.

Serena, A. (2017). *Data analytics and celebrity brand endorsements should work together. Here's why.* Retrieved from https://www.linkedin.com/pulse/data-analytics-celebrity-brand-endorsements-should-work-alicia-serena/

Spry, A., Pappu, R., & Bettina Cornwell, T. (2011). Celebrity endorsement, brand credibility and brand equity. *European Journal of Marketing, 45*(6), 882–909.

Stanford. (2016). *A brief look at the power of celebrities in fashion branding.* Retrieved from https://fashionjournal.com.au/fashion/fashion-news/a-brief-look-at-the-power-of-celebrities-in-fashion-branding/

Taylor & Francis. (2015). *Celebrity studies cultural report.*

Walton, J. (2021). *Twitter vs. Facebook vs. Instagram: What's the difference?* Retrieved from https://www.investopedia.com/articles/markets/100215/twitter-vs-facebook-vs-instagram-who-target-audience.asp

Index